Drawing
Animals

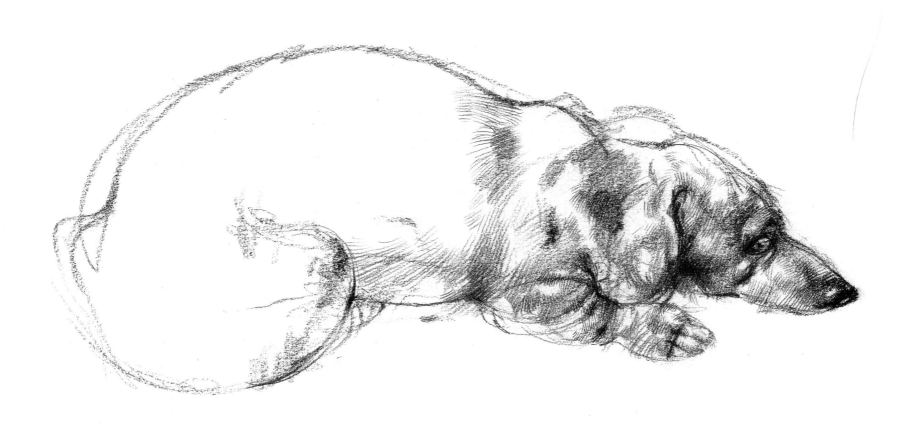

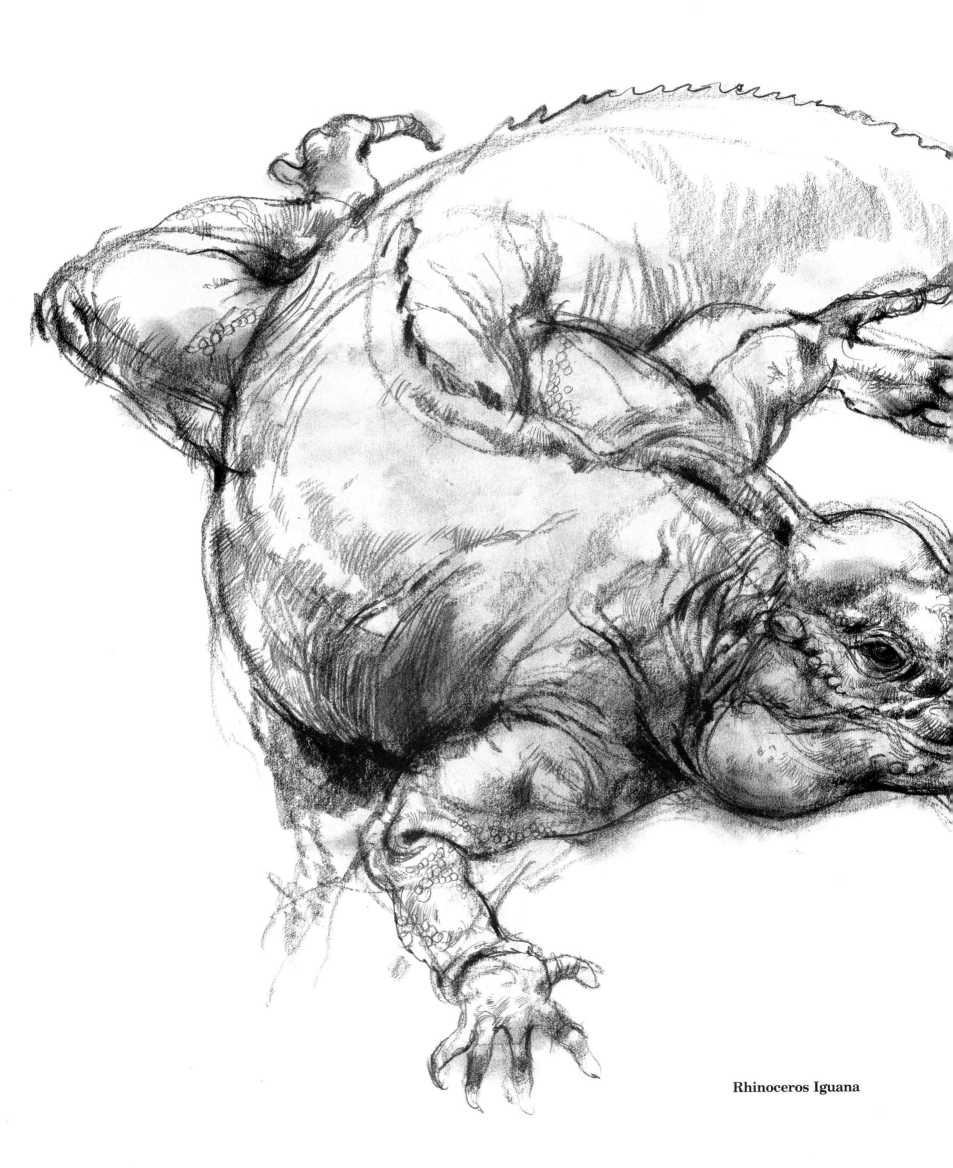

Rhinoceros Iguana

Drawing
Animals
Victor Ambrus

With zoological notes by Mark Ambrus B.Sc.

CHARTWELL
BOOKS, INC.

Contents

**This edition first published in the USA by
Chartwell Books Inc.
a Division of Book Sales Inc.
110 Enterprise Avenue
Secaucus, New Jersey**

Copyright © 1990 Brian Trodd Publishing House Limited

ISBN 1-55521-399-5

Printed in Italy

Author's acknowledgments

The illustrations in this book were drawn on location at:
London Zoo, London, England
Marwell Park, Winchester, England
Birdworld, Farnham, England
Tiergarten, Vienna, Austria
Allatkert, Budapest, Hungary
Hammamet, Nabul, Tunisia

My grateful thanks to the authorities, and to all friends who allowed me
to draw their pet animals.

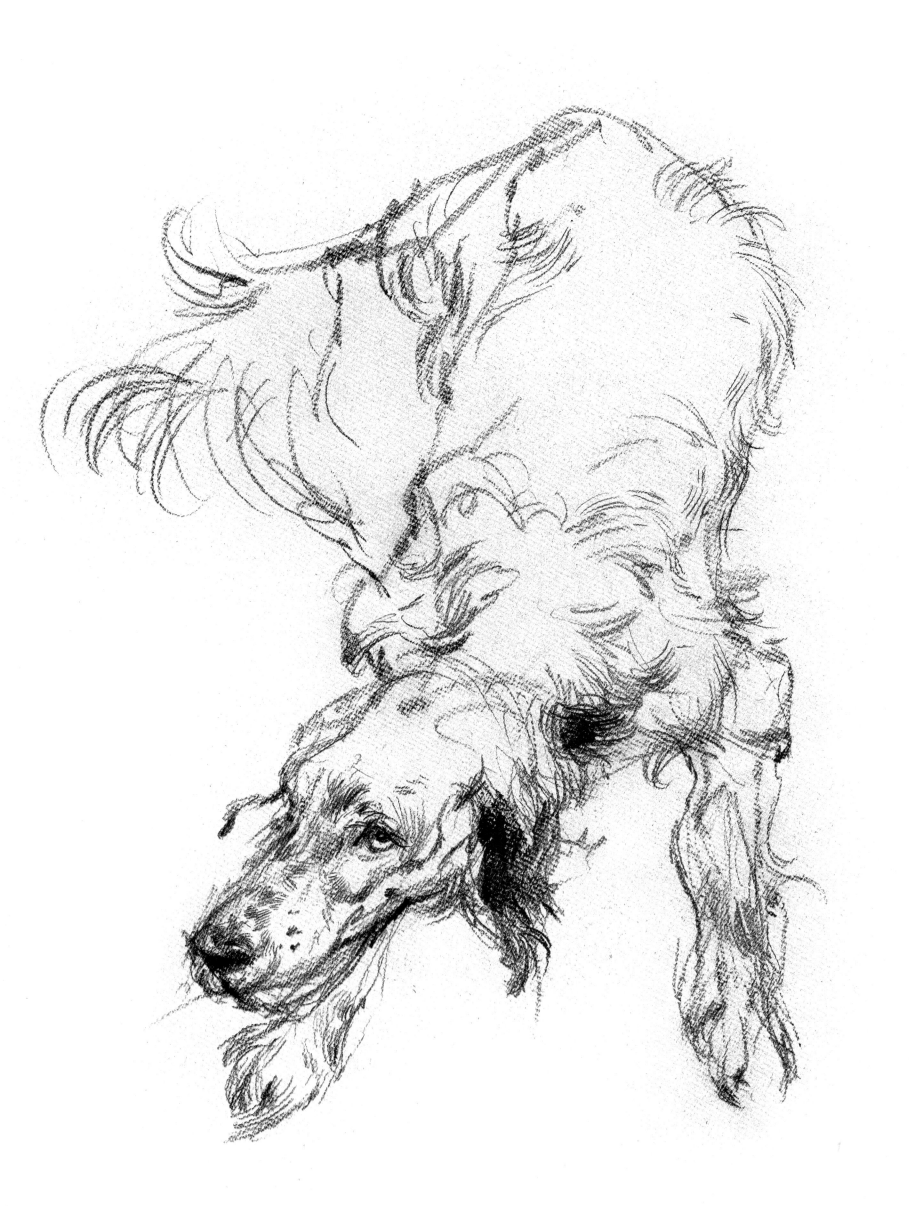

Introduction

This book is a companion to *How to Draw the Human Figure*. In this volume I have set out to show a wide selection of animal drawings, ranging from domestic to wild animals and birds of all shapes and sizes, explaining the problems and delights of drawing animals with illustrations of very quick sketches and longer, more detailed studies. I hope that this book will encourage the would-be wildlife artist to take pencil and sketchpad to the nearest wildlife park or zoo, if not all the way to a safari in Africa. If you do not feel experienced enough to launch yourself on a lion, you can make a start with your cat or your next door neighbour's dog. I have to

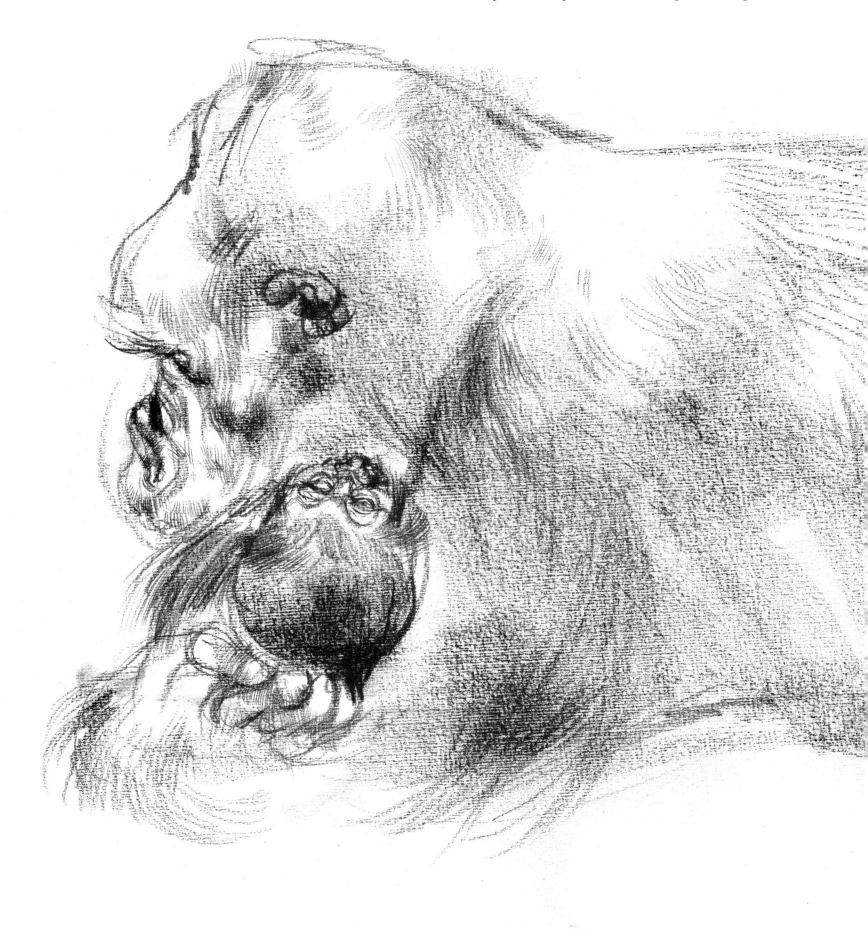

Female Gorilla

6

admit that you will need a certain amount of experience of drawing as animals are not the easiest of subjects, but you can make it easier for yourself if you follow a few important principles. Never start with an eye, an ear or a nose and hope to put the creature together like a jigsaw puzzle. It will not work. Always start with the whole shape, be it a large animal or just the head of one, and then work back towards the detail. You can always add on to a sound drawing, but if it is badly drawn in the first place, no amount of detail will make it come right. Pick on simple and compact animals to start with, or a complex animal in a simple pose.

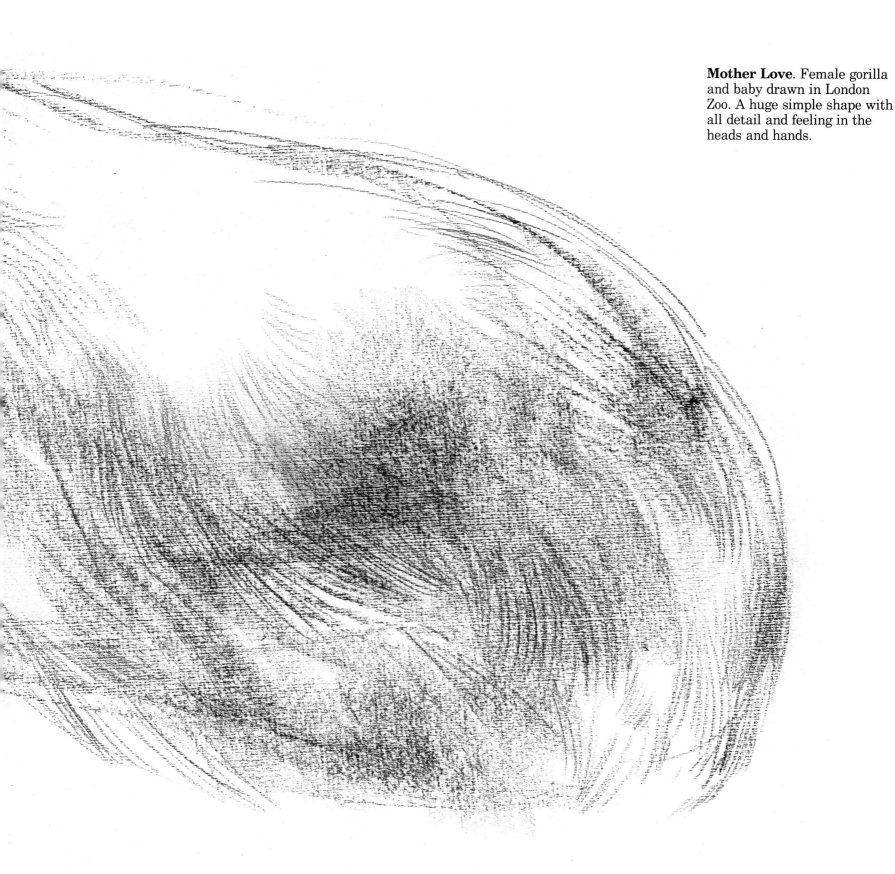

Mother Love. Female gorilla and baby drawn in London Zoo. A huge simple shape with all detail and feeling in the heads and hands.

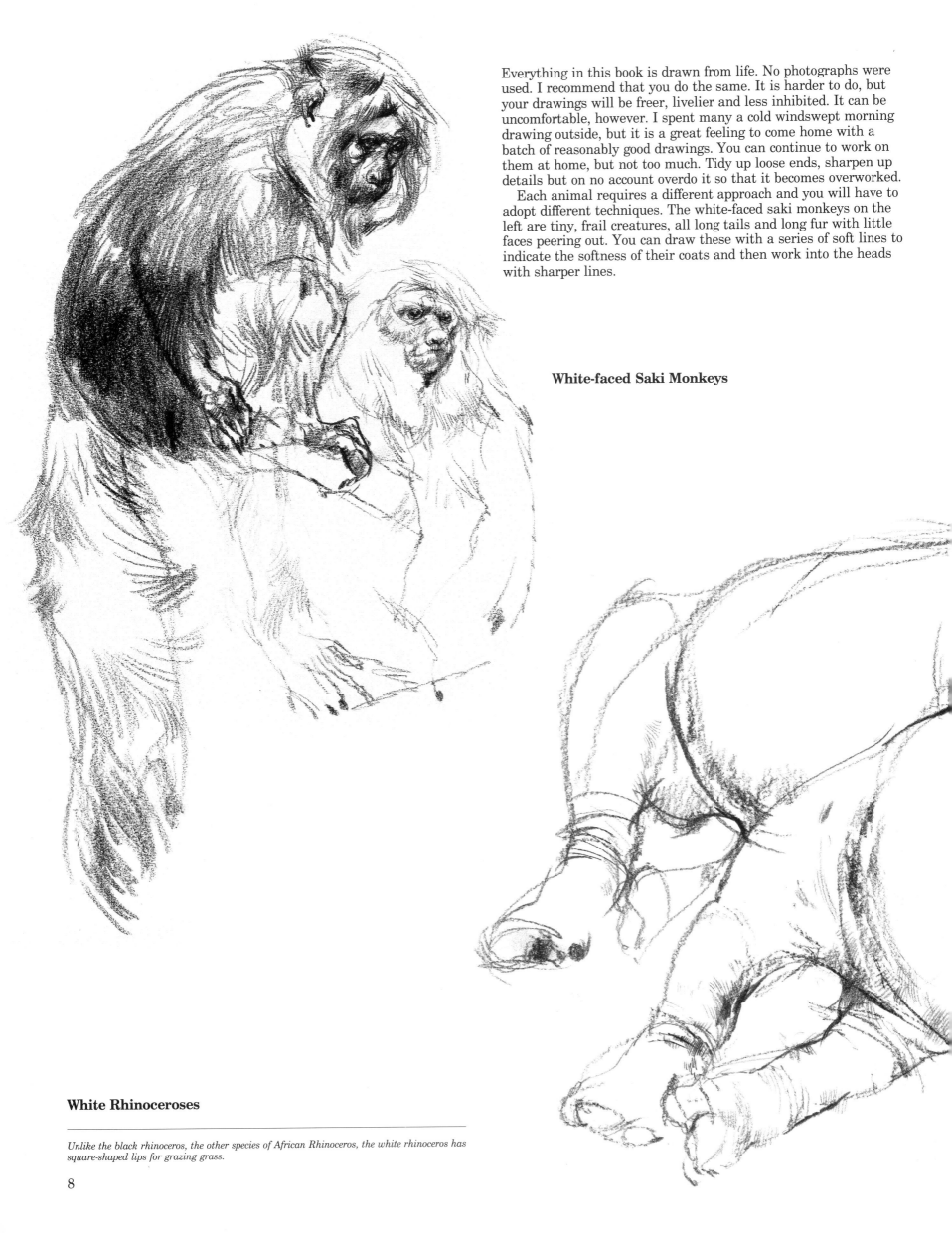

Everything in this book is drawn from life. No photographs were used. I recommend that you do the same. It is harder to do, but your drawings will be freer, livelier and less inhibited. It can be uncomfortable, however. I spent many a cold windswept morning drawing outside, but it is a great feeling to come home with a batch of reasonably good drawings. You can continue to work on them at home, but not too much. Tidy up loose ends, sharpen up details but on no account overdo it so that it becomes overworked.

Each animal requires a different approach and you will have to adopt different techniques. The white-faced saki monkeys on the left are tiny, frail creatures, all long tails and long fur with little faces peering out. You can draw these with a series of soft lines to indicate the softness of their coats and then work into the heads with sharper lines.

White-faced Saki Monkeys

White Rhinoceroses

Unlike the black rhinoceros, the other species of African Rhinoceros, the white rhinoceros has square-shaped lips for grazing grass.

On the other hand, the three friends draped across the bottom of the page are huge, heavy creatures with tough, smooth skins. Use a bold, soft carbon pencil and draw the bulk of them first as correctly as you can. I came across these white rhinos in Marwell Park near Winchester. They were some distance away and had formed into a convenient group. Only when I had a good sound line drawing of them did I elaborate with the use of tone, searching out the forms and details of their faces and feet.

This drawing represents a transition from the linear start towards the full study of the forms of these resting giants. Being drawn in glorious summer light, this is achieved with the help of light and shade which brings forms alive.

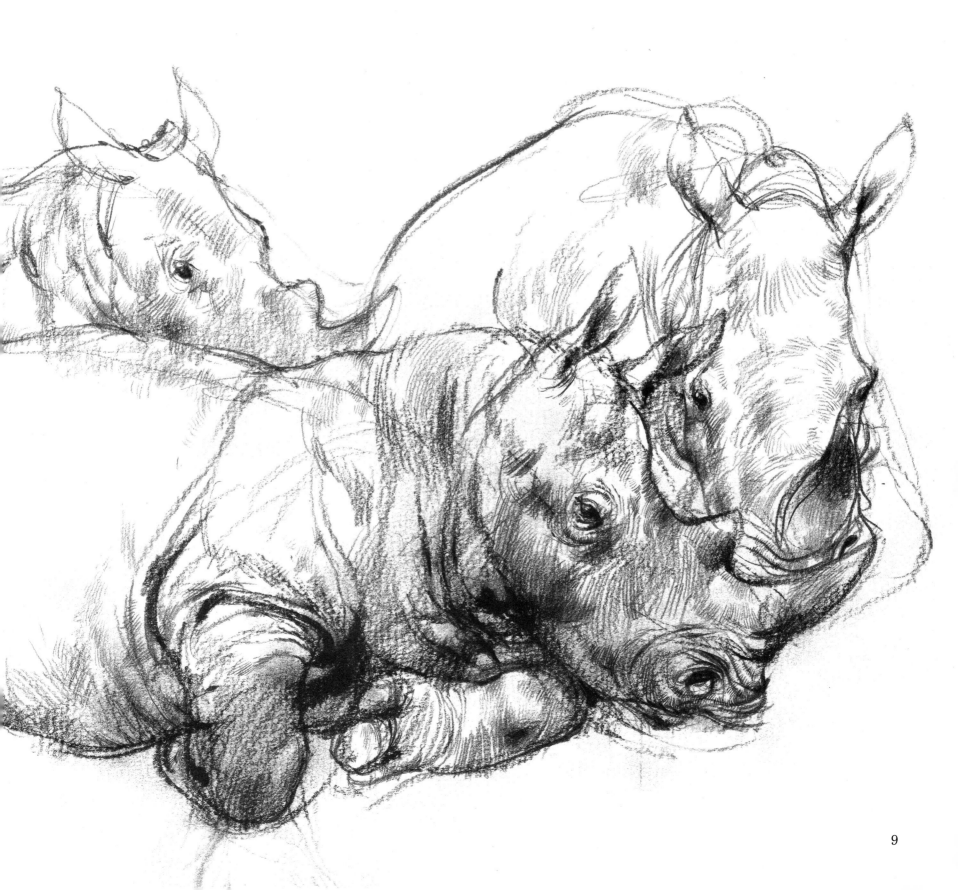

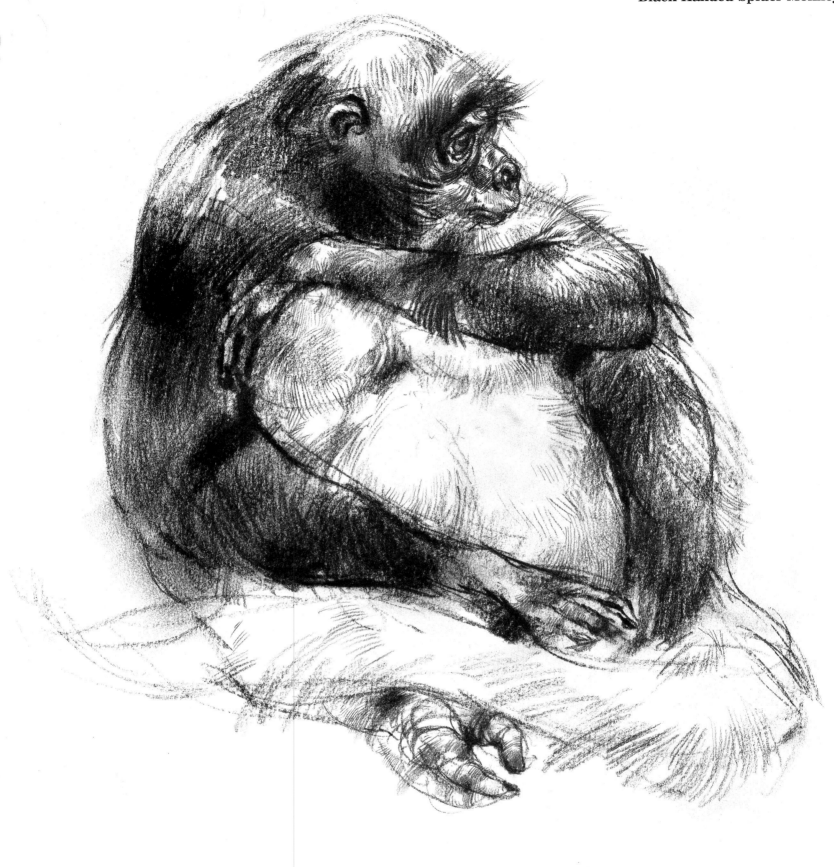

Now move on to the next stage. This monkey is still a nice simple
shape and makes a neat and compact composition. But if you have
time, and the animal will stay still for you, you can develop it to a
drawing of full tonal value as you see above. The arms were
crucial, cradled round the white pot belly, with the toes peeping out
from beneath the long, white tail. Once this is established, use
tone, but always follow the form that you are drawing. Let the
lines follow the shape, gradually building up their strength until
you are using solid blacks where needed.

Always pay special attention to heads, facial expressions and
hands. This little monkey had a worried look which I was
determined to get down on paper.

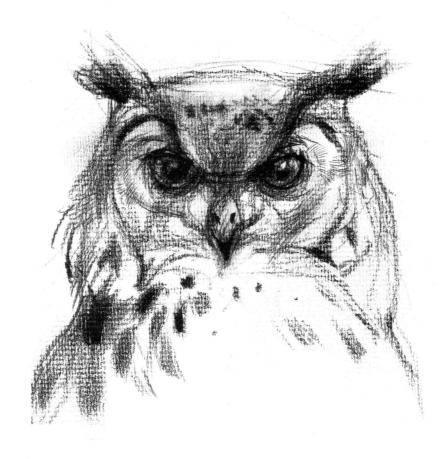

European Eagle Owl

Not every subject has to be a complicated four-legged beast. Drawing the head of an owl can be a hugely rewarding experience, despite its being a relatively simple creature to draw. You can put a tremendous amount of feeling, richness and quality into a small drawing if you give it your concentrated best. It is always a challenge but it is so satisfying to return home with a successful drawing. You will not succeed at every attempt, but it is all good experience and will bear fruit in the long run.

Quick sketches are a good way to warm up and more will be said about these in the following pages. However, two examples are illustrated here. Few animals will stay still for very long, but you can get very fresh and lively drawings by sketching rapidly as they jig about.

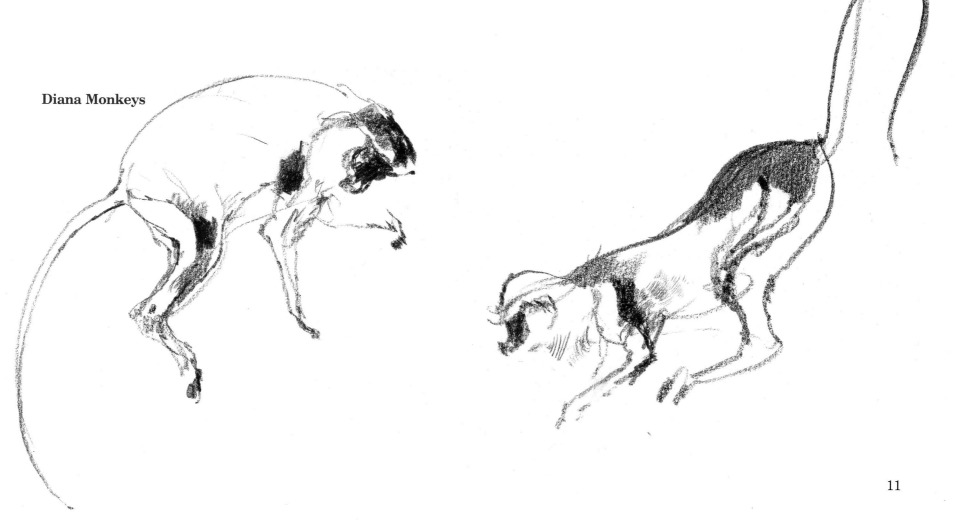

Diana Monkeys

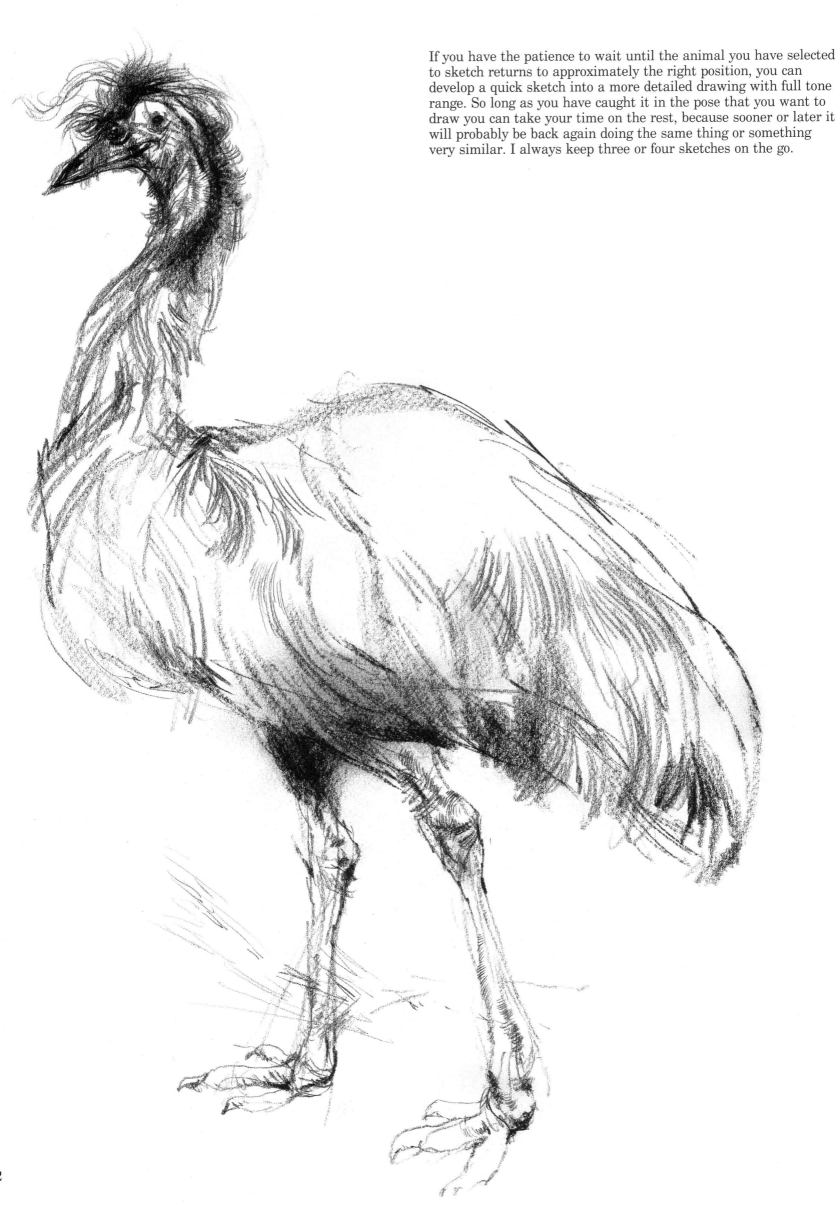

If you have the patience to wait until the animal you have selected to sketch returns to approximately the right position, you can develop a quick sketch into a more detailed drawing with full tone range. So long as you have caught it in the pose that you want to draw you can take your time on the rest, because sooner or later it will probably be back again doing the same thing or something very similar. I always keep three or four sketches on the go.

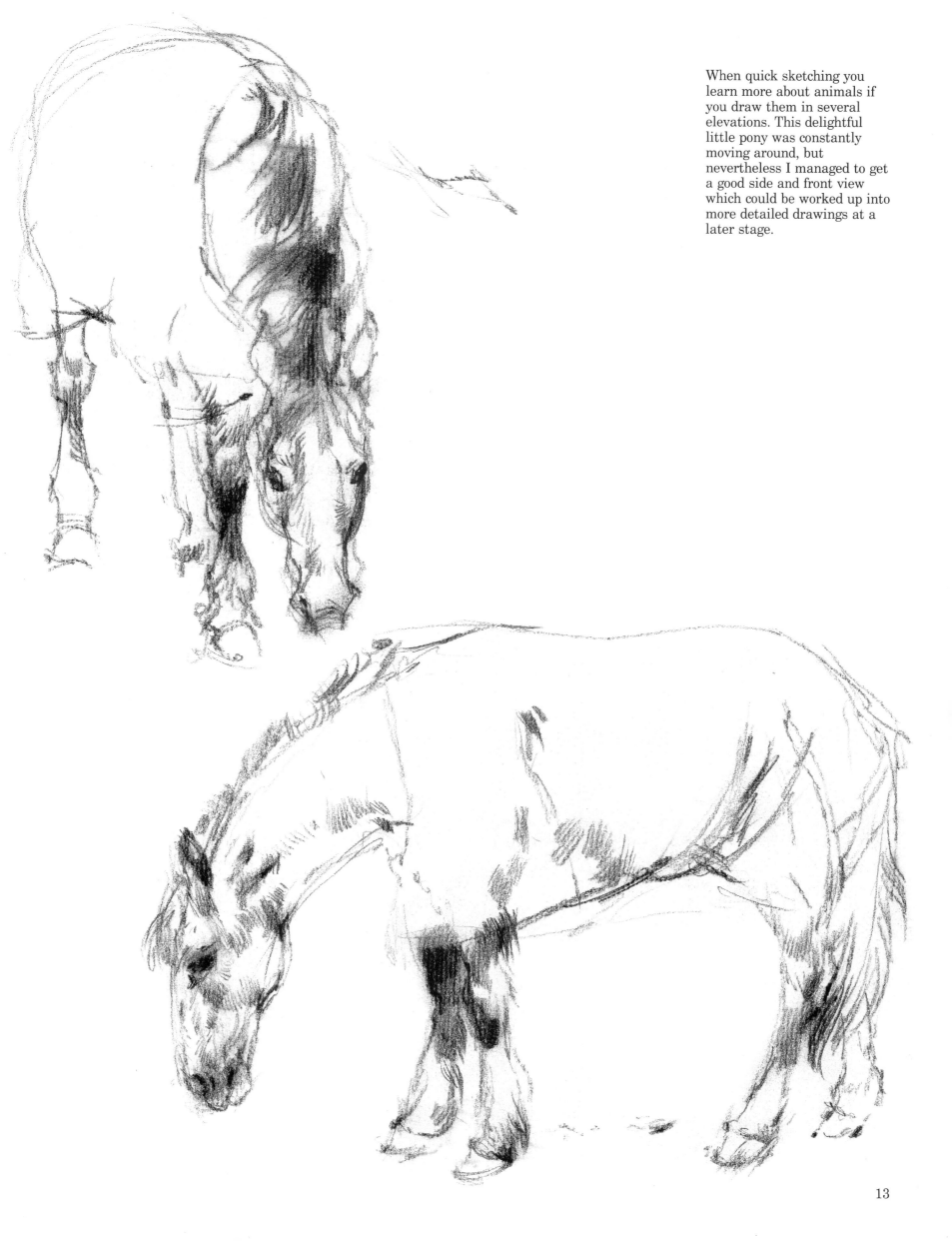

When quick sketching you learn more about animals if you draw them in several elevations. This delightful little pony was constantly moving around, but nevertheless I managed to get a good side and front view which could be worked up into more detailed drawings at a later stage.

Getting Started

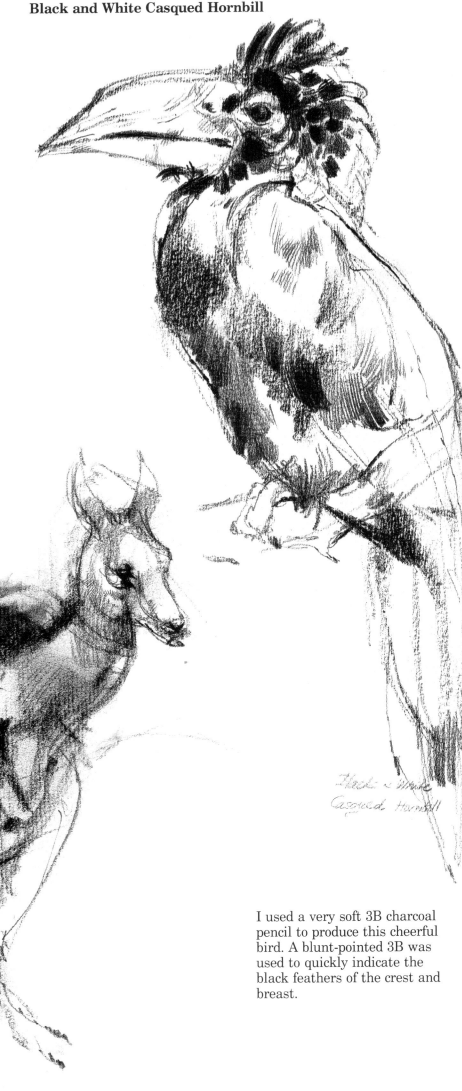

First, arm yourself with a large enough but very lightweight drawing board. An ordinary piece of plywood or hardboard is better than a purpose-made drawing board which is inclined to be too heavy. I use a very light board with a large bulldog clip attached which is strong enough to hold the paper very firmly, but quick to release when a change of paper is required. Take at least six to eight sheets of good quality cartridge paper or slightly tinted pastel paper which comes in a variety of colours and has a fine texture, giving a good surface on which to draw. I personally use Ingres and Canson papers in greys and warm ochre. You can use both ordinary graphite pencils or the slightly richer, more brown-black carbon pencil which I have used in all these drawings. Assuming that you opt for the carbon or charcoal pencils, be very careful. They are a slightly too advanced medium for beginners because they make a strong, dark line. But if you are very light-handed to begin with and get used to them gradually, they work very well. You will need several, of different grades. I have about ten in a pencil box, ready-sharpened as the points soon wear down in the course of a session. I have a range of 3B, the very softest, 2B and B and several HBs which I sharpen to a fine point to draw the final fine details.

Kangaroos

I used a very soft 3B charcoal pencil to produce this cheerful bird. A blunt-pointed 3B was used to quickly indicate the black feathers of the crest and breast.

14

Asiatic Lion

The lion's mane serves both as a means of intimidating other male lions by making him seem larger and more powerful than he really is, and of protecting his head and neck against blows from their forepaws. These are important advantages to gain so that a coalition of lions (usually brothers) can retain their right to breed with a pride of lionesses for a few months or years before being ousted by another, usually younger, coalition.

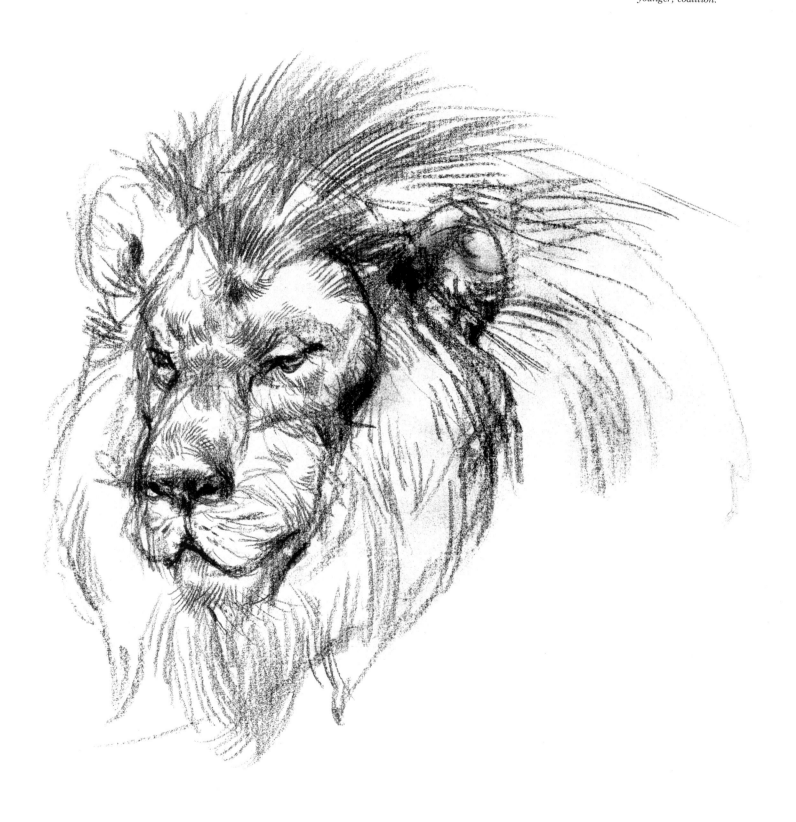

A male Asiatic lion from Marwell Park drawn on good-textured tinted paper. The mane was sketched in with very light lines using a carbon pencil held on its side. Sharply-pointed B and HB pencils were then used to draw in the special features of the head, with very hard pressure being applied around the cheeks, ears, etc. to outline the head and to bring the nose forward.

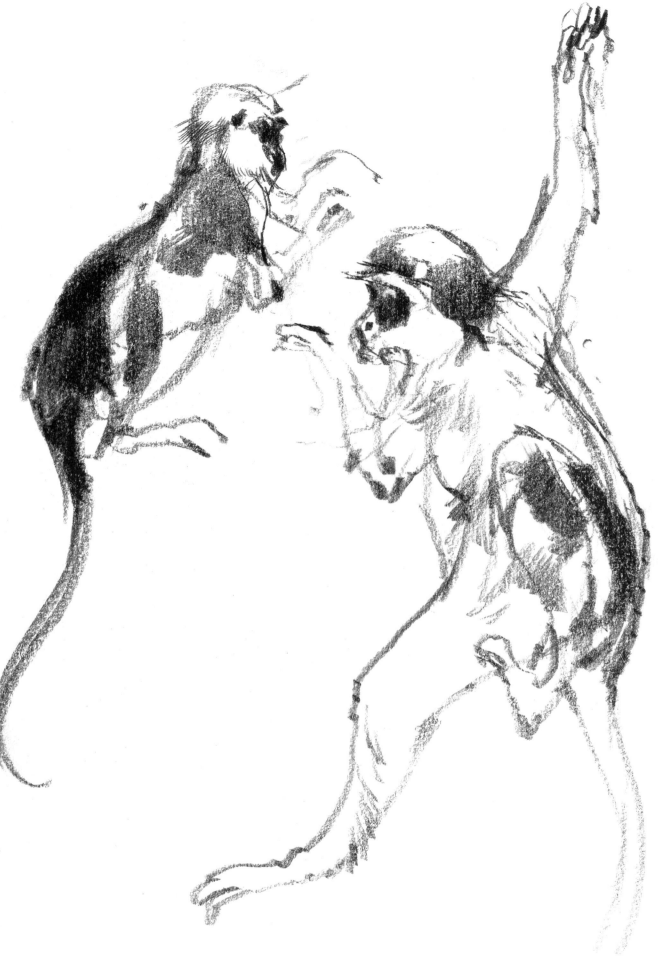

Diana Monkeys. Very quick scribbles of monkeys. You will hardly have any time to catch the movements, but it is an excellent exercise and will force you to concentrate on the essentials.

I usually carry with me a black Conté crayon, sometimes broken up into small pieces, which I can lay on its side and use to block in large areas of tone or to indicate shadows. They are useful if you have to cover large areas in a hurry or for doing quick sketches. Sometimes I use a piece of charcoal for very fine, soft tone, but unlike Conté and carbon charcoal smudges easily so can only be used to lay down a background tone. Always use a good quality rubber eraser. I know that these are frowned on by purists, but we all make mistakes. Try not to use it very much as it can mess up a nice drawing, and the odd search lines left in will not affect the quality of your finished work. Always keep several layers of papers under the one you are working on to act as padding and take up the pressure of your pencil, making drawing much easier.

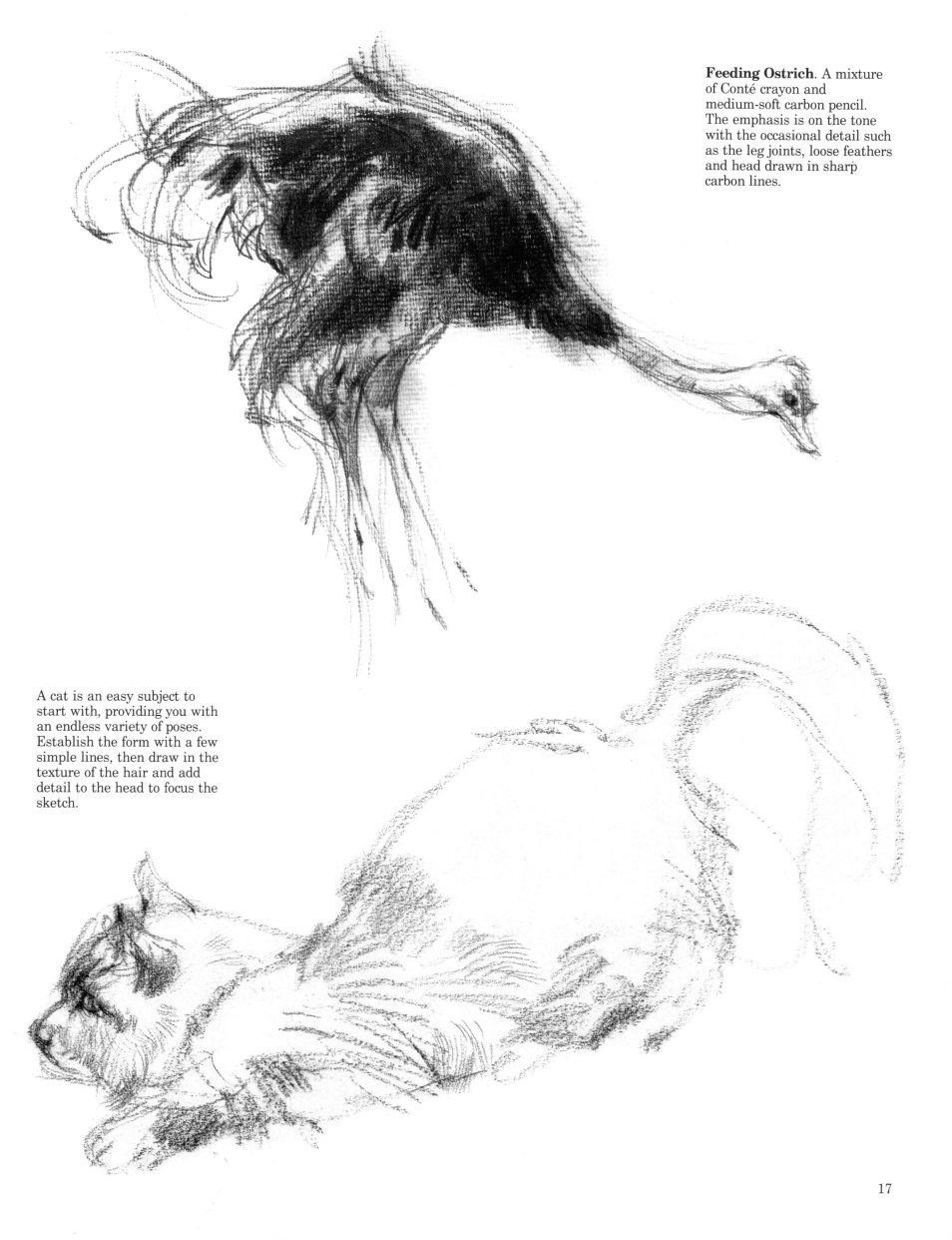

Feeding Ostrich. A mixture of Conté crayon and medium-soft carbon pencil. The emphasis is on the tone with the occasional detail such as the leg joints, loose feathers and head drawn in sharp carbon lines.

A cat is an easy subject to start with, providing you with an endless variety of poses. Establish the form with a few simple lines, then draw in the texture of the hair and add detail to the head to focus the sketch.

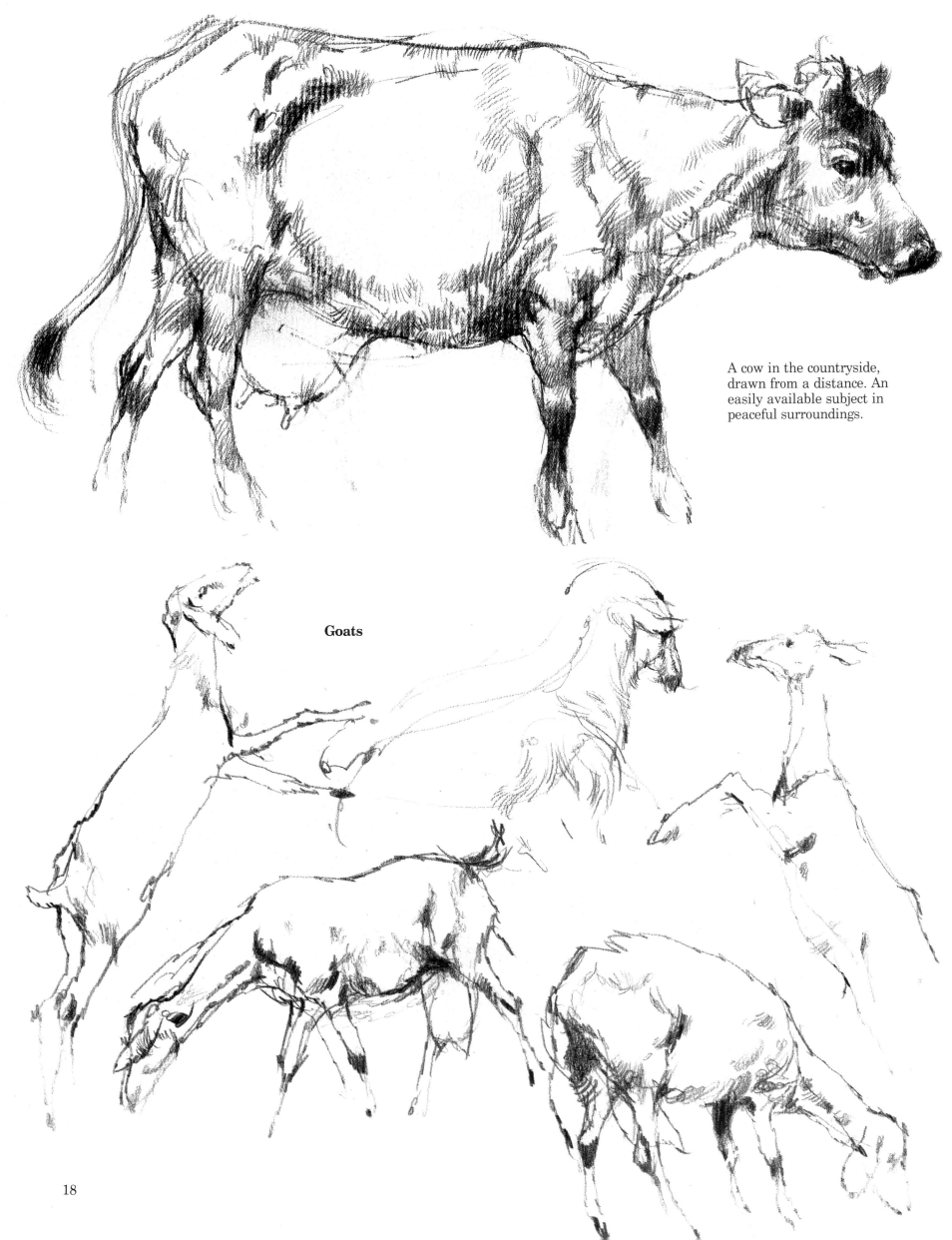

A cow in the countryside, drawn from a distance. An easily available subject in peaceful surroundings.

Goats

Do not worry if the crayon smudges the paper as long as the finer details are not obliterated. I often use my hands to wipe over a drawing which is too hard, or a finger to rub away an area that is too prominent. Do not be afraid to use such methods especially when working under difficult circumstances in a wildlife park or zoo when you often have the weather to contend with too. Carry a waterproof folder to keep your drawings and drawing board dry, or better still, choose a nice warm day. A lot of these drawings were done in bitterly cold weather in windswept fields, but I tried to choose days when the light at least was good.

If you wish to avoid popular interest in your efforts, choose a mid-week day to visit a wildlife park and to be hopefully left in peace. Zoos have superb animals to draw but you are likely to be mobbed by adults and children alike. I once experienced what felt like an entire class of youngsters practically sitting on me while I was drawing a gorilla, and a keen video buff nearly knocked me on the nose with his zoom lens in an effort to get a better view, not of the animal but of the drawing. Perhaps it is better to start with your own pets or animals in the countryside while you gain experience before taking on the hazards of the wildlife park or zoo with its inevitable crowds. You will soon learn to ignore people and get on with the work in hand.

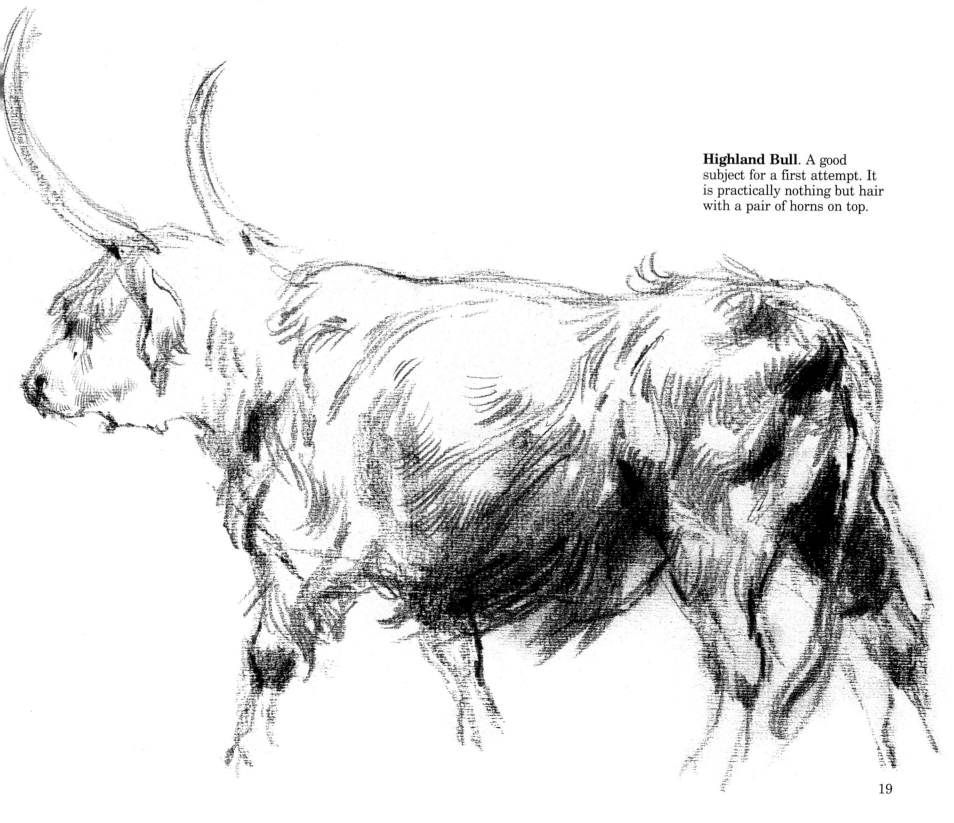

Highland Bull. A good subject for a first attempt. It is practically nothing but hair with a pair of horns on top.

19

Quick Sketches

You will always start your drawings as a 'quick sketch' because your first priority is to capture the proportions, character and movement of an animal. I hold the pencil on its side to give me more freedom to draw quickly. Once I get the general shape and pose of the animal, and provided it stays still, I can progress further with tone and detail. I would still use the pencil or crayon on its side for general tone (see the polar bear opposite) and use the point for the finer detail on the head and eyes.
On the next few pages you will see samples of sketches ranging from a few seconds to ten minutes.

A temporarily seated western Colobus monkey provides a chance to quickly sketch in the streamlined body with its long tail. You may get a second chance to develop the head, allowing you to draw into it in more detail, as the monkey will often turn back to face you.

The polar bear at right was restlessly pacing up and down in his enclosure. I quickly managed to catch the outline of his body, but the legs were a different matter. They had to be drawn in in seconds when he was walking back and forth in an identical way. With more time for the head I was able to give it more modelling.

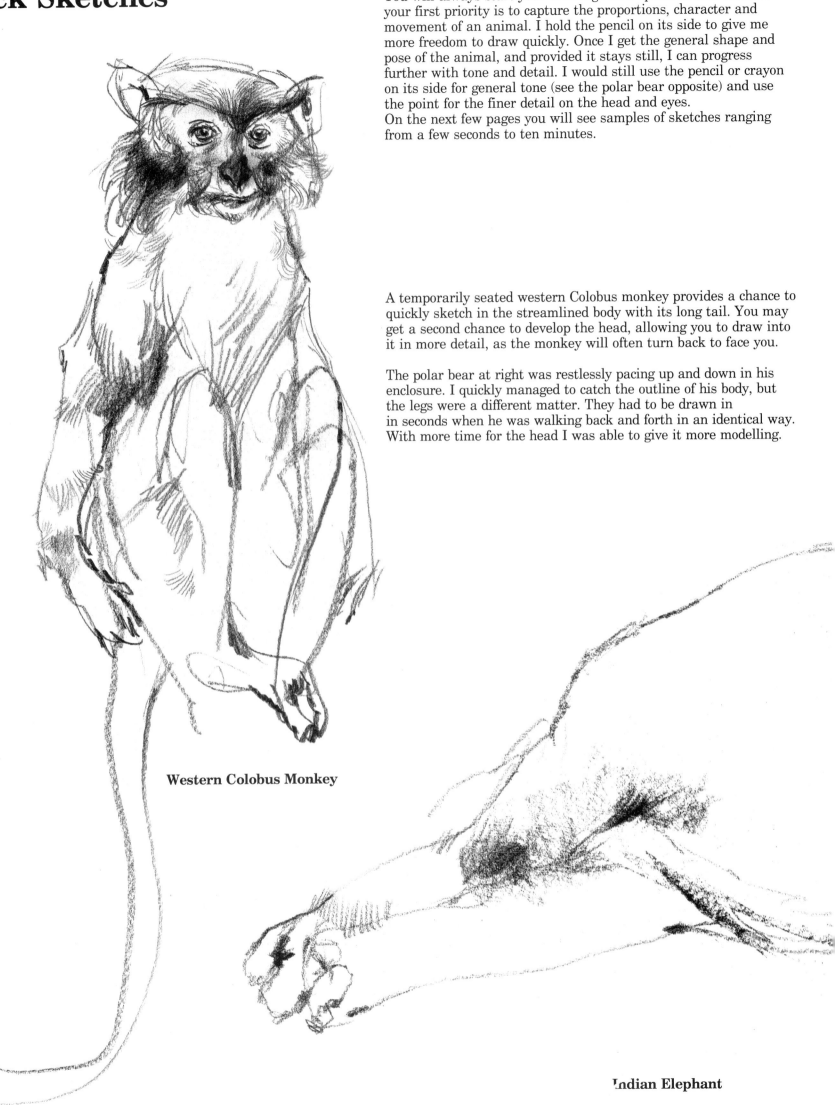

Western Colobus Monkey

Indian Elephant

20

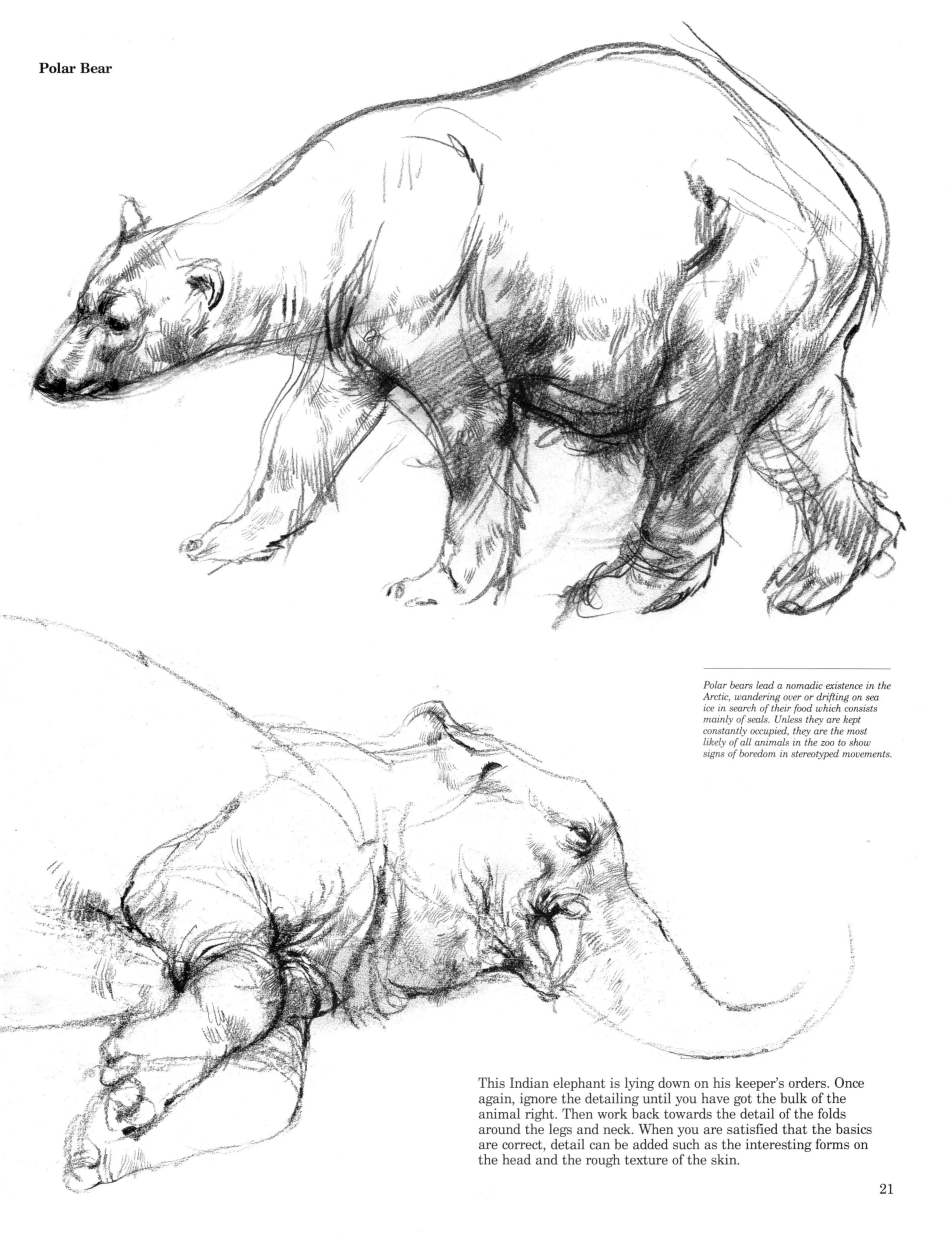

Polar Bear

Polar bears lead a nomadic existence in the Arctic, wandering over or drifting on sea ice in search of their food which consists mainly of seals. Unless they are kept constantly occupied, they are the most likely of all animals in the zoo to show signs of boredom in stereotyped movements.

This Indian elephant is lying down on his keeper's orders. Once again, ignore the detailing until you have got the bulk of the animal right. Then work back towards the detail of the folds around the legs and neck. When you are satisfied that the basics are correct, detail can be added such as the interesting forms on the head and the rough texture of the skin.

21

Young chimps drawn with blunt, soft carbon pencil which is useful for line work and for quickly laying down strong tone. Faced with a group of young animals constantly moving around, I had to wait patiently until they remained static for a few minutes. I also had to wait for an interesting pose or composition typical of the animal, such as the inquisitive one in the centre. When one of them settled down to 'meditate' I could work a little more expression into the head and indicate more tone.

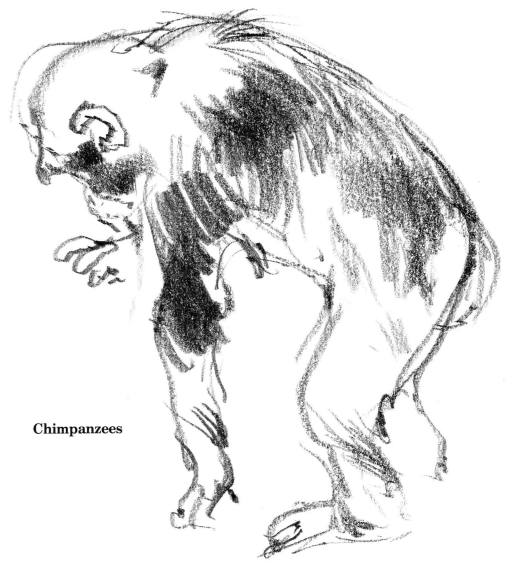

Chimpanzees

London Zoo's young black rhino, Rosie, a creature constantly on the move, drawn in 'quick bursts'. To supply the shadows and details alike, a 2B carbon pencil was used.

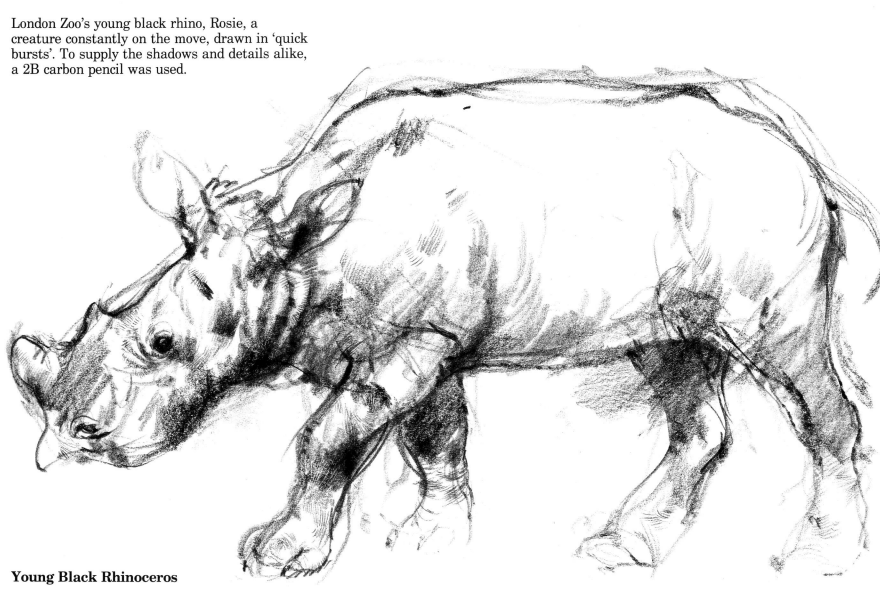

Young Black Rhinoceros

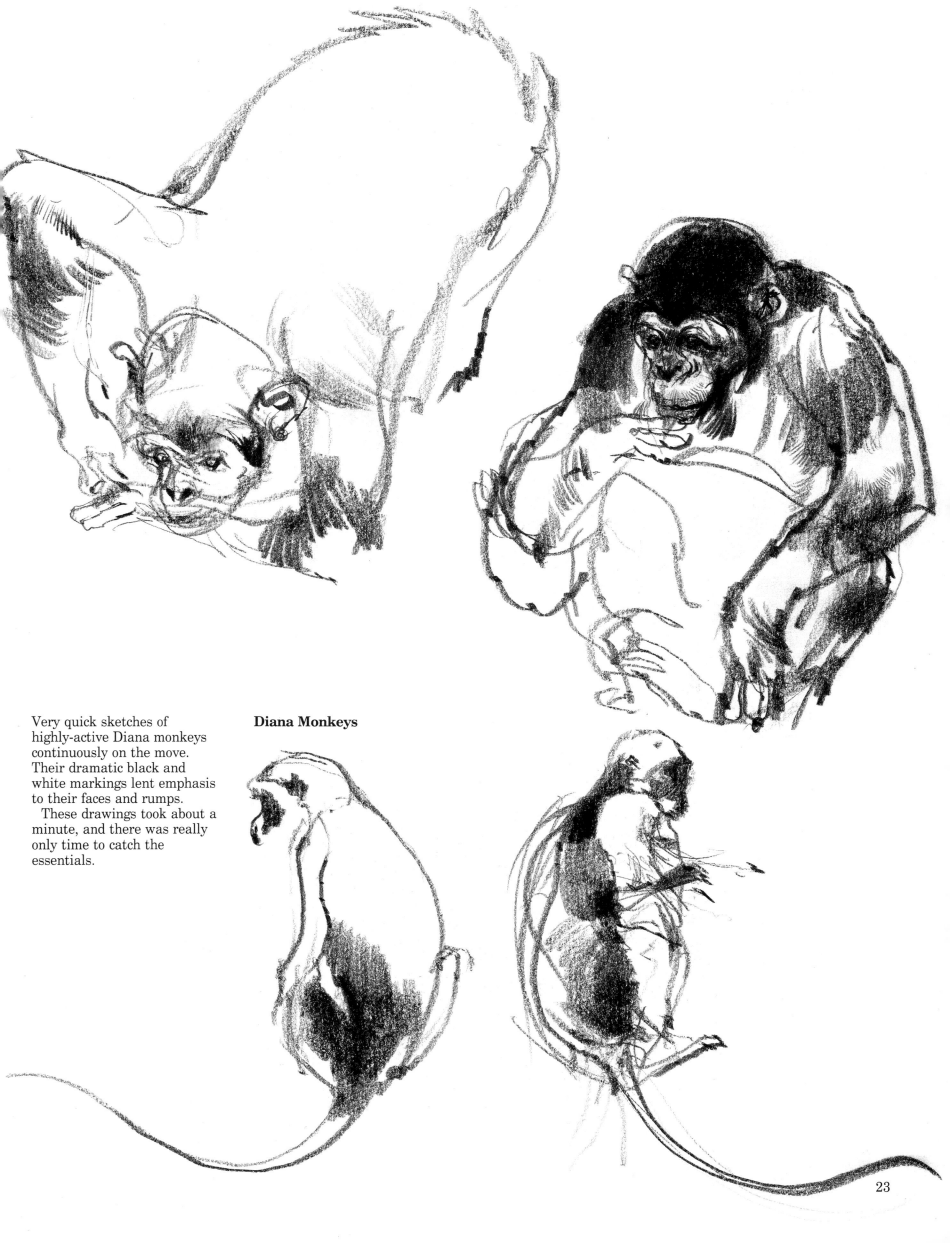

Very quick sketches of highly-active Diana monkeys continuously on the move. Their dramatic black and white markings lent emphasis to their faces and rumps.

These drawings took about a minute, and there was really only time to catch the essentials.

Diana Monkeys

23

The compact shape of a fine Siberian tiger curled up after feeding. This drawing was quickly made, after a long, tiring day, with a very soft crayon held on its side. I merely indicated the beautiful markings on the animal's back and head but worked extra detail into the sleeping face in order to give the drawing a focal point.

It can often take a long day's drawing to loosen you up, and by the time I did this drawing I was able to work quite rapidly and concentrate on the essentials.

Siberian Tiger

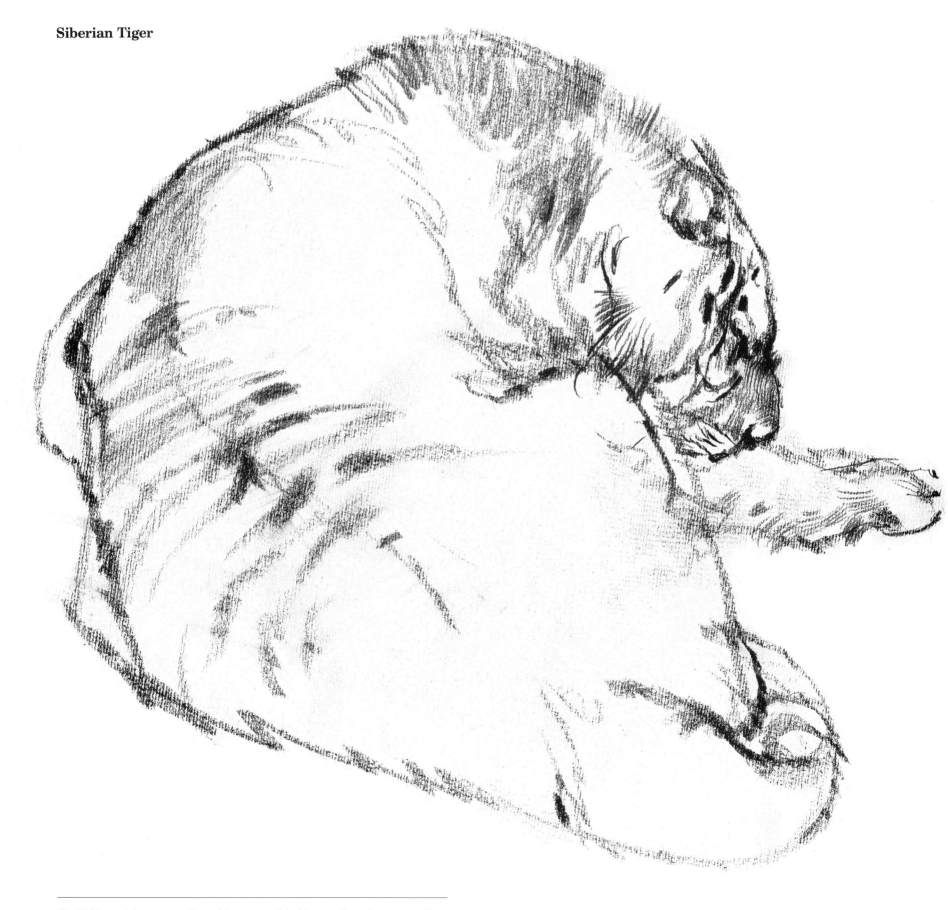

The highly nutritious protein diet and large prey of the big cats allows them to spend long periods resting and sleeping between meals of perhaps once a week in the wild. In captivity they have even more time for the first two activities!

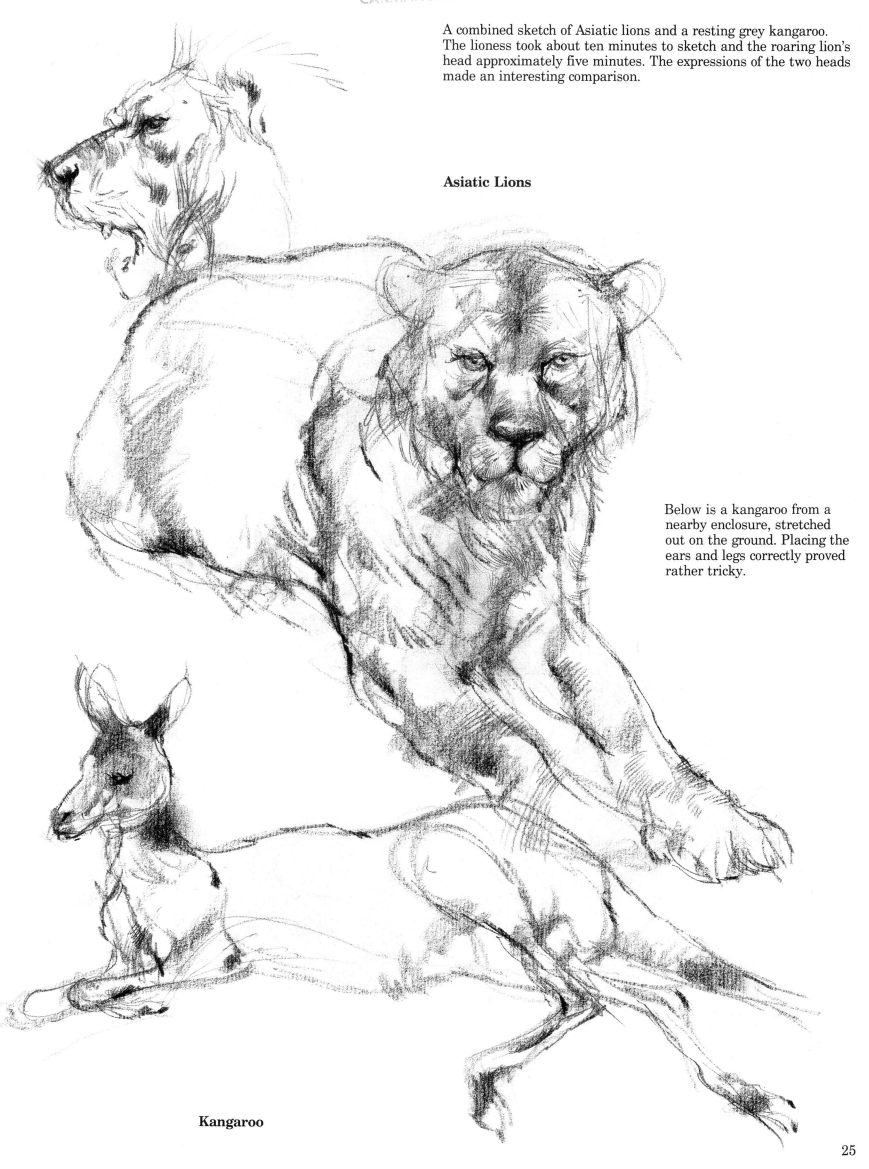

A combined sketch of Asiatic lions and a resting grey kangaroo. The lioness took about ten minutes to sketch and the roaring lion's head approximately five minutes. The expressions of the two heads made an interesting comparison.

Asiatic Lions

Below is a kangaroo from a nearby enclosure, stretched out on the ground. Placing the ears and legs correctly proved rather tricky.

Kangaroo

25

Specialist bird zoos are a useful source for subjects. Birds come in many shapes and sizes and can provide an easy subject with which to start because you are dealing with relatively simple forms.

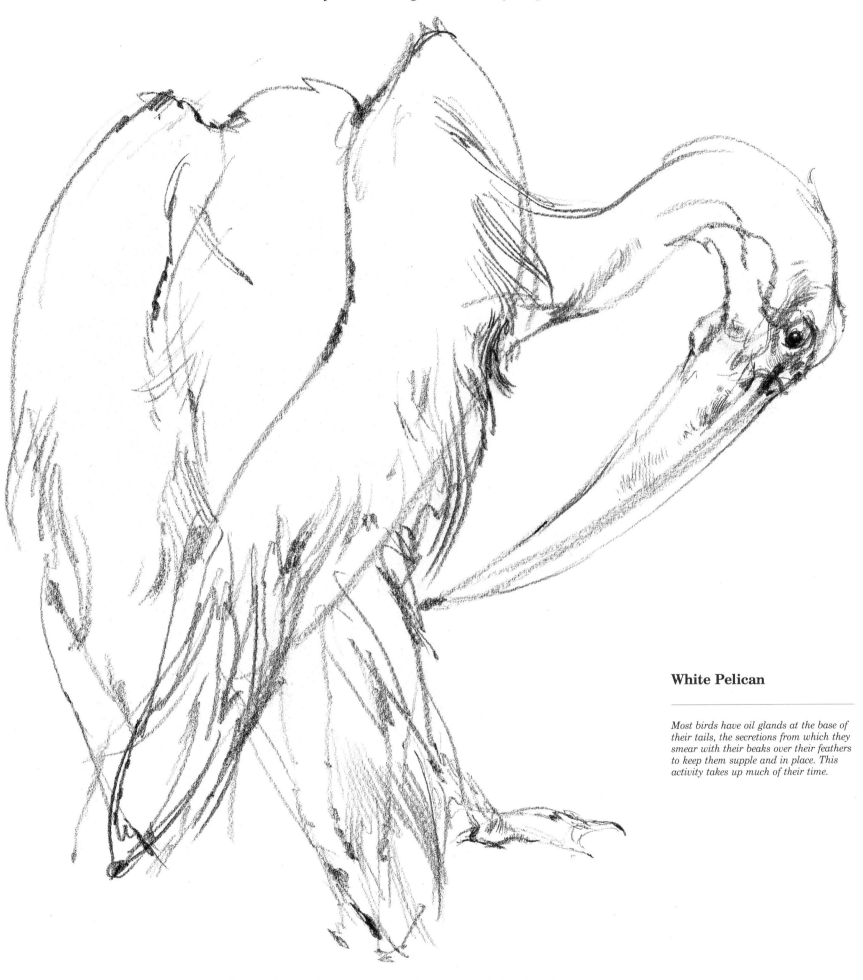

White Pelican

Most birds have oil glands at the base of their tails, the secretions from which they smear with their beaks over their feathers to keep them supple and in place. This activity takes up much of their time.

A preening white pelican. I had to use quick-flowing lines to capture this back view and indicate the texture of the long white feathers, carefully drawing the curve of the neck. As always, I gave particular attention to the bird's face, detailing the eye and strange, long beak.

A page out of a sketchbook with an assortment of birds from a wildlife park. African crowned cranes, barnacle geese and white storks are shown here in a series of sketches, each drawn in a few minutes. They are engaged in a number of activities from stretching their wings to pecking on the ground.

A combined page of sketches can make an interesting composition.

African Crowned Crane

Barnacle Goose

27

A female orangutan from London Zoo. A rather bedraggled specimen, but then, they all look a bit like that. She moved about constantly but paused for just a few minutes, long enough for me to scribble a quick sketch. She was hanging onto a bar with one arm which made an interesting shape, but it was the expression on her face – a world-weary, 'after an all-night party' look – that I wanted to capture.

A lovely scruffy animal to draw with her bold head and long hairy arms. She was painfully shy and tried to avoid me at any cost. Others I drew were quite content to hang on the rails and stare me out.

Orangutan

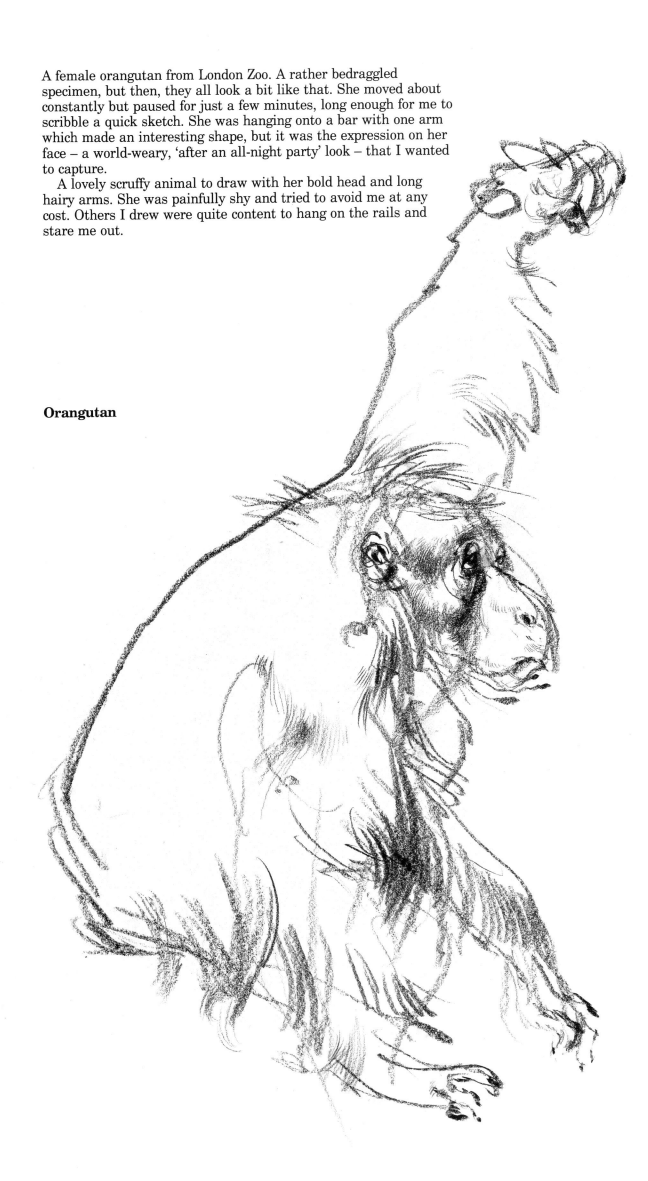

Tapirs

Tapirs, at right, foraging around and resting in Marwell Park. They were sleek, healthy-looking animals with well-fed, well-rounded figures and neat shiny coats.

Constructed mainly of oval shapes, and with curious elephantine noses (although they are not related), they provided an excellent compact subject.

I particularly liked the two friends at the bottom of the page. The black and white markings of the Malayan tapir also provided strong graphic impact – here I deliberately pressed in the carbon tone. Carefully sharpened pencils will help to detail the faces of these attractive animals.

28

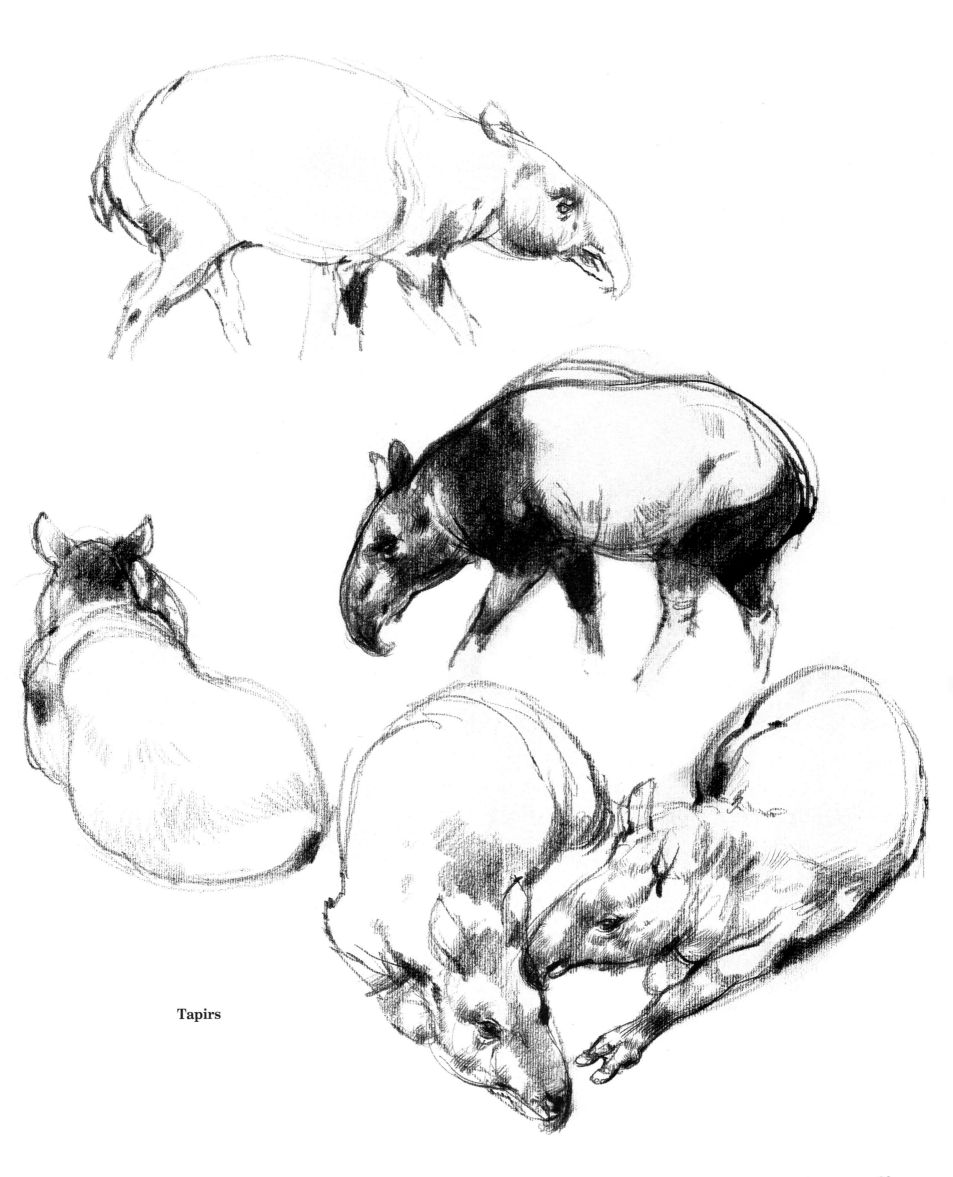

Tapirs

29

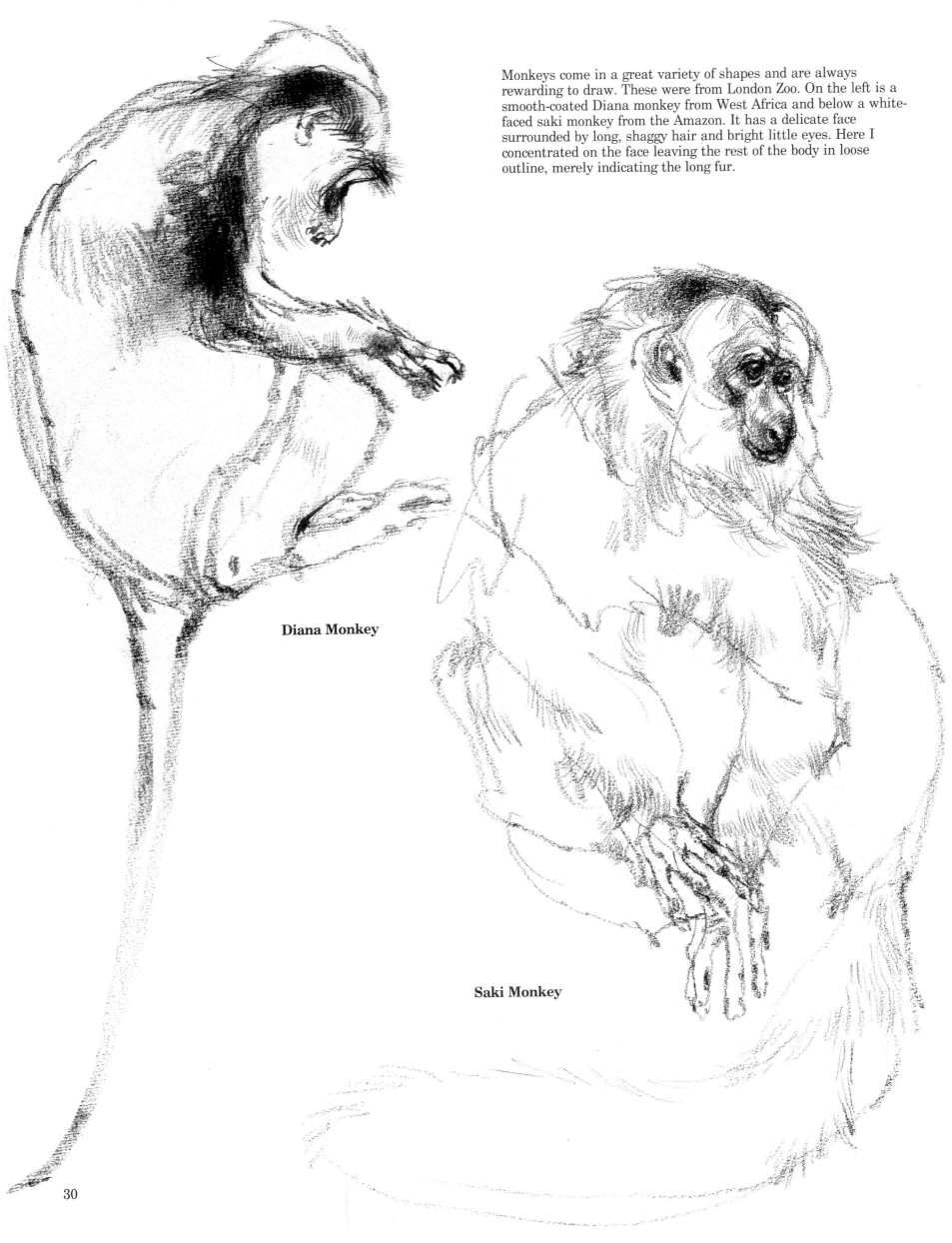

Monkeys come in a great variety of shapes and are always rewarding to draw. These were from London Zoo. On the left is a smooth-coated Diana monkey from West Africa and below a white-faced saki monkey from the Amazon. It has a delicate face surrounded by long, shaggy hair and bright little eyes. Here I concentrated on the face leaving the rest of the body in loose outline, merely indicating the long fur.

Diana Monkey

Saki Monkey

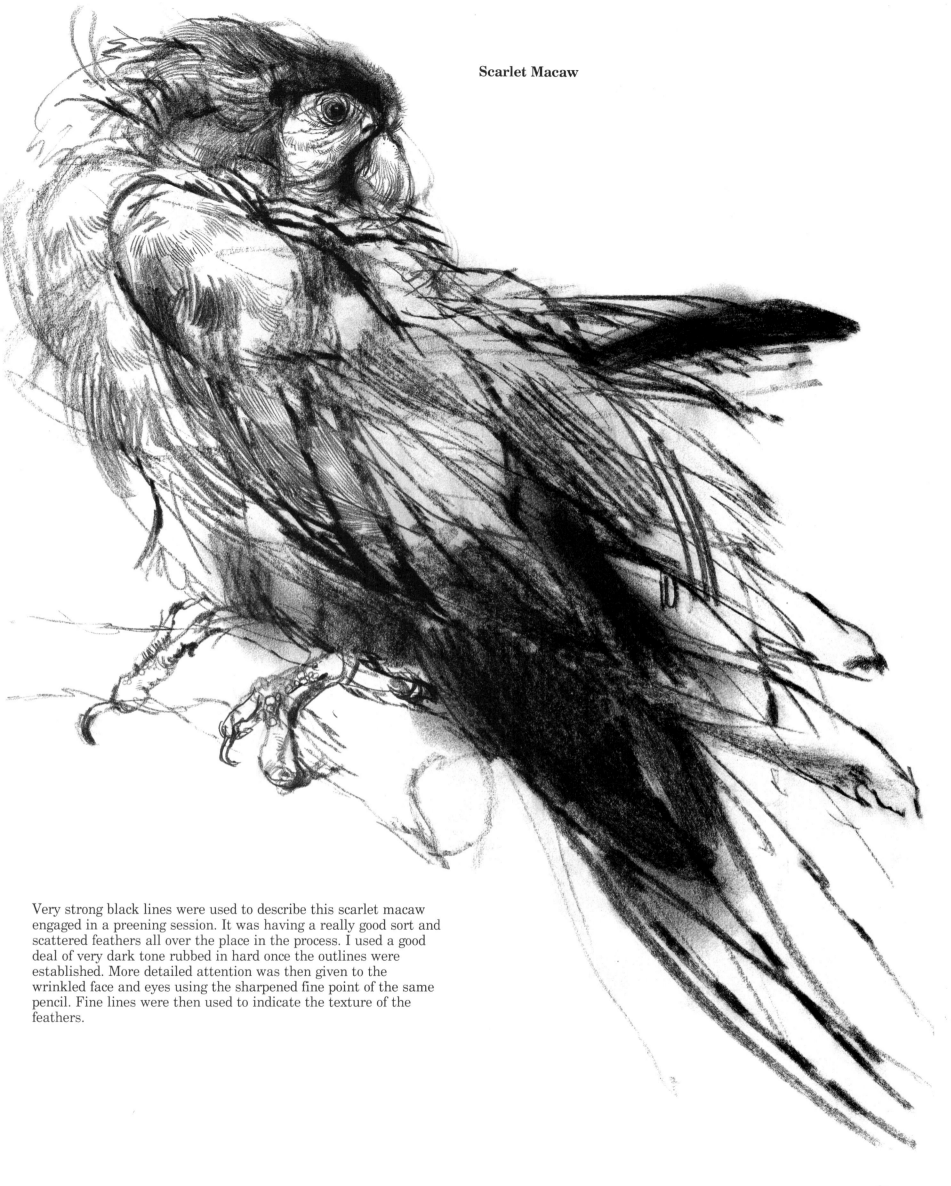

Scarlet Macaw

Very strong black lines were used to describe this scarlet macaw engaged in a preening session. It was having a really good sort and scattered feathers all over the place in the process. I used a good deal of very dark tone rubbed in hard once the outlines were established. More detailed attention was then given to the wrinkled face and eyes using the sharpened fine point of the same pencil. Fine lines were then used to indicate the texture of the feathers.

Wild Animals

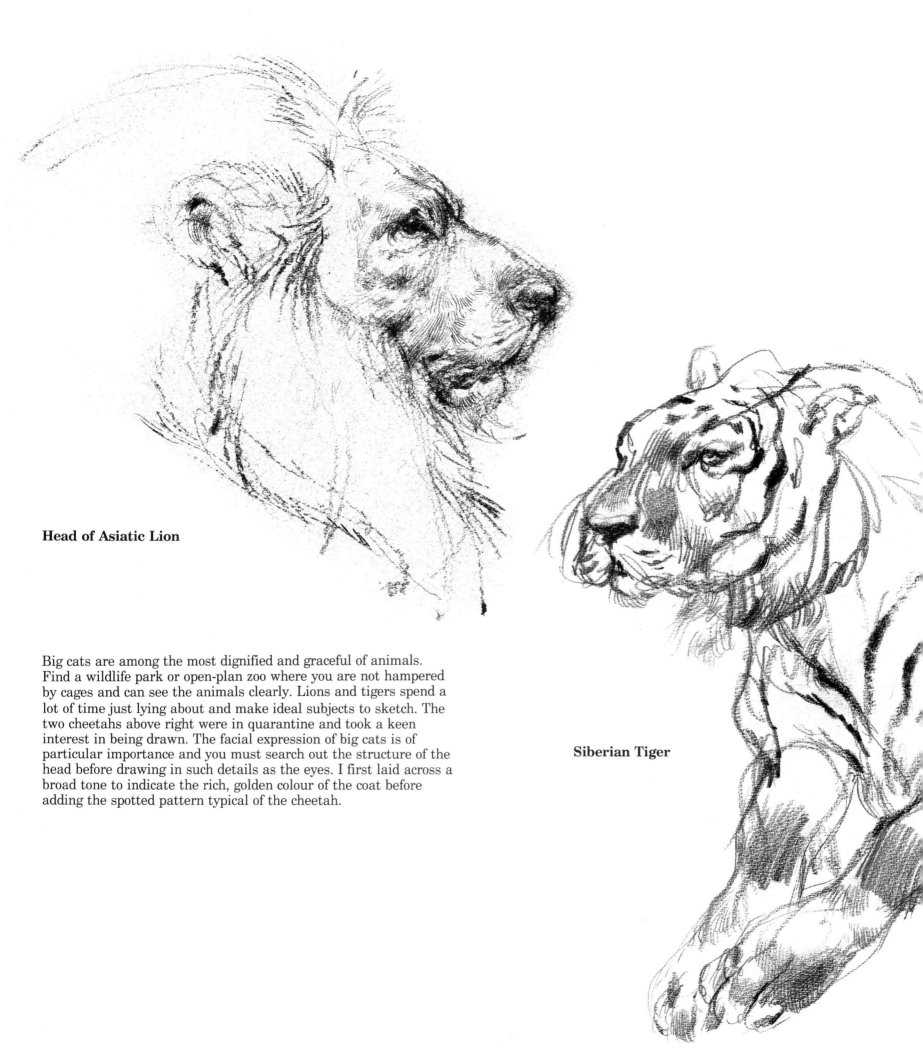

Head of Asiatic Lion

Siberian Tiger

Big cats are among the most dignified and graceful of animals.
Find a wildlife park or open-plan zoo where you are not hampered
by cages and can see the animals clearly. Lions and tigers spend a
lot of time just lying about and make ideal subjects to sketch. The
two cheetahs above right were in quarantine and took a keen
interest in being drawn. The facial expression of big cats is of
particular importance and you must search out the structure of the
head before drawing in such details as the eyes. I first laid across a
broad tone to indicate the rich, golden colour of the coat before
adding the spotted pattern typical of the cheetah.

Cheetah

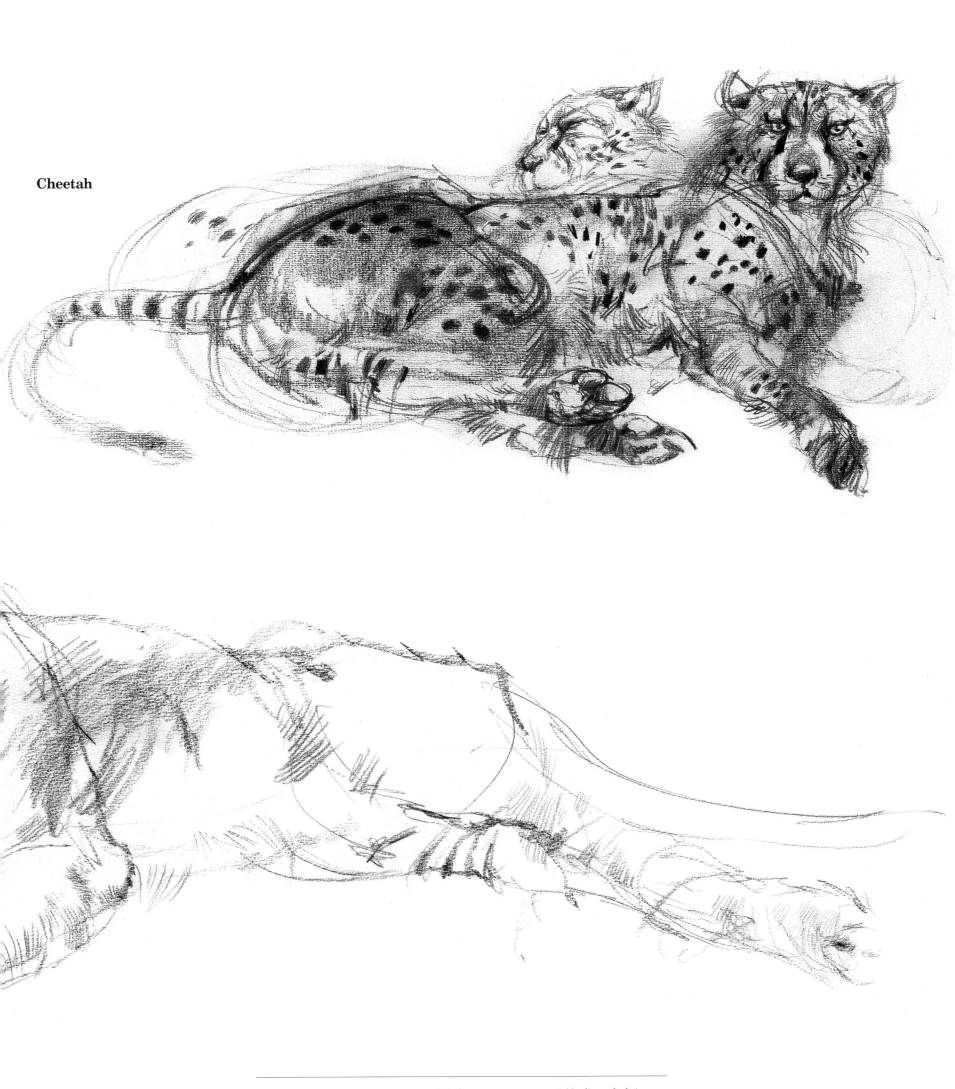

Most cats lie carefully concealed in ambush before springing out to quickly dispatch their prey by knocking it over or by grasping onto it with their forepaws and biting through its throat. For this reason they are mostly powerfully built for strength and agility rather than speed. The cheetah from Africa and South-West Asia is unusual among cats in that it rapidly runs down a gazelle across open grassland after first having approached it as closely as possible without frightening it away. For this reason it is more lightly built like a dog.

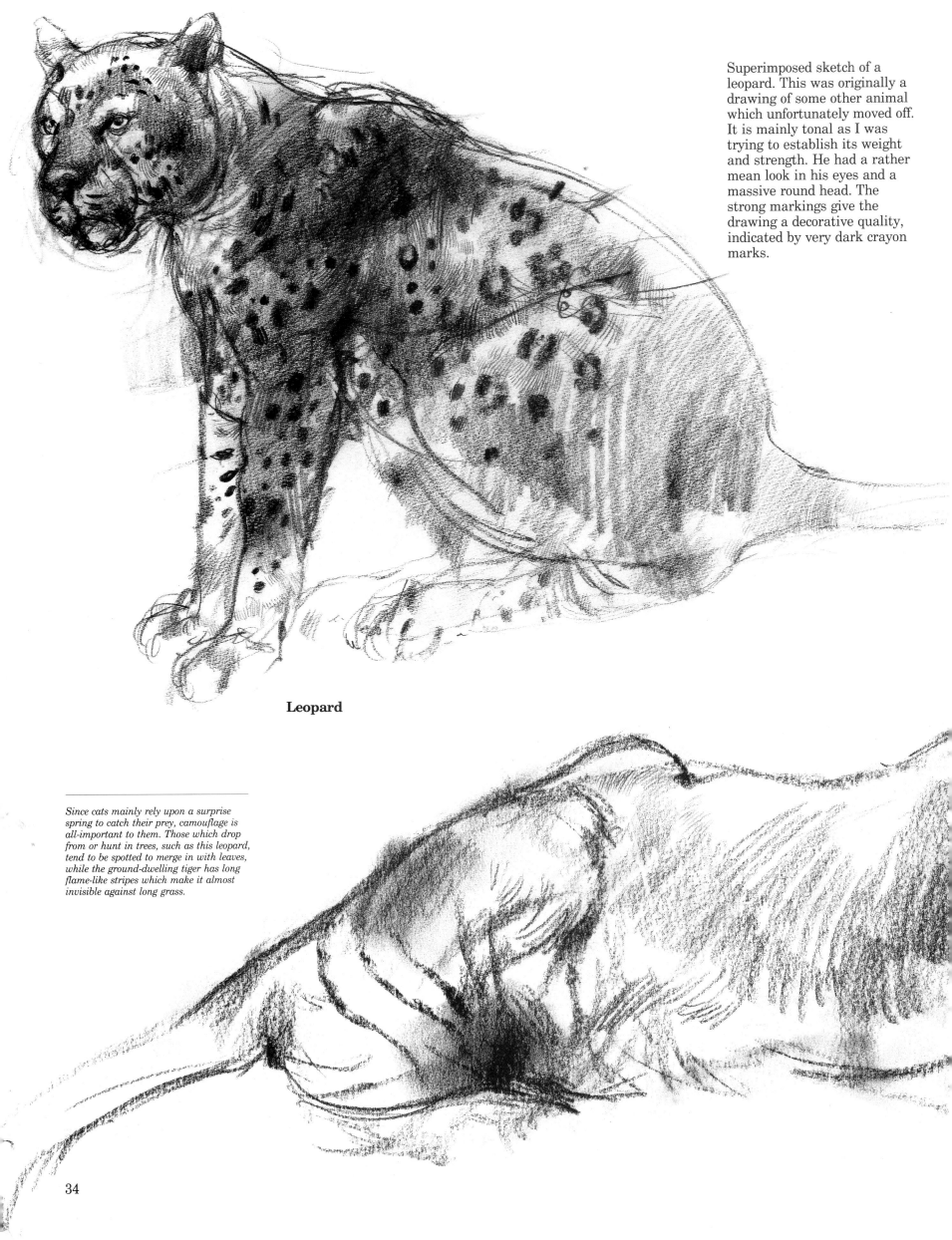

Superimposed sketch of a leopard. This was originally a drawing of some other animal which unfortunately moved off. It is mainly tonal as I was trying to establish its weight and strength. He had a rather mean look in his eyes and a massive round head. The strong markings give the drawing a decorative quality, indicated by very dark crayon marks.

Leopard

Since cats mainly rely upon a surprise spring to catch their prey, camouflage is all-important to them. Those which drop from or hunt in trees, such as this leopard, tend to be spotted to merge in with leaves, while the ground-dwelling tiger has long flame-like stripes which make it almost invisible against long grass.

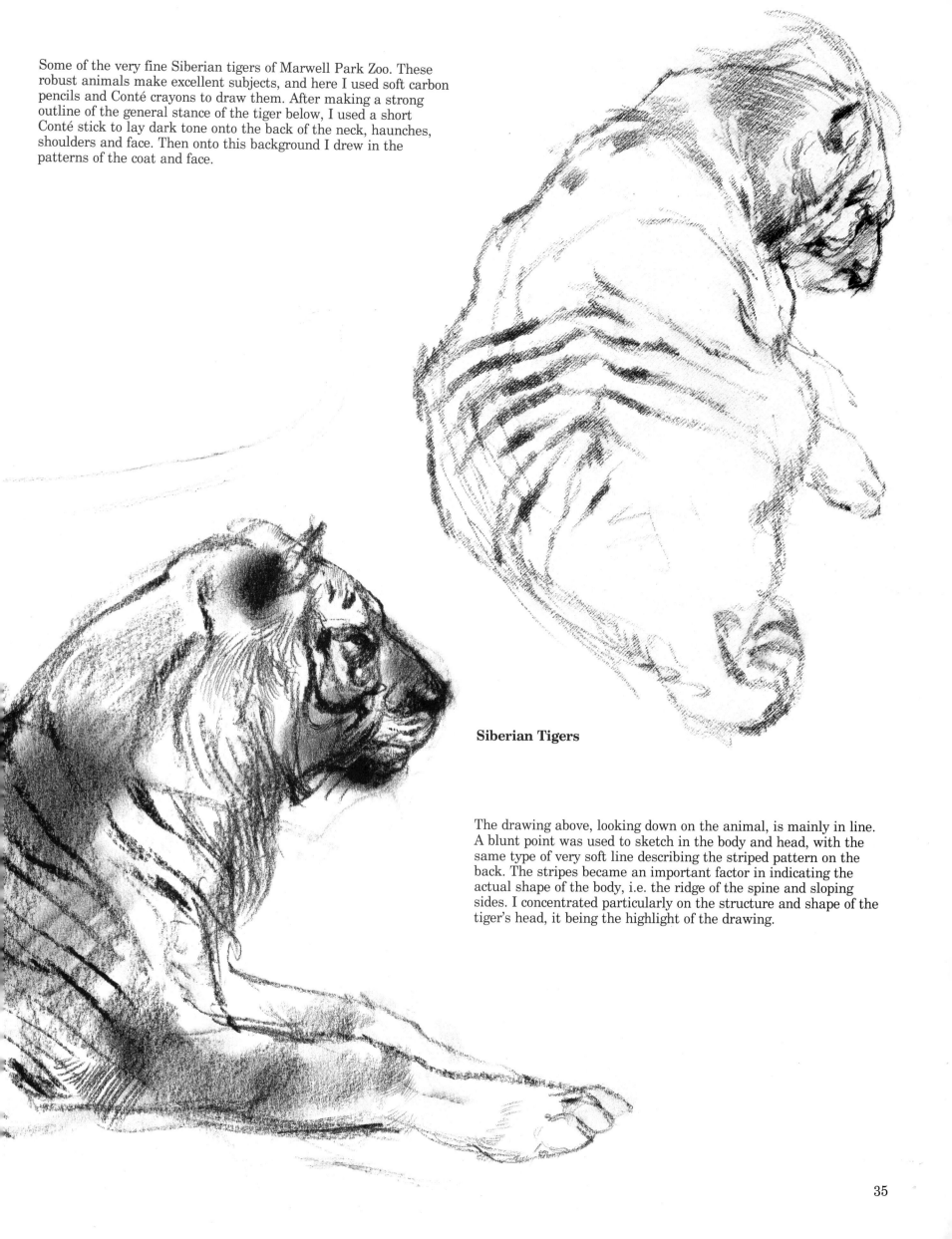

Some of the very fine Siberian tigers of Marwell Park Zoo. These robust animals make excellent subjects, and here I used soft carbon pencils and Conté crayons to draw them. After making a strong outline of the general stance of the tiger below, I used a short Conté stick to lay dark tone onto the back of the neck, haunches, shoulders and face. Then onto this background I drew in the patterns of the coat and face.

Siberian Tigers

The drawing above, looking down on the animal, is mainly in line. A blunt point was used to sketch in the body and head, with the same type of very soft line describing the striped pattern on the back. The stripes became an important factor in indicating the actual shape of the body, i.e. the ridge of the spine and sloping sides. I concentrated particularly on the structure and shape of the tiger's head, it being the highlight of the drawing.

A tiger sketched from a distance, very much in tone with bold lines added to indicate its markings. These can really help you to describe the form of the animal, particularly on the head and shoulders.

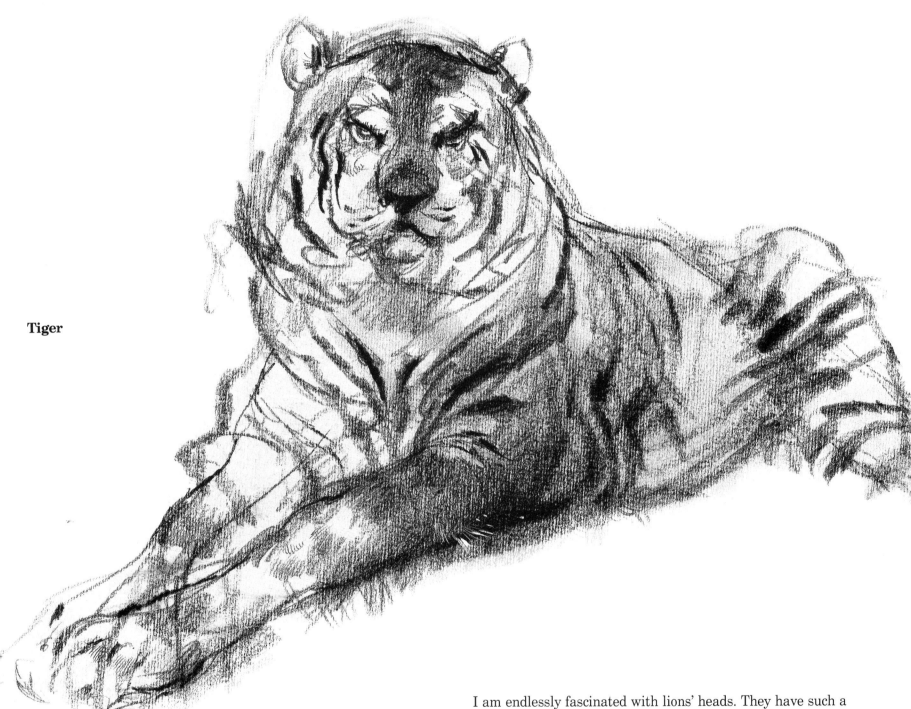

Tiger

I am endlessly fascinated with lions' heads. They have such a robust structure and expression that I am drawn again and again to sketch them. The studies on the opposite page are of a male Asiatic lion. The central drawing is in full tone, but I tried to restrict myself more to line in the others in order to capture the facial expressions as they ranged from full alertness, sagging into gradual sleepiness. You can often get the best effects by using pure line.

At the bottom of the sheet I drew a brief sketch of a dozing lioness, mainly in line with a little dark tone on the haunches and shoulder.

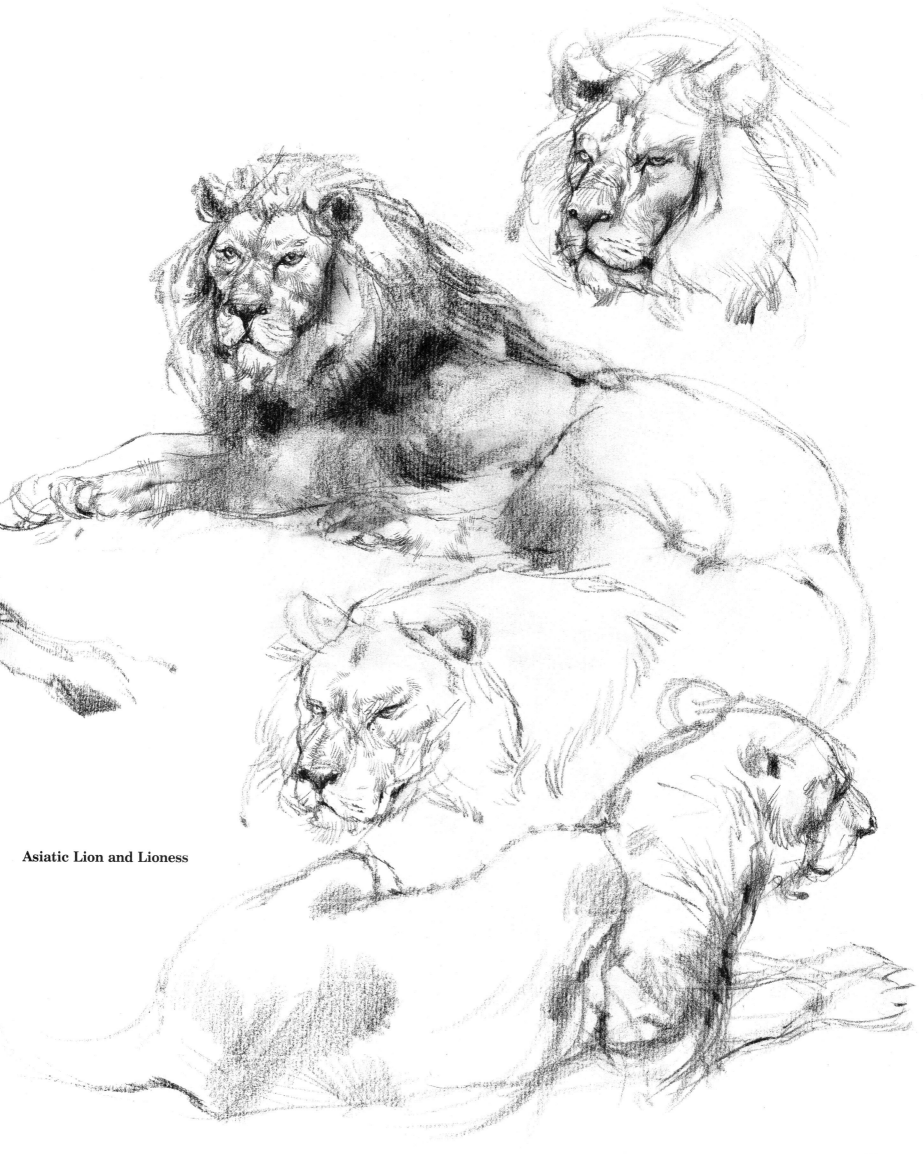

Asiatic Lion and Lioness

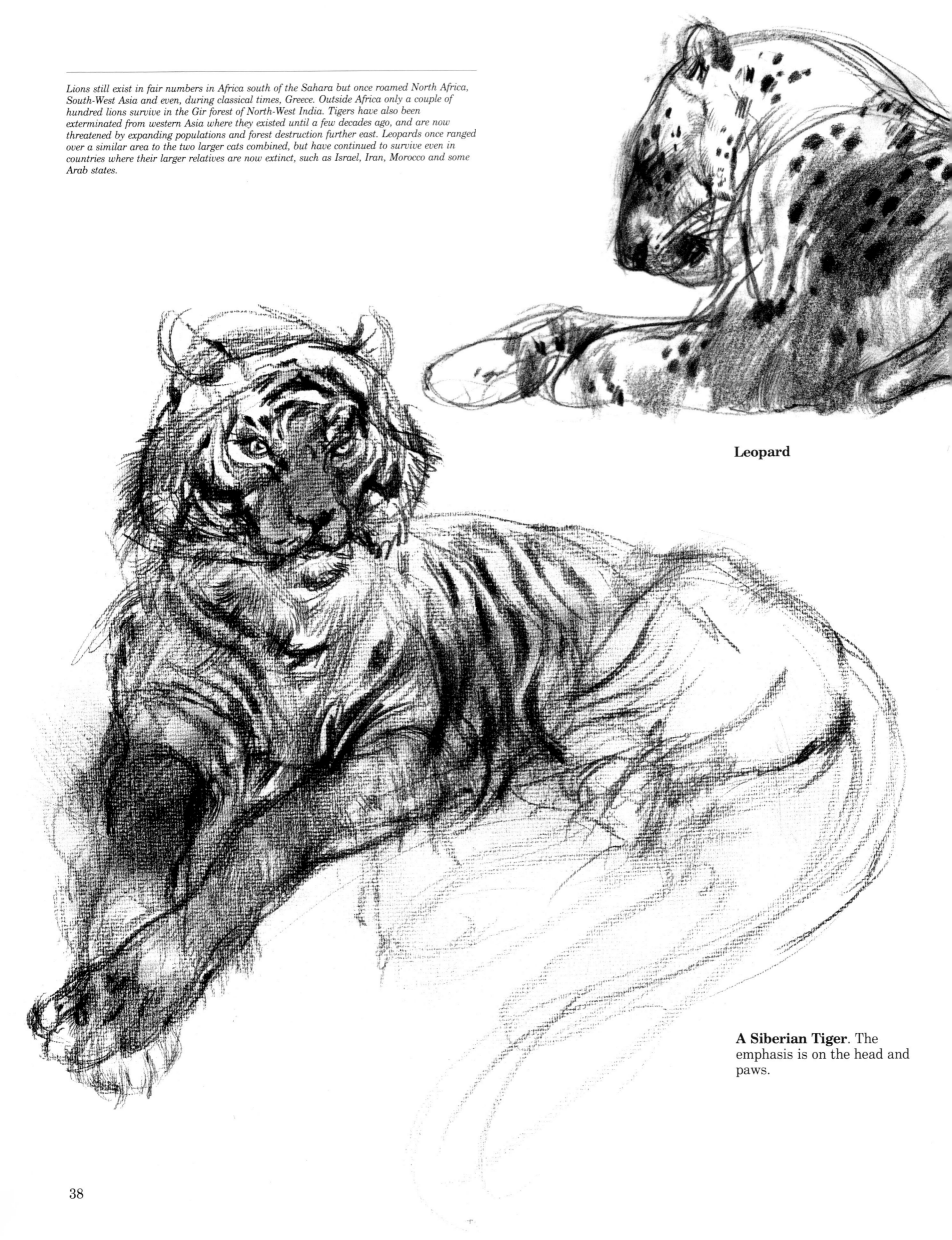

Lions still exist in fair numbers in Africa south of the Sahara but once roamed North Africa, South-West Asia and even, during classical times, Greece. Outside Africa only a couple of hundred lions survive in the Gir forest of North-West India. Tigers have also been exterminated from western Asia where they existed until a few decades ago, and are now threatened by expanding populations and forest destruction further east. Leopards once ranged over a similar area to the two larger cats combined, but have continued to survive even in countries where their larger relatives are now extinct, such as Israel, Iran, Morocco and some Arab states.

Leopard

A Siberian Tiger. The emphasis is on the head and paws.

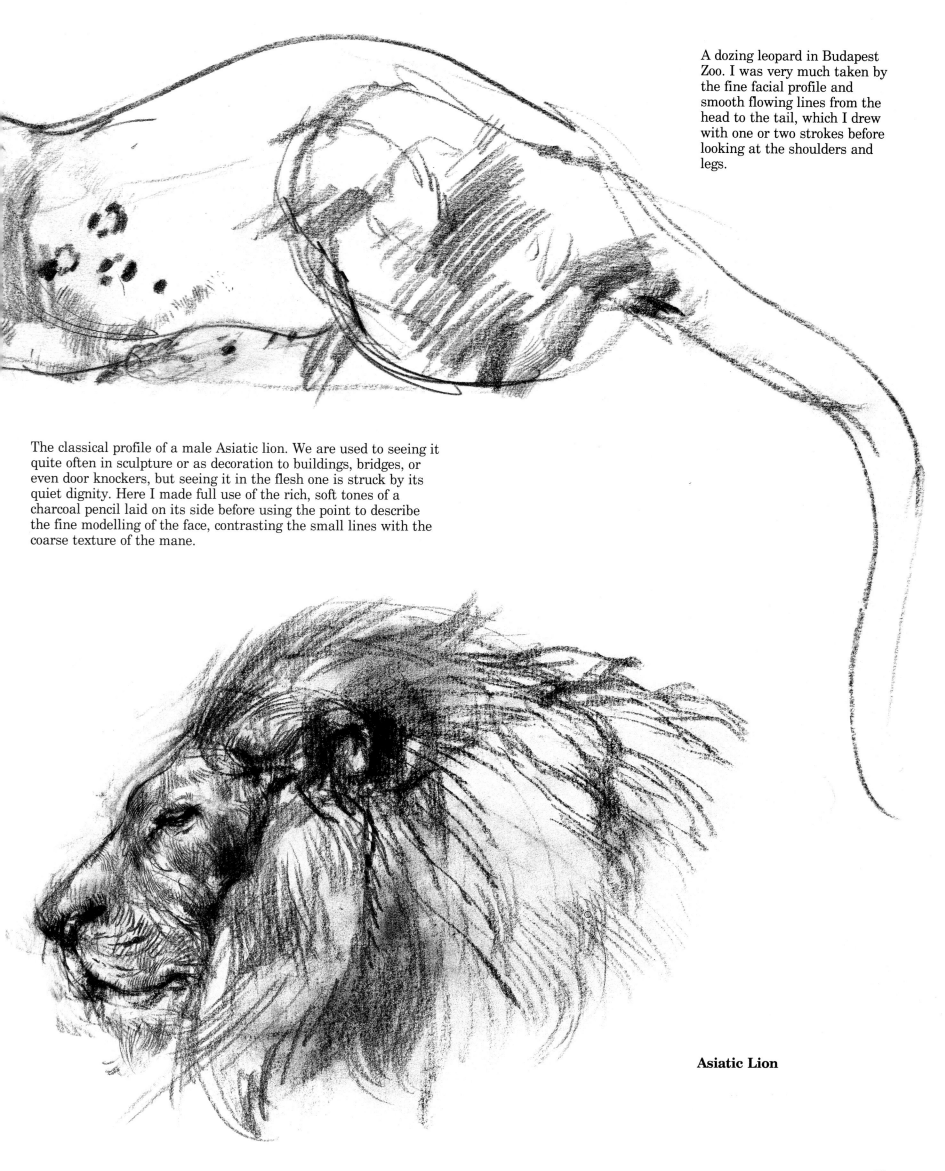

A dozing leopard in Budapest Zoo. I was very much taken by the fine facial profile and smooth flowing lines from the head to the tail, which I drew with one or two strokes before looking at the shoulders and legs.

The classical profile of a male Asiatic lion. We are used to seeing it quite often in sculpture or as decoration to buildings, bridges, or even door knockers, but seeing it in the flesh one is struck by its quiet dignity. Here I made full use of the rich, soft tones of a charcoal pencil laid on its side before using the point to describe the fine modelling of the face, contrasting the small lines with the coarse texture of the mane.

Asiatic Lion

39

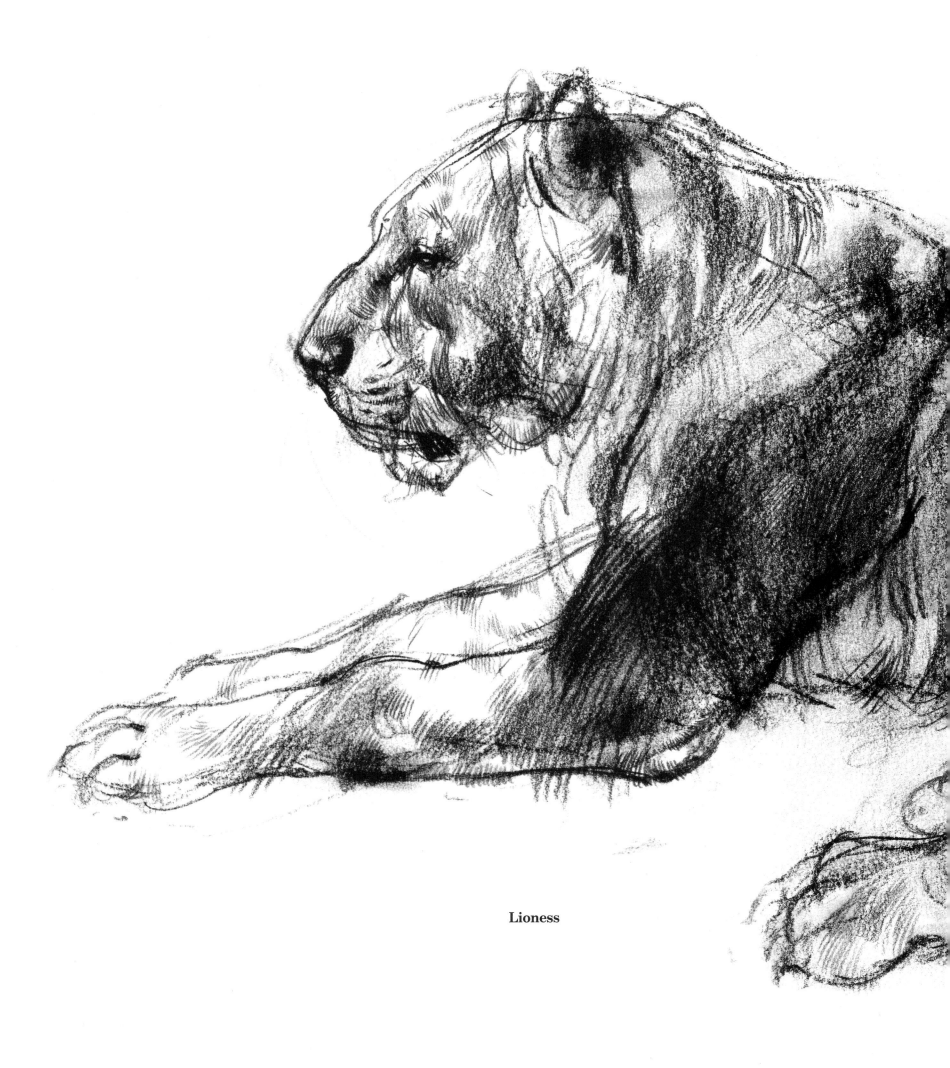

Lioness

The lioness is of lighter build than the lion since agility as well as strength is necessary for her to capture prey such as zebra and large antelope. The male lion usually takes little part in the hunt except perhaps to drive prey towards his female providers where they are lying in ambush. Instead he uses his strength to fend off other male rivals, although he is always first to feed on the kill. In this drawing the light was coming from above and to the left because the sun was setting. This gave me the opportunity to use masses of rich tone to indicate the strong muscular body of this lioness. The tone, ranging from black to fine half tone, produced a background into which I worked a pattern of lines to accentuate the muscles of the hind legs, head and shoulders. I always use the direction of the lines to describe a form; they are always dictated by the shape which I am drawing. Your animal should always feel three-dimensional. Anyone looking at it should get the feeling that they could actually walk around it. This lioness too sat still long enough for me to achieve a more closely observed drawing.

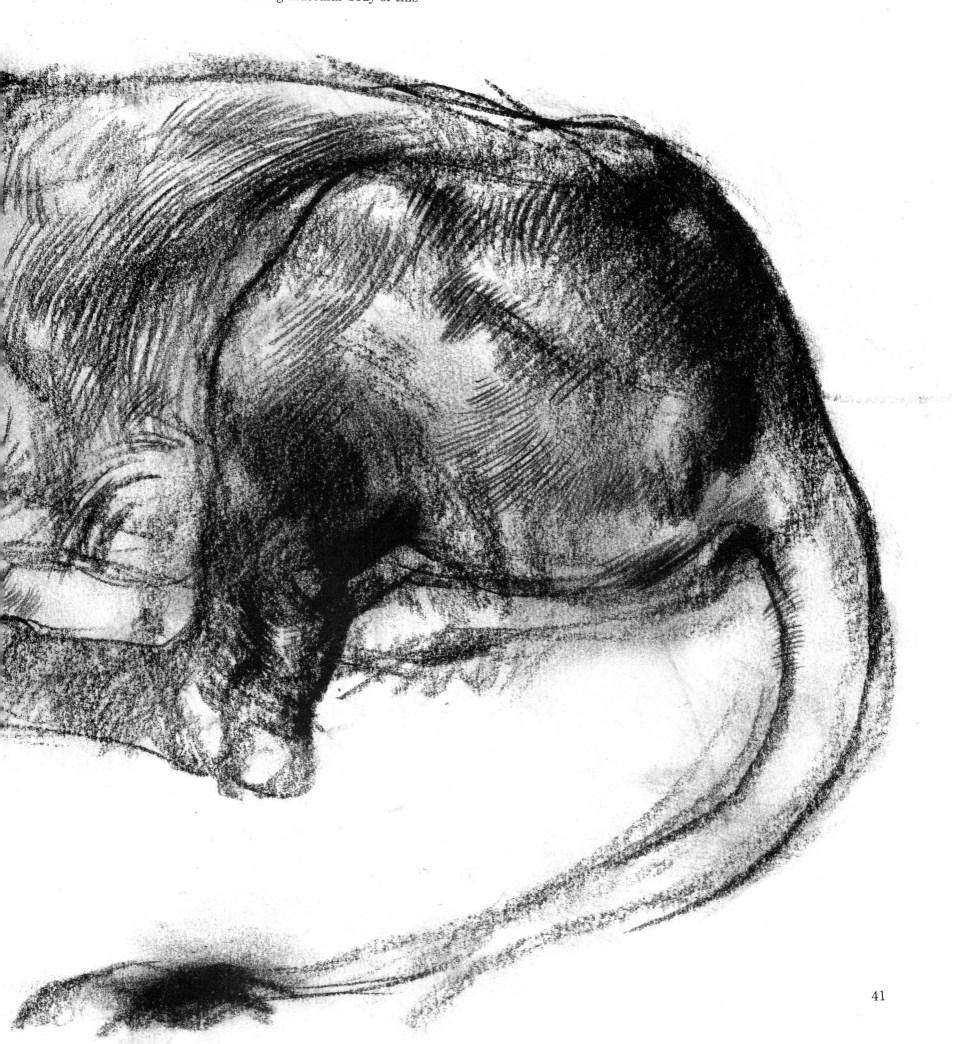

41

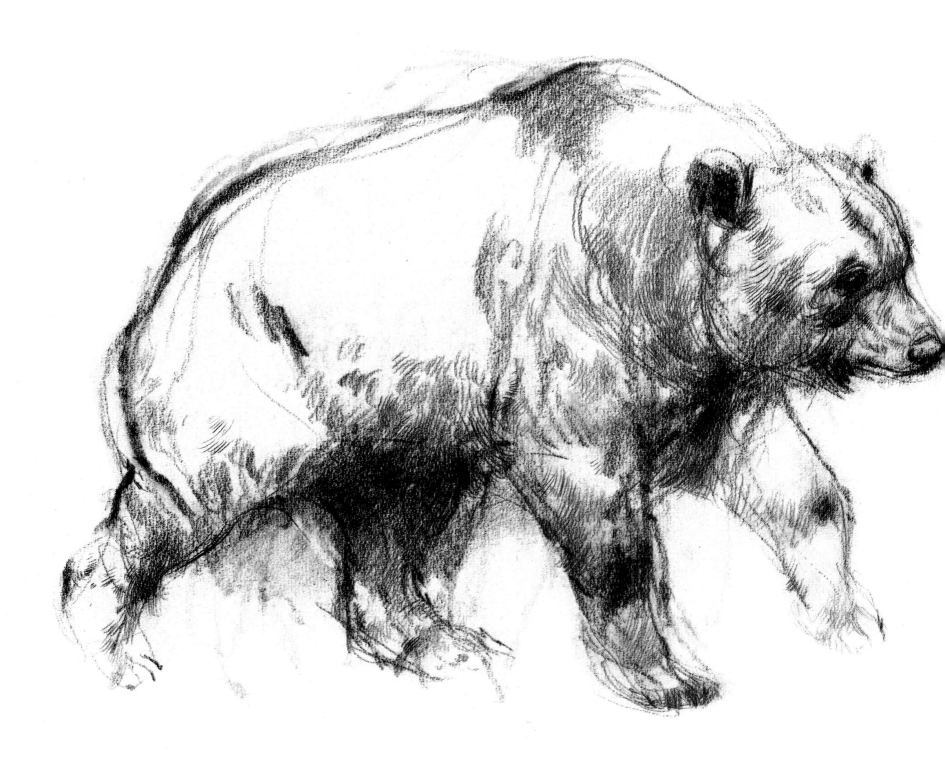

I had to hunt high and low to find bears to draw, but at last I tracked down these handsome specimens in Budapest Zoo. The European brown bear still turns up in the Carpathian Mountains.

These two paced up and down, constantly on the move, so I had to draw them in motion or when they returned to the same spot. I could see the head more or less in the same place so I could sketch it in more detail. It was interesting to see the contrast between the long face of the polar bear and the fuller, more rounded face of the brown bear, which incidentally gave him a rather friendlier look. As usual, the crowds were pressing, time was short and I had to work rapidly. As a result, the bear's body in the sketch above is suggested in line only. In some ways this is more effective as the sketch is concentrated on the head.

As it happened to be a lovely hot day, with the mid-day sun directly above, only the underside of the animal was in deep shadow.

42

The great size, well-rounded form and shaggy coat of bears allows them to more easily retain warmth, so that they are well suited to the cool climates of northerly or mountainous regions. Two tropical species do exist however in South-East Asia. Being too stocky to run down or spring out at large herbivorous mammals like cats or dogs, they are only able to capture them during chance encounters, such as when for instance they are immobilized in heavy snowdrifts. Hence, most bears must rely upon a wide variety of animal and plant matter for their food, which includes fruit, roots, fish, honey, small mammals and carrion. Brown bears such as this one were once found across almost the whole of the Northern Hemisphere, including Anglo-Saxon Britain. Few now exist in the mountains of Western Europe, but they are more numerous further east towards Russia.

Brown Bears

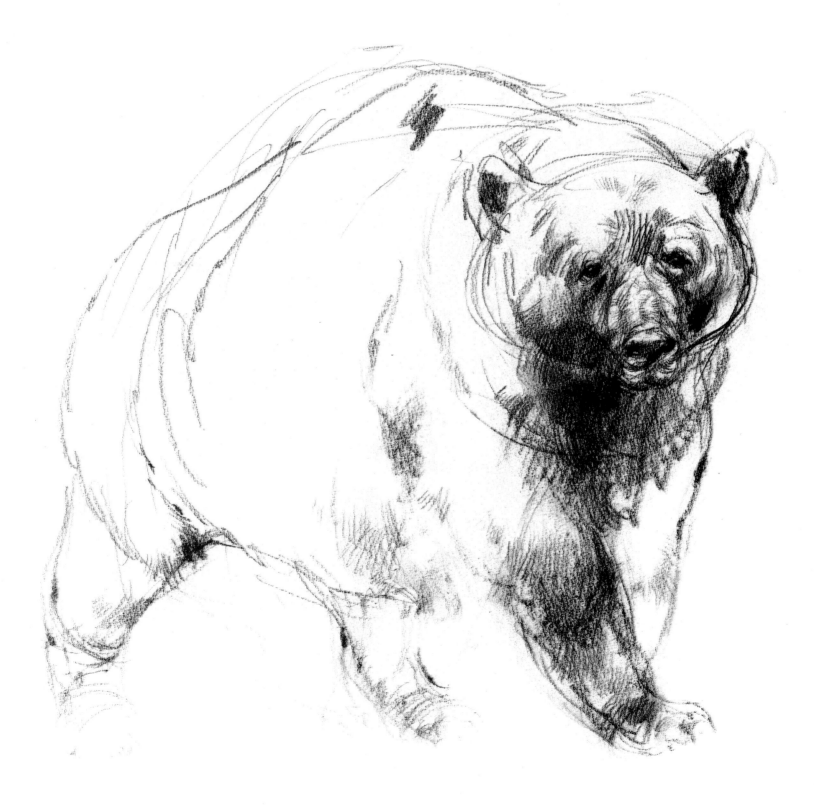

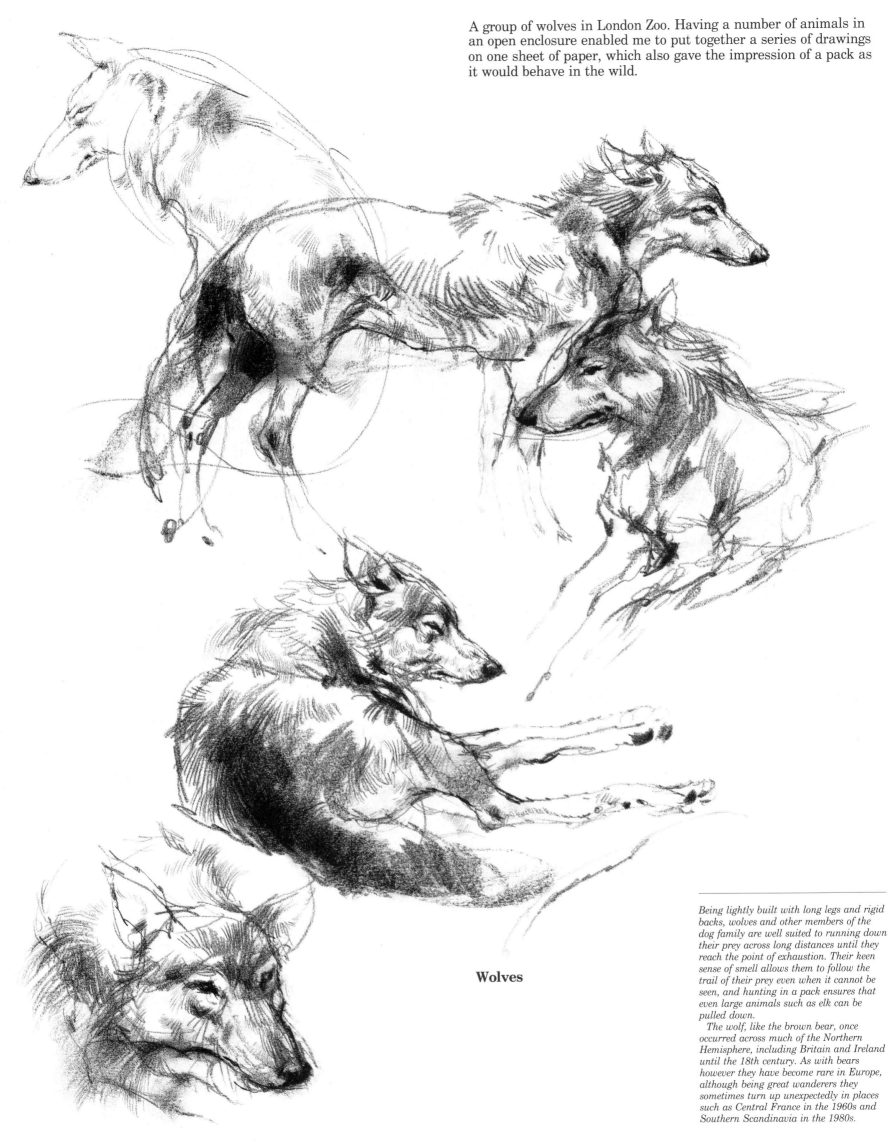

A group of wolves in London Zoo. Having a number of animals in an open enclosure enabled me to put together a series of drawings on one sheet of paper, which also gave the impression of a pack as it would behave in the wild.

Wolves

Being lightly built with long legs and rigid backs, wolves and other members of the dog family are well suited to running down their prey across long distances until they reach the point of exhaustion. Their keen sense of smell allows them to follow the trail of their prey even when it cannot be seen, and hunting in a pack ensures that even large animals such as elk can be pulled down.

The wolf, like the brown bear, once occurred across much of the Northern Hemisphere, including Britain and Ireland until the 18th century. As with bears however they have become rare in Europe, although being great wanderers they sometimes turn up unexpectedly in places such as Central France in the 1960s and Southern Scandinavia in the 1980s.

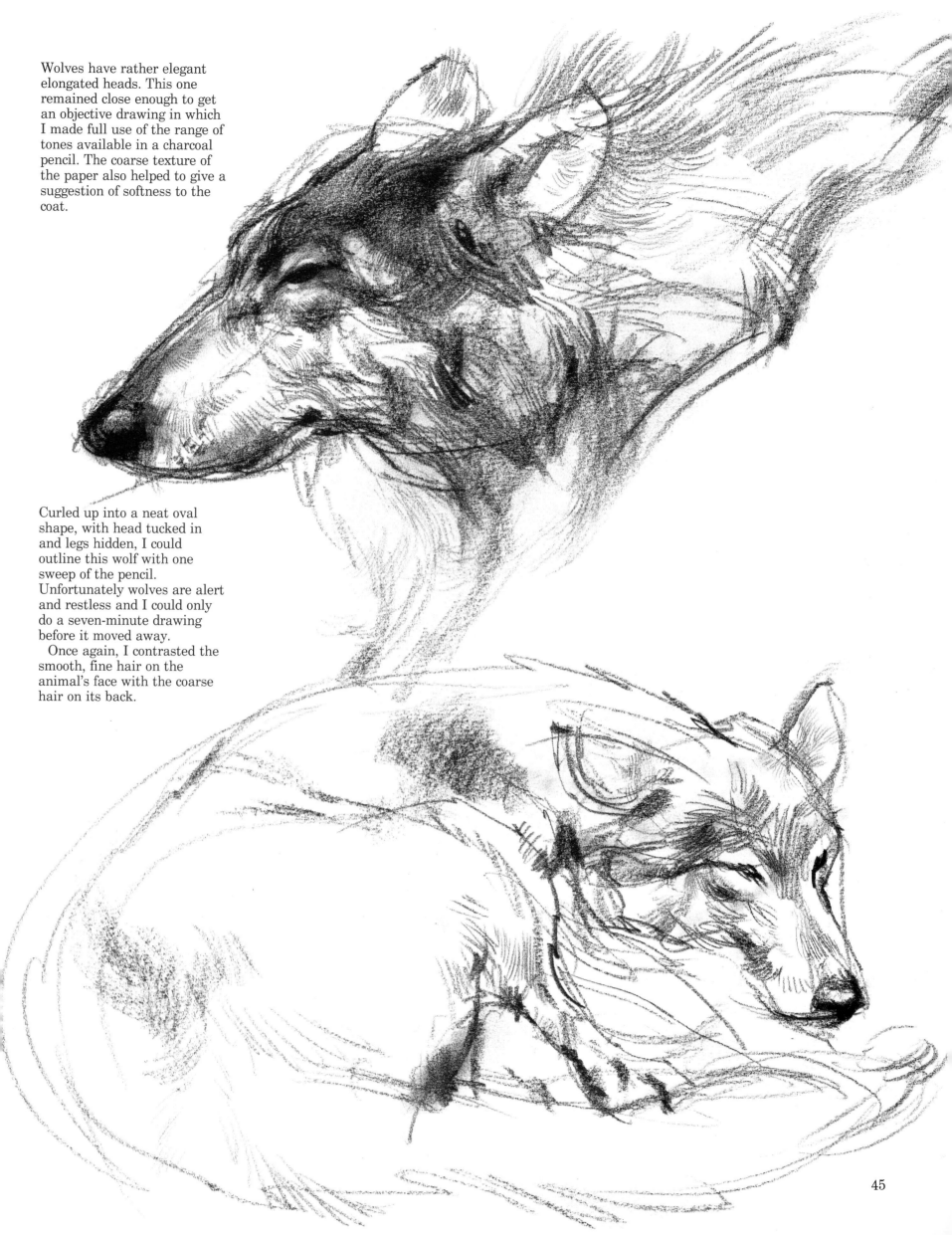

Wolves have rather elegant elongated heads. This one remained close enough to get an objective drawing in which I made full use of the range of tones available in a charcoal pencil. The coarse texture of the paper also helped to give a suggestion of softness to the coat.

Curled up into a neat oval shape, with head tucked in and legs hidden, I could outline this wolf with one sweep of the pencil. Unfortunately wolves are alert and restless and I could only do a seven-minute drawing before it moved away.

Once again, I contrasted the smooth, fine hair on the animal's face with the coarse hair on its back.

The gorillas of London Zoo are magnificent, monumental beasts composed of huge smooth shapes. This is a male in meditative mood staring back at his inquisitive human audience. It gave me the chance to get down on paper the impressive profile, searching eyes and massive shoulders. A fast and generous use of tone was called for, and I blunted a soft, carbon pencil several times to give the right depth to his black coat.

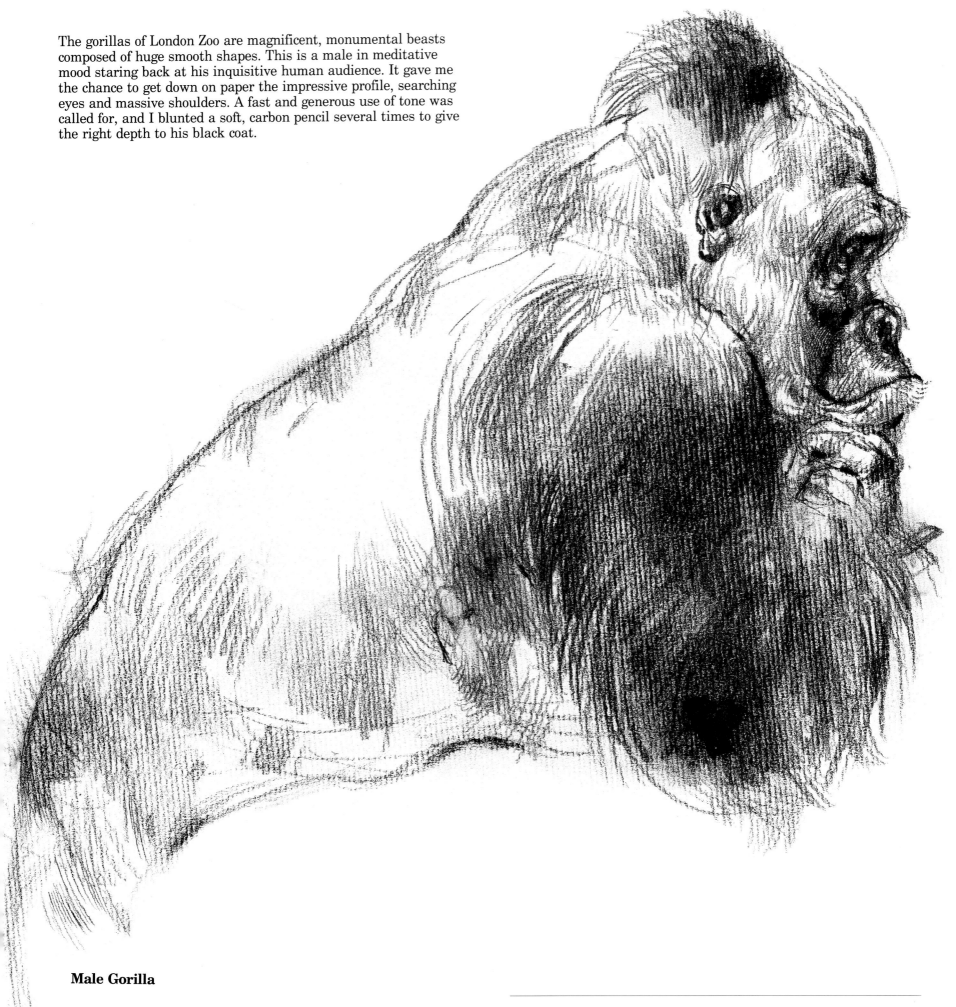

Male Gorilla

Biochemical studies have shown the two African apes, the gorilla and chimpanzee, to be our nearest living relatives, and suggest that we diverged from a common ancestor maybe six or eight million years ago. Behavioural studies have also shown them to be rather more intelligent than was previously supposed, with young individuals of both species being able to learn up to 200-300 'words' in sign language and even string a few of them together at one time.

The docile gorilla lives in small family groups usually led by a single large male, like the one drawn here. During the day gorillas spend their time constantly foraging and feeding on herbs, buds, roots and stems, and at night they build nests in trees to sleep in. Although still hunted and captured, the most serious threat to them is the destruction of the forests in Central Africa through timber extraction and the expansion of agriculture.

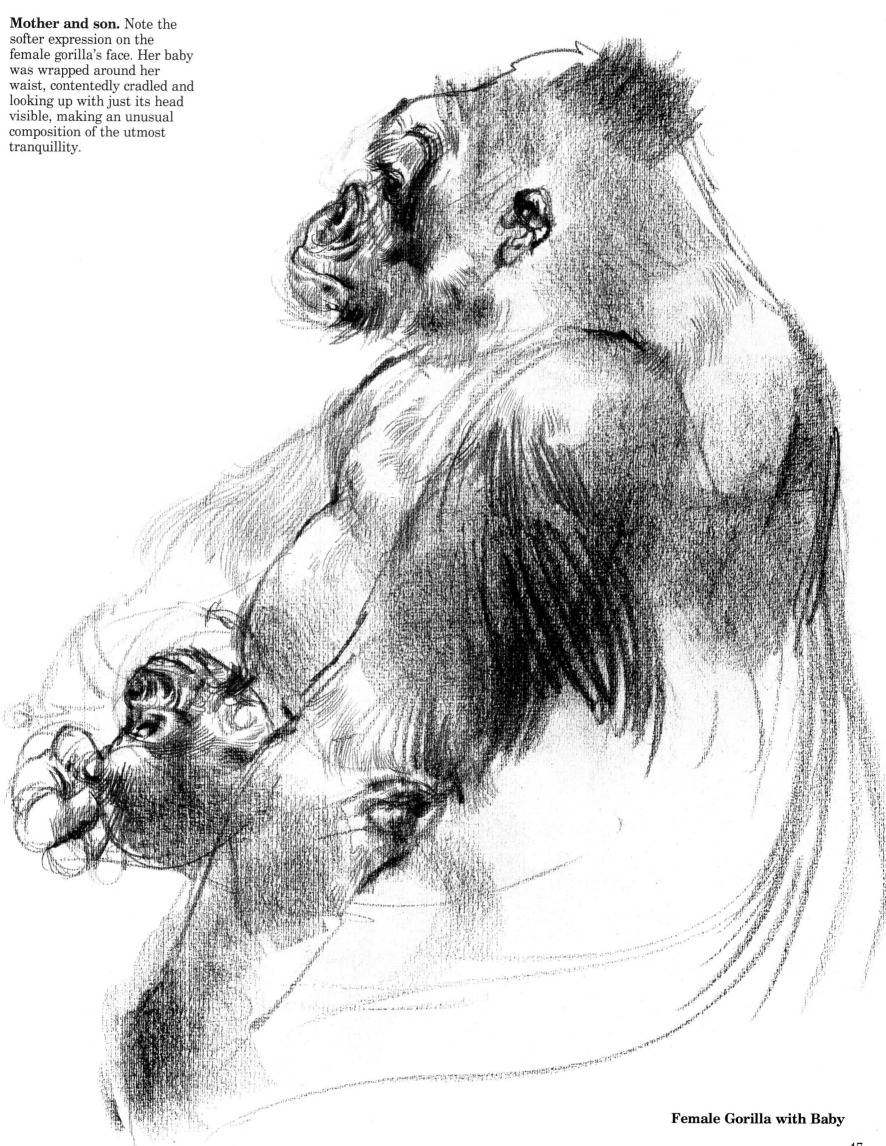

Mother and son. Note the softer expression on the female gorilla's face. Her baby was wrapped around her waist, contentedly cradled and looking up with just its head visible, making an unusual composition of the utmost tranquillity.

Female Gorilla with Baby

Male Gorilla

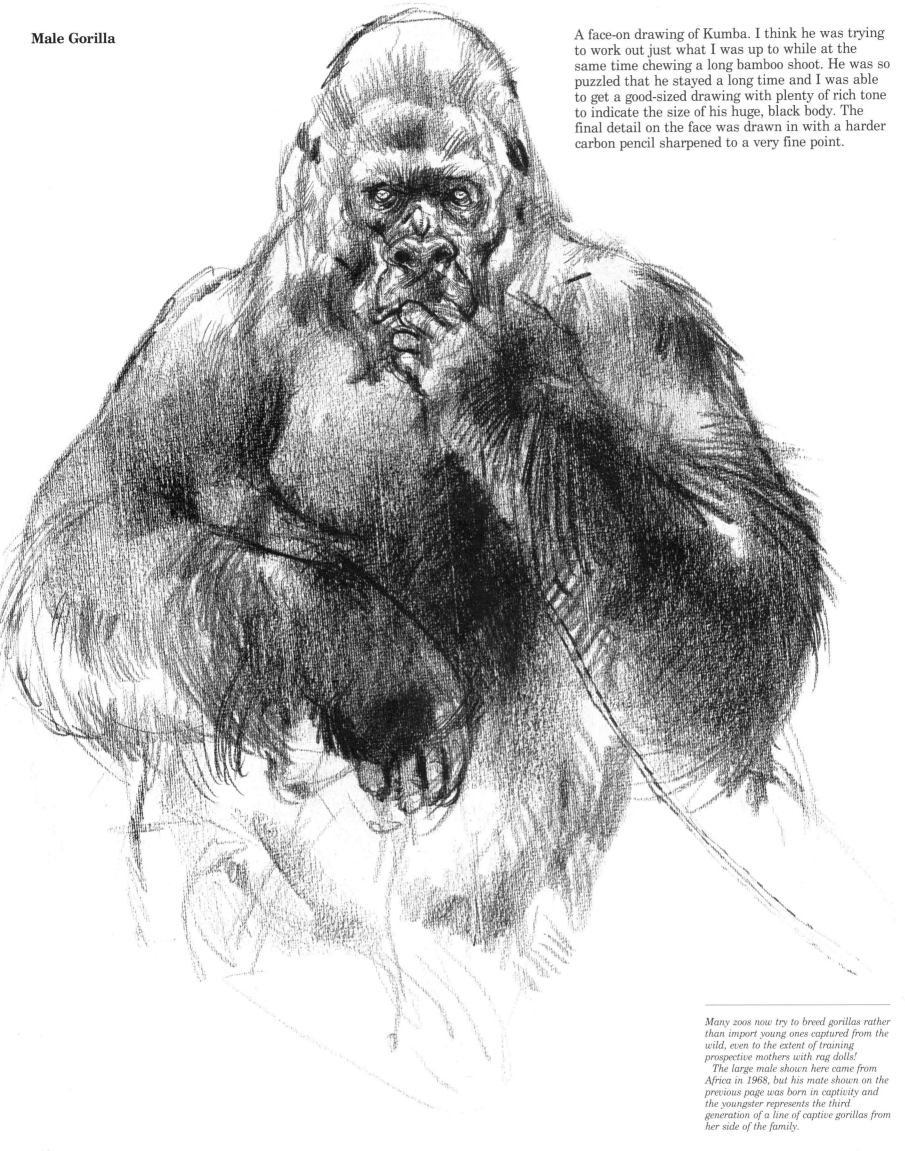

A face-on drawing of Kumba. I think he was trying to work out just what I was up to while at the same time chewing a long bamboo shoot. He was so puzzled that he stayed a long time and I was able to get a good-sized drawing with plenty of rich tone to indicate the size of his huge, black body. The final detail on the face was drawn in with a harder carbon pencil sharpened to a very fine point.

Many zoos now try to breed gorillas rather than import young ones captured from the wild, even to the extent of training prospective mothers with rag dolls!
The large male shown here came from Africa in 1968, but his mate shown on the previous page was born in captivity and the youngster represents the third generation of a line of captive gorillas from her side of the family.

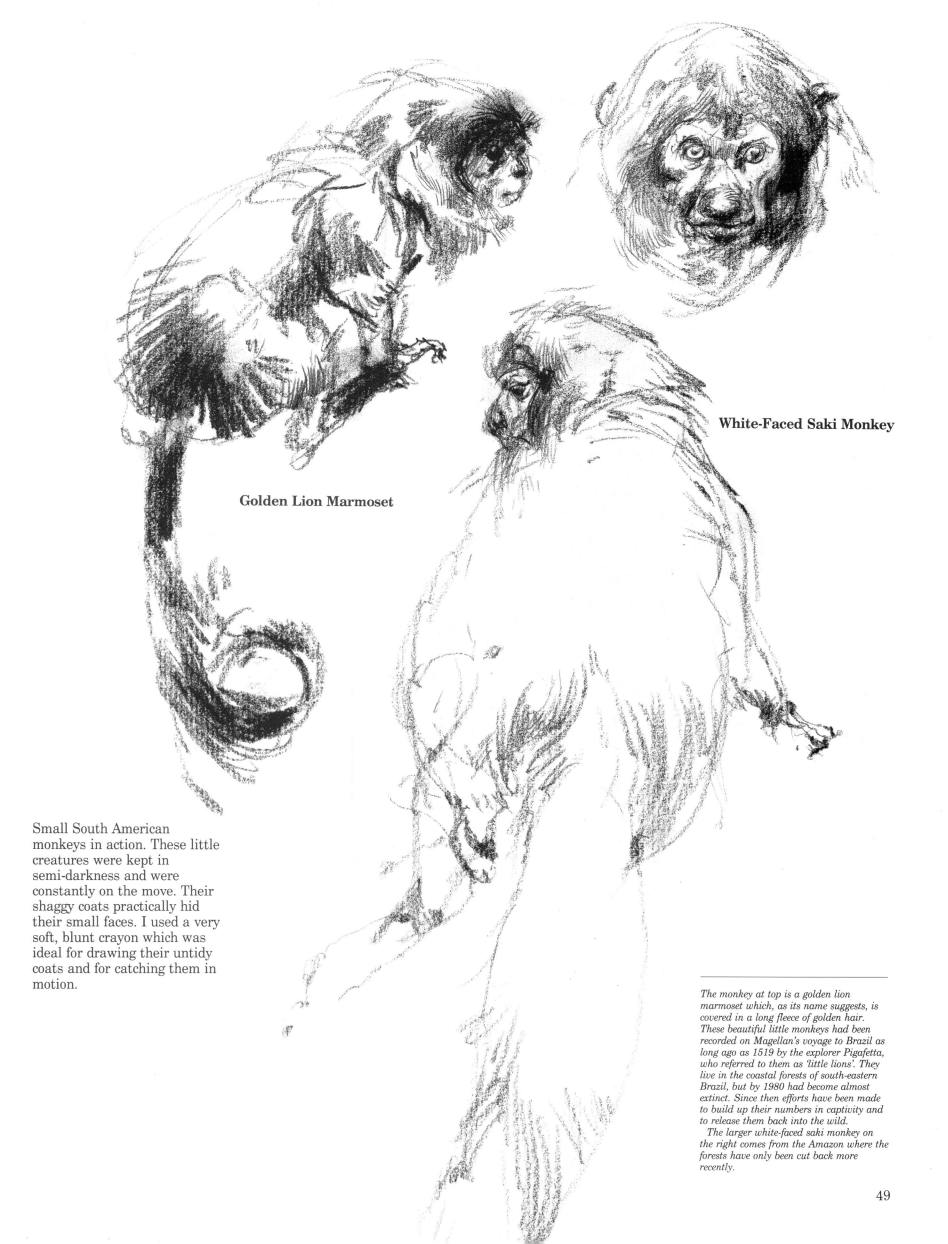

White-Faced Saki Monkey

Golden Lion Marmoset

Small South American monkeys in action. These little creatures were kept in semi-darkness and were constantly on the move. Their shaggy coats practically hid their small faces. I used a very soft, blunt crayon which was ideal for drawing their untidy coats and for catching them in motion.

The monkey at top is a golden lion marmoset which, as its name suggests, is covered in a long fleece of golden hair. These beautiful little monkeys had been recorded on Magellan's voyage to Brazil as long ago as 1519 by the explorer Pigafetta, who referred to them as 'little lions'. They live in the coastal forests of south-eastern Brazil, but by 1980 had become almost extinct. Since then efforts have been made to build up their numbers in captivity and to release them back into the wild.

The larger white-faced saki monkey on the right comes from the Amazon where the forests have only been cut back more recently.

This exhibitionist orangutan spent quite a few minutes staring out the visitors before moving off. I cannot blame her. It was an uncomfortable pose to hold for a long time, but she did not give me time to finish her hind legs. She had a lovely cheeky face and was obviously thoroughly enjoying pulling faces at people who were pulling faces at her. The smoothness of the animal's head contrasted well with the long, silky hair of her arms and body. I used the lines to indicate the forms on the long arms and the rounded pot belly. The long coat also had a highly decorative quality and I drew the lines to enhance this feature.

The orangutans in this enclosure had very different characters. One was extremely shy and when I tried to draw her, covered her face with an arm. This one was quite the opposite, very extrovert indeed.

Orangutan

Orangutans are to be found in Borneo and northernmost Sumatra. Although they diverged from the evolutionary line which led to ourselves earlier than the chimpanzee and gorilla of Africa, in zoos they seem to be just as bright as the other apes with some having proved themselves to be great escapologists. Orangutans are more solitary than their African cousins and spend more time in the trees where they feed mostly upon leaves, fruit and insects.

Although frequently captured for zoos and in the past as pets, the areas where they live are now being most seriously reduced by timber extraction.

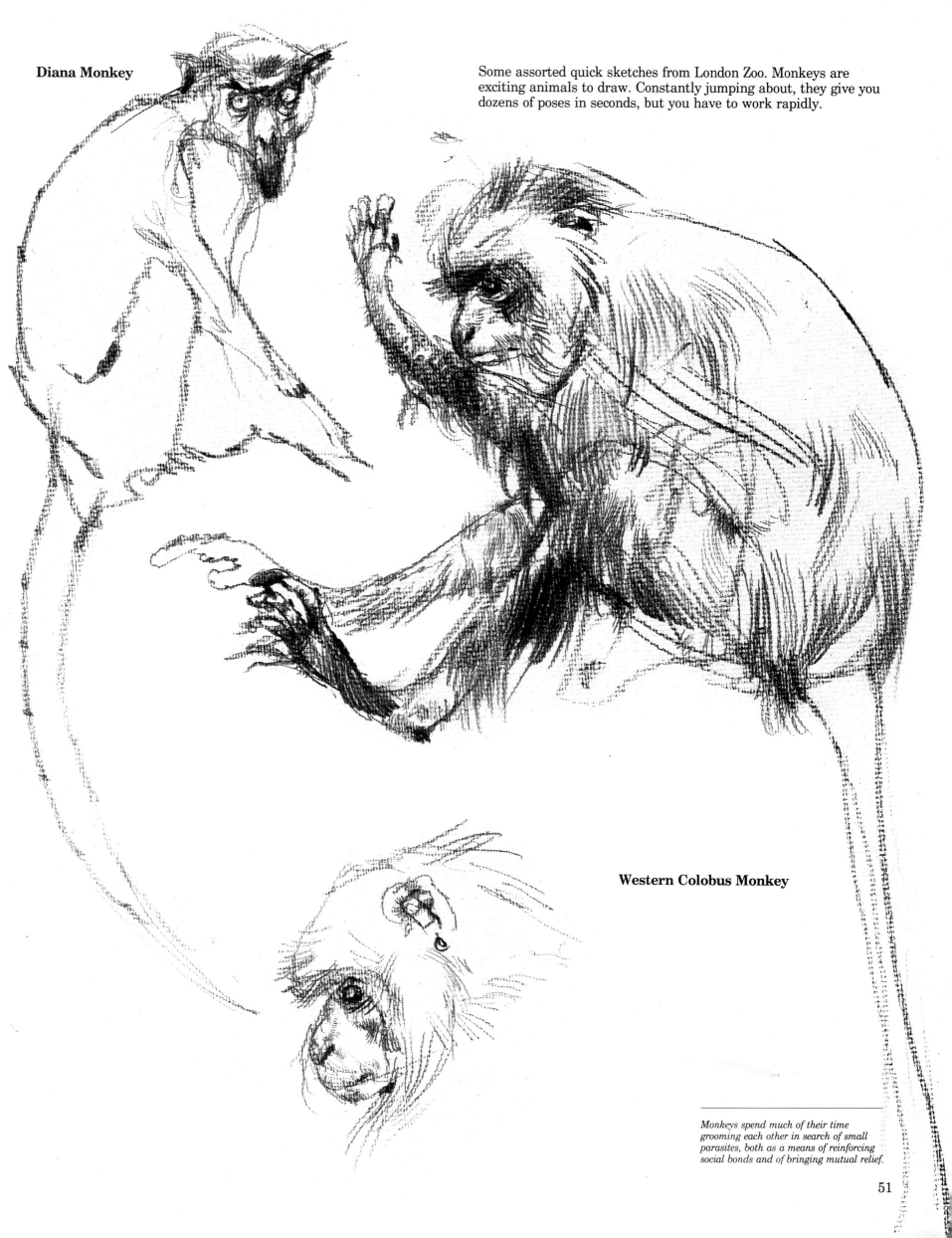

Diana Monkey

Some assorted quick sketches from London Zoo. Monkeys are exciting animals to draw. Constantly jumping about, they give you dozens of poses in seconds, but you have to work rapidly.

Western Colobus Monkey

Monkeys spend much of their time grooming each other in search of small parasites, both as a means of reinforcing social bonds and of bringing mutual relief.

51

Opposite: The grumpy male chimpanzee, brooding in a corner with arms and legs folded together, made a neat, compact shape to draw. I always try to concentrate on the hands and feet of these animals, because without them the body is meaningless. This period of meditation was followed by an explosion of screaming anger as he tore up and down the enclosure terrifying the rest of his group. Like all apes, chimps have intelligent, penetrating eyes, well worth drawing properly.

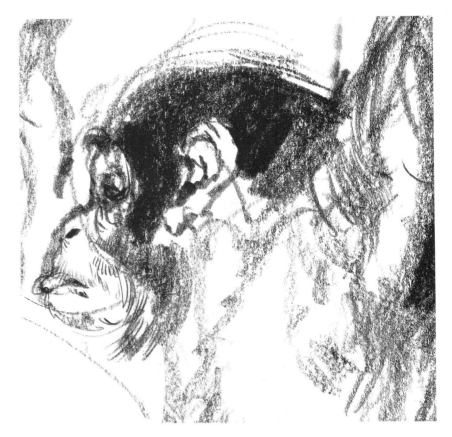

Below: A resting chimpanzee daydreaming. After drawing the bulk of this animal, I became totally involved with his face. It had a wonderful expression which I attempted to capture on paper. I roughly laid on the black tone of his body and then concentrated on the features with a fine series of lines. My training as an etcher-engraver often comes in useful when describing forms such as the folds and wrinkles of this chimp's face. Having used up the soft 2B carbon pencil on the tone, I reached for a harder HB to complete the details.

Above: Close-up of a sketch of a young chimp's head. If you only have ten minutes available you will be forced to use the minimum of lines to the greatest effect. This youngster was swinging from a bar.

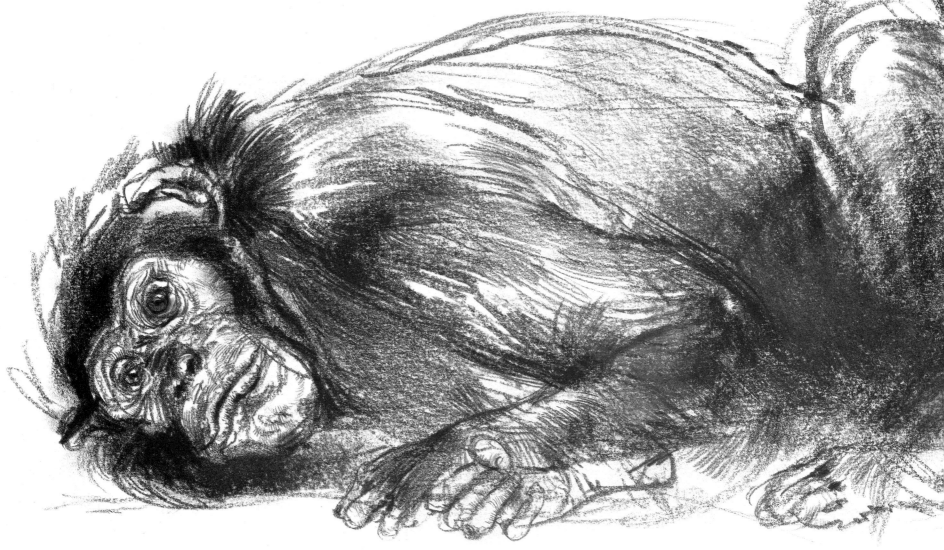

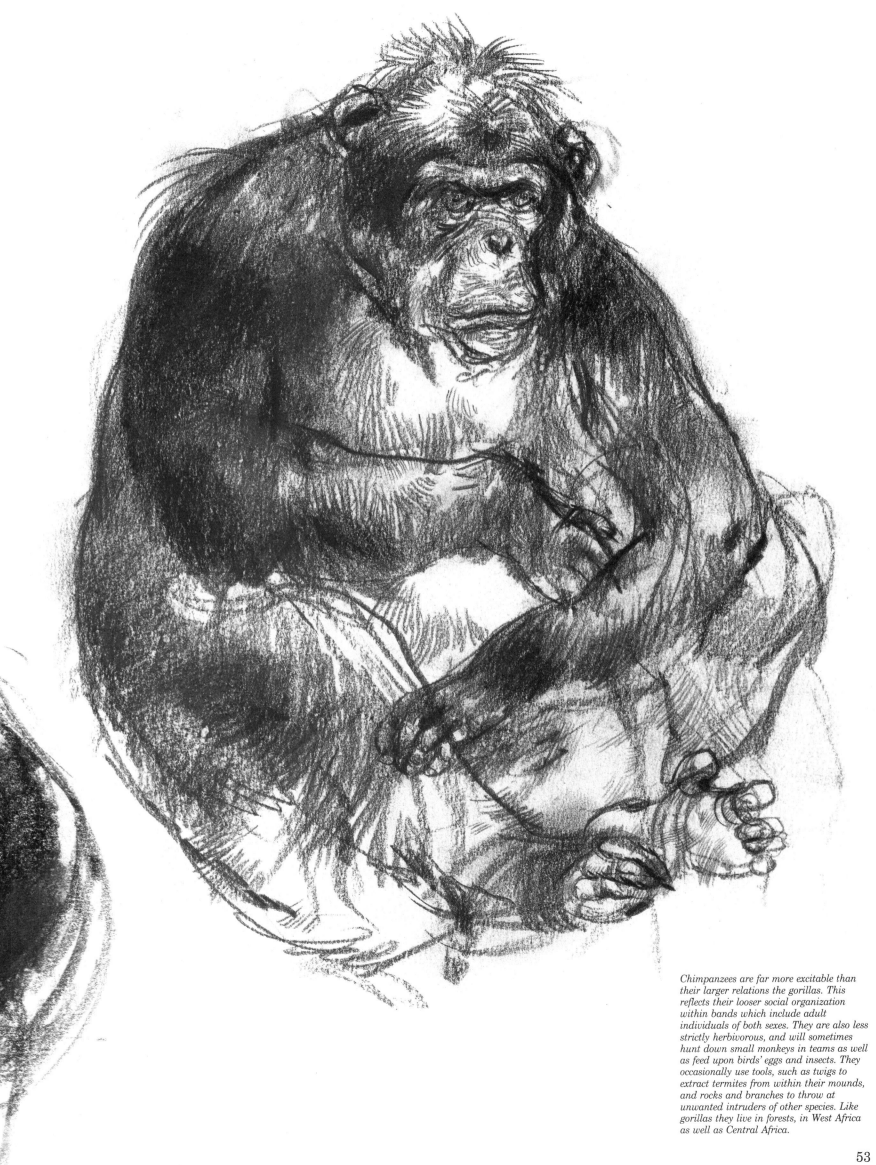

Chimpanzees are far more excitable than their larger relations the gorillas. This reflects their looser social organization within bands which include adult individuals of both sexes. They are also less strictly herbivorous, and will sometimes hunt down small monkeys in teams as well as feed upon birds' eggs and insects. They occasionally use tools, such as twigs to extract termites from within their mounds, and rocks and branches to throw at unwanted intruders of other species. Like gorillas they live in forests, in West Africa as well as Central Africa.

53

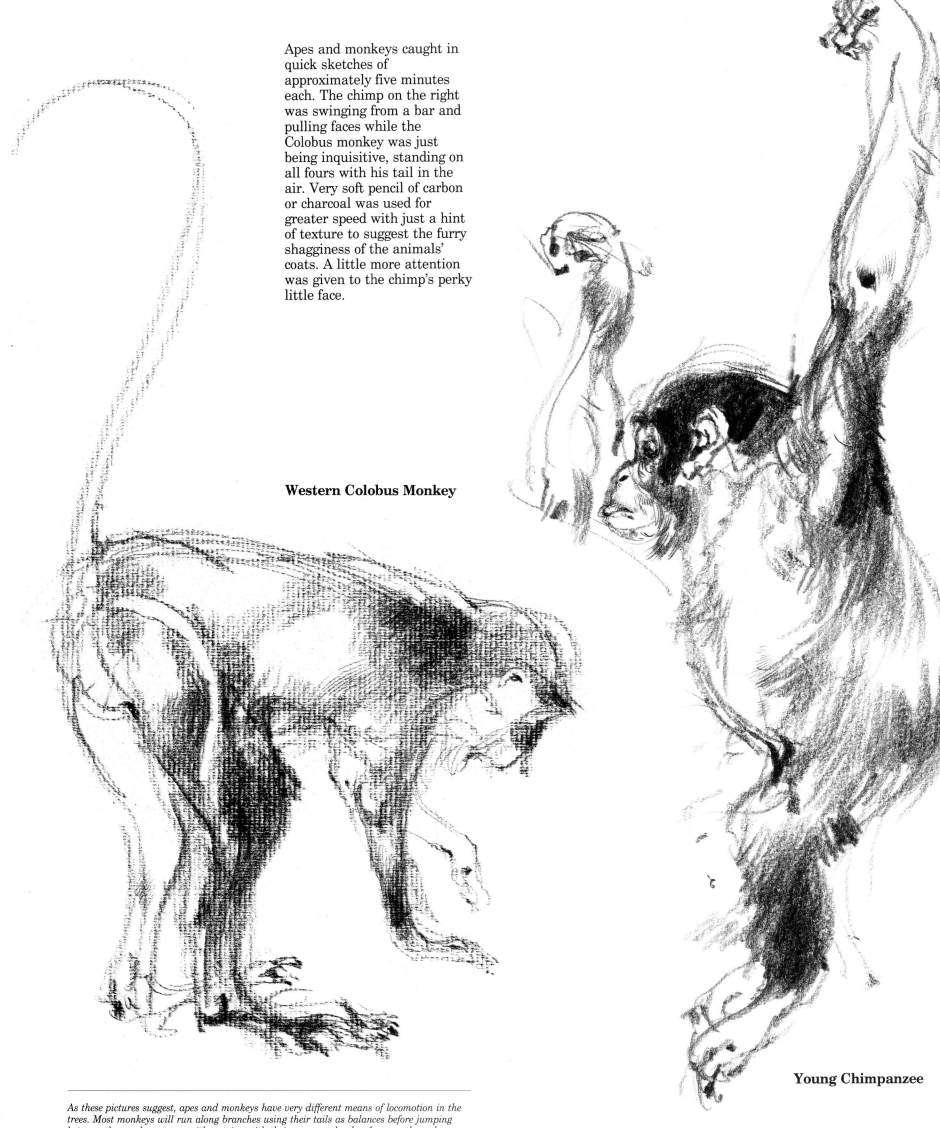

Apes and monkeys caught in quick sketches of approximately five minutes each. The chimp on the right was swinging from a bar and pulling faces while the Colobus monkey was just being inquisitive, standing on all fours with his tail in the air. Very soft pencil of carbon or charcoal was used for greater speed with just a hint of texture to suggest the furry shagginess of the animals' coats. A little more attention was given to the chimp's perky little face.

Western Colobus Monkey

Young Chimpanzee

As these pictures suggest, apes and monkeys have very different means of locomotion in the trees. Most monkeys will run along branches using their tails as balances before jumping between them, whereas apes either swing with their arms or clamber from one branch to the other.

54

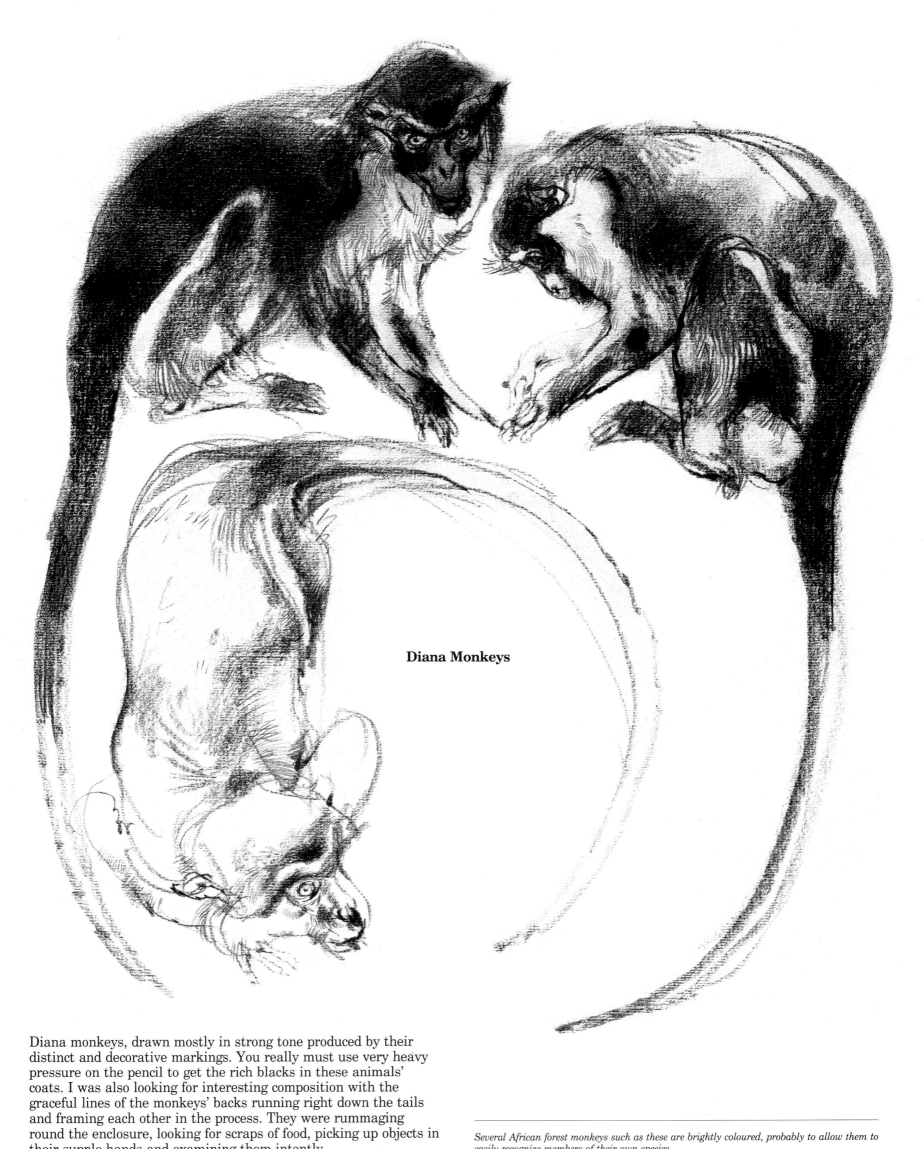

Diana Monkeys

Diana monkeys, drawn mostly in strong tone produced by their distinct and decorative markings. You really must use very heavy pressure on the pencil to get the rich blacks in these animals' coats. I was also looking for interesting composition with the graceful lines of the monkeys' backs running right down the tails and framing each other in the process. They were rummaging round the enclosure, looking for scraps of food, picking up objects in their supple hands and examining them intently.

Several African forest monkeys such as these are brightly coloured, probably to allow them to easily recognize members of their own species.

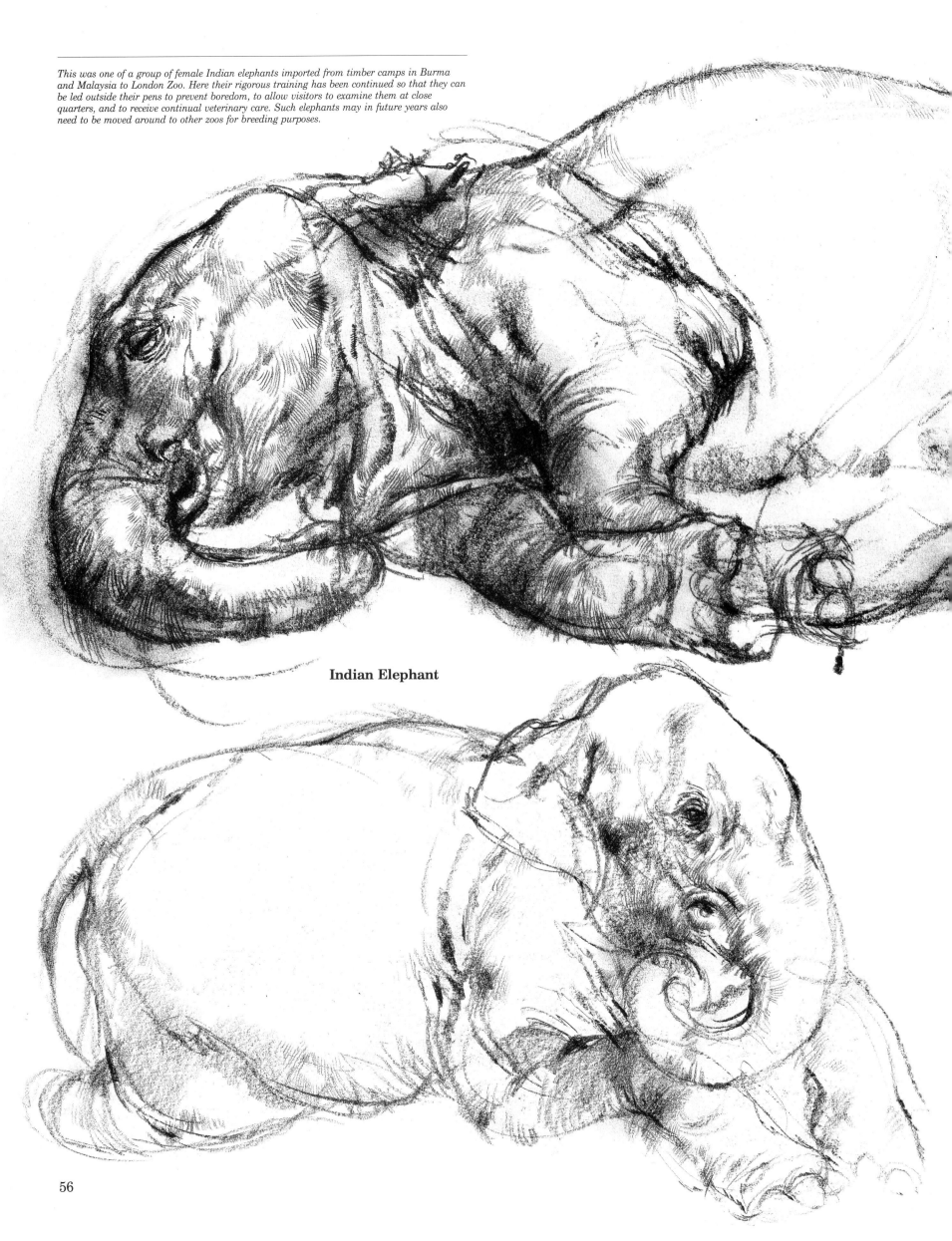

This was one of a group of female Indian elephants imported from timber camps in Burma and Malaysia to London Zoo. Here their rigorous training has been continued so that they can be led outside their pens to prevent boredom, to allow visitors to examine them at close quarters, and to receive continual veterinary care. Such elephants may in future years also need to be moved around to other zoos for breeding purposes.

Indian Elephant

Head of a young African elephant with typical huge flapping ears. Black tone was used here to bring forward the skull and trunk. This was the last African elephant to be kept at London Zoo.

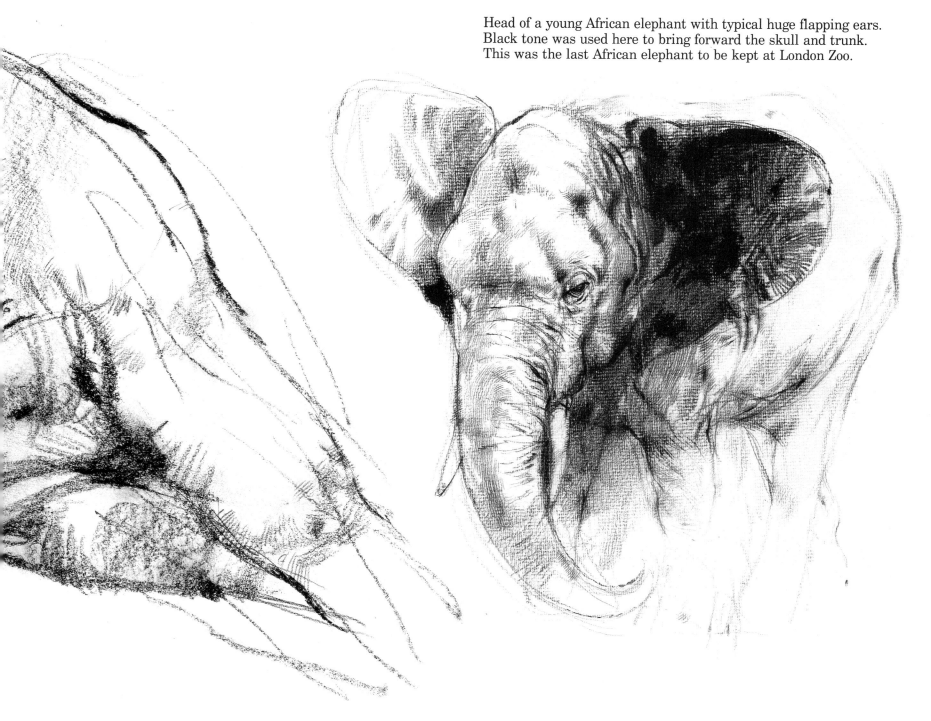

Young African Elephant

An Indian elephant lying down while keepers removed stones from between his toes. Seen from an unusual angle I found the head particularly interesting, being full of strange forms. The fact that the front legs were foreshortened also gave an unusual twist to the composition.

I drew the entire animal first with a very soft blunt-pointed crayon. Then I quickly indicated the late afternoon sunlight with some flat tone before returning to the folds and bumps of the head and legs.

The elephant was now allowed to sit up, head and curled-up trunk looking like an Indian carving. I had very little time to draw this, but now the bone structure of the head could be seen quite clearly. I paid particular attention to the eyes which, though tiny, were expressive and full of wisdom.

Elephants are well adapted to consume the vast amounts of plant material needed to sustain their huge bodies, their food ranging from grasses and roots to tree bark and foliage. Their legs are long to enable them to forage across wide areas. Their trunks enable them to pluck food from between ground level and twice their shoulder height. Elephants are highly intelligent animals, and although they may not be fast to learn they certainly seem never to forget. They live in herds led by an experienced old matriarchal cow elephant and communicate with each other by a range of sounds, most of which are of too low a frequency to be audible to the human ear.

In South-East Asia elephants are threatened mainly by forest destruction, in Africa by ivory poaching. They are one of the few favourite zoo animals which still need to be imported from the wild since male elephants have proved to be too unmanageable for most zoos to maintain.

57

Again a couple of Malayan tapirs, among my favourite subjects, seen from two different angles, one with foreshortening away from you, one towards you. The first animal has very strong black and white markings giving it a powerful decorative impact. In this case the hind leg and rump required dramatic dark tone detailing, while lighter tone with just as much detail was used on the head to draw it away from the foreground.

You will also see that I have made a sketch of the head in line only. This is to enable the forms to be more clearly seen. Neatly curled up the tapir below has one leg tucked away, while the other with its curious toes, is outstretched. The eyes, nose and leg nearest to you demand special attention to detail in order to bring the animal forward.

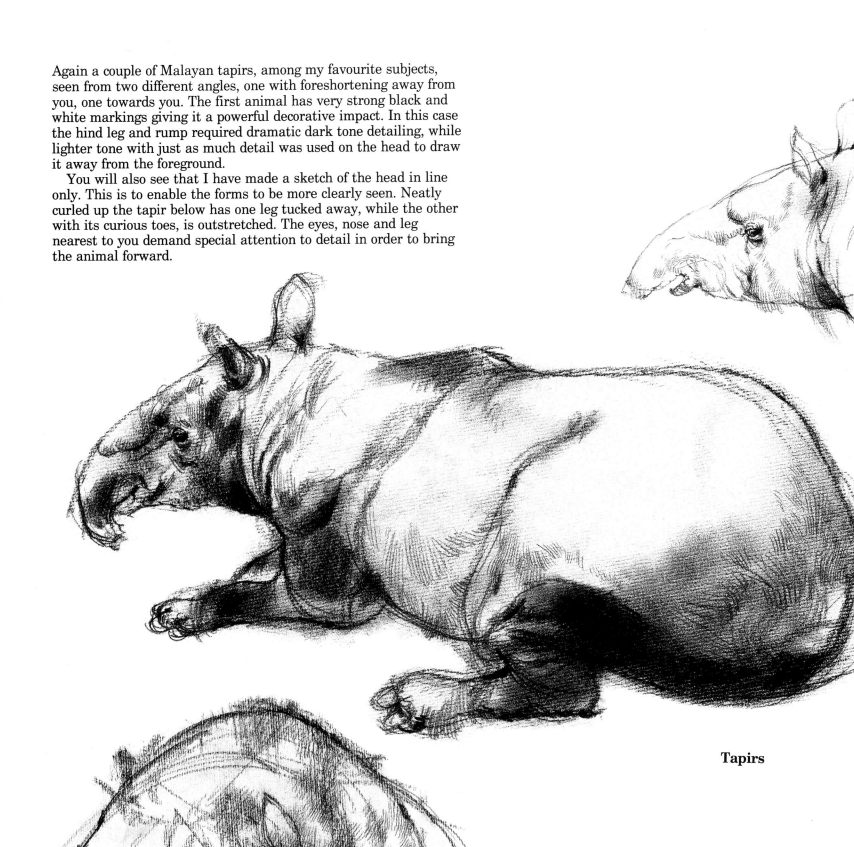

Tapirs

Tapirs are distant relatives of the horse and rhinoceros and among the most ancient of mammals, having had ancestors almost identical to them 30 million years ago. They are rather timid browsing animals which live in dense forests close to water where they feed on succulent plants. They have keen senses of hearing and smell but poor eyesight.

The South American species is coloured in rather plain shades of brown, but the Malayan tapir is mainly black with a white band across its hindquarters. This strange coloration may serve to break up their outline in undergrowth but essentially remains a mystery.

58

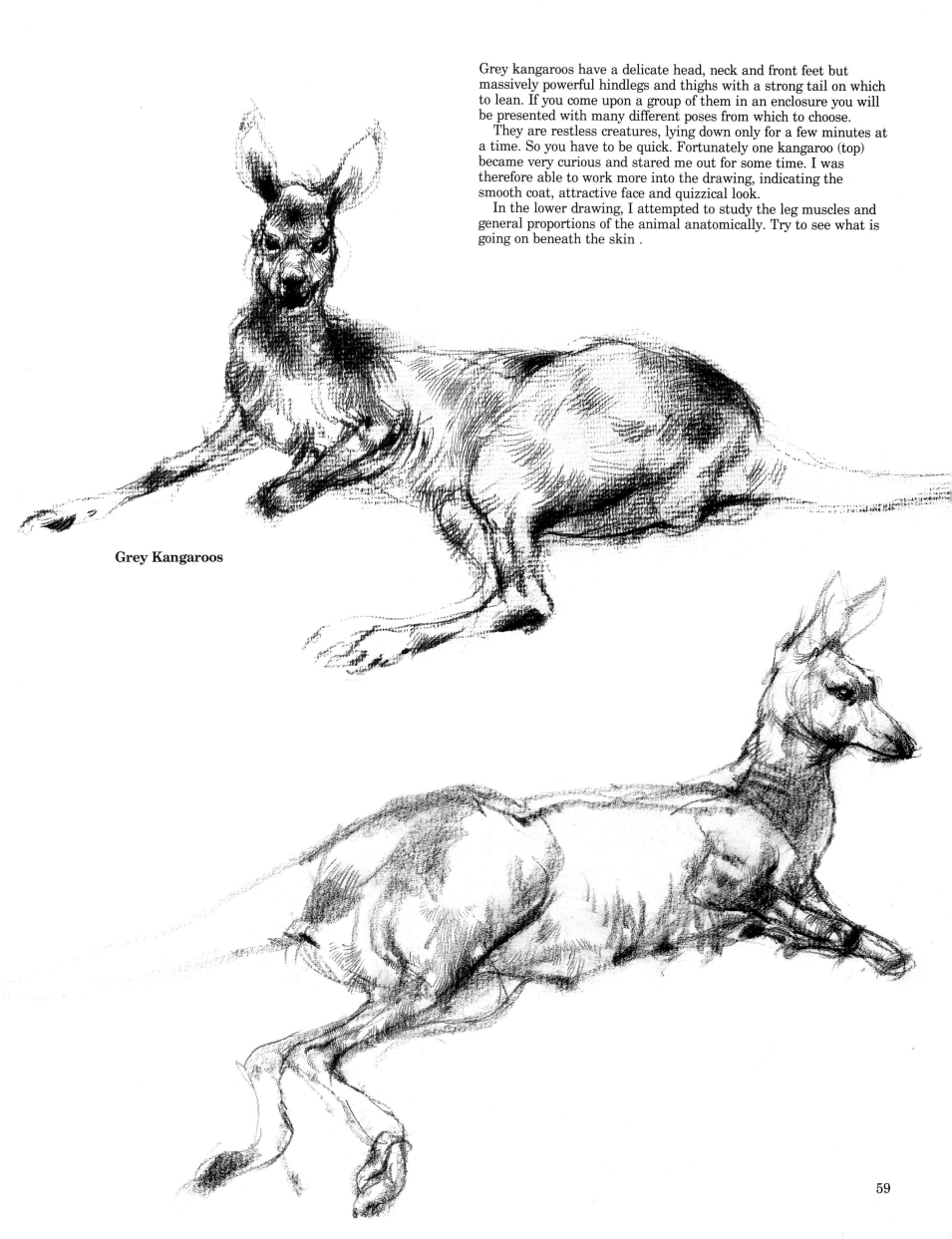

Grey kangaroos have a delicate head, neck and front feet but massively powerful hindlegs and thighs with a strong tail on which to lean. If you come upon a group of them in an enclosure you will be presented with many different poses from which to choose.

They are restless creatures, lying down only for a few minutes at a time. So you have to be quick. Fortunately one kangaroo (top) became very curious and stared me out for some time. I was therefore able to work more into the drawing, indicating the smooth coat, attractive face and quizzical look.

In the lower drawing, I attempted to study the leg muscles and general proportions of the animal anatomically. Try to see what is going on beneath the skin .

Grey Kangaroos

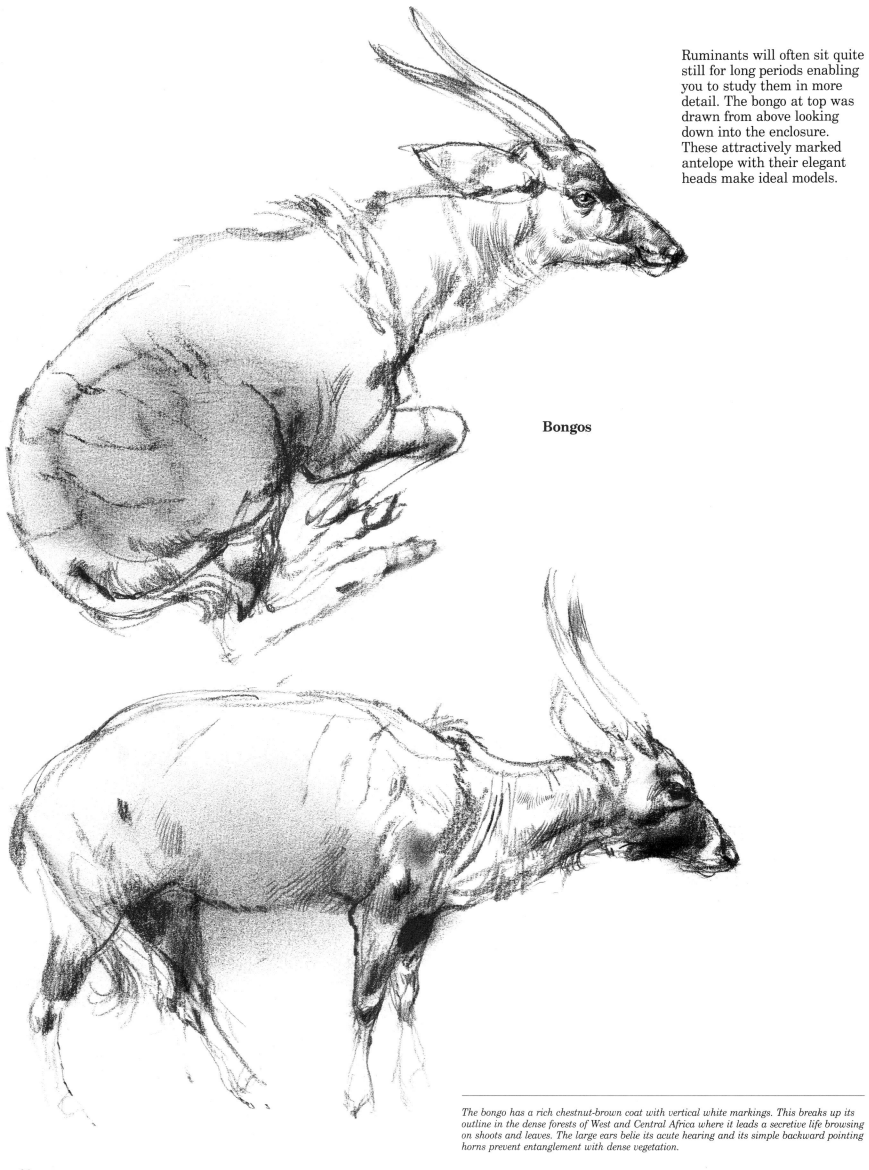

Ruminants will often sit quite still for long periods enabling you to study them in more detail. The bongo at top was drawn from above looking down into the enclosure. These attractively marked antelope with their elegant heads make ideal models.

Bongos

The bongo has a rich chestnut-brown coat with vertical white markings. This breaks up its outline in the dense forests of West and Central Africa where it leads a secretive life browsing on shoots and leaves. The large ears belie its acute hearing and its simple backward pointing horns prevent entanglement with dense vegetation.

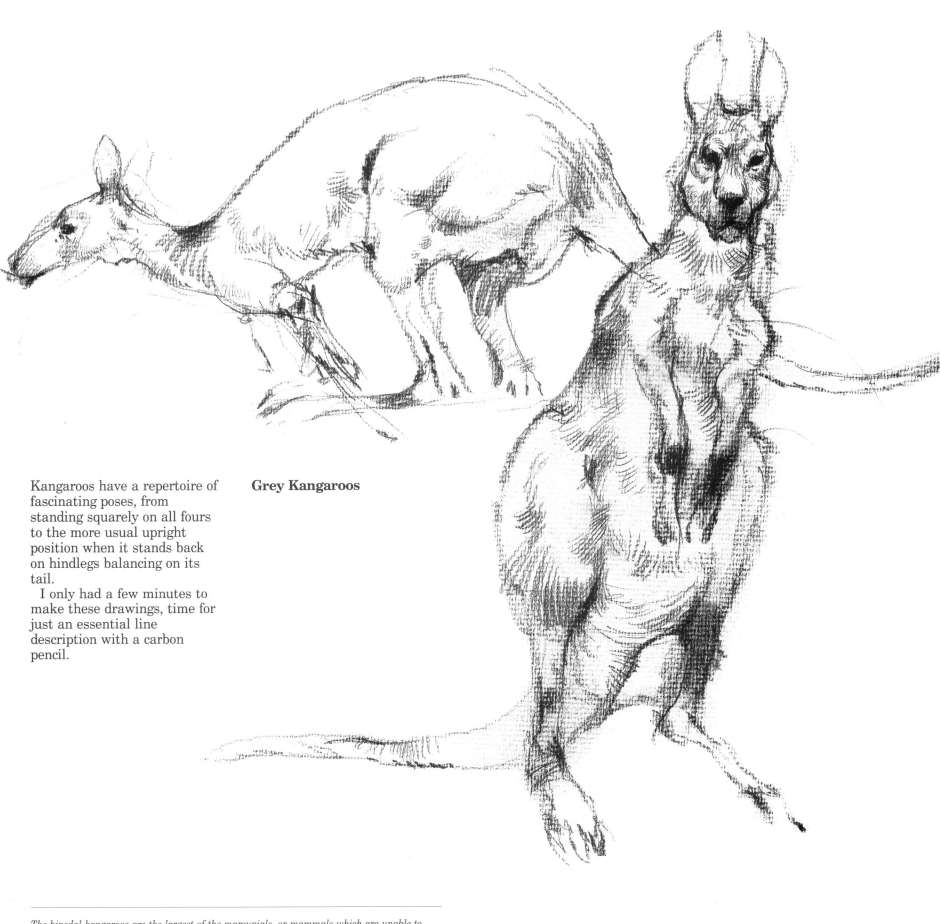

Kangaroos have a repertoire of fascinating poses, from standing squarely on all fours to the more usual upright position when it stands back on hindlegs balancing on its tail.

I only had a few minutes to make these drawings, time for just an essential line description with a carbon pencil.

Grey Kangaroos

The bipedal kangaroos are the largest of the marsupials, or mammals which are unable to nourish their young beyond the very earliest stages of gestation. This is due to the absence of a placenta within the womb. The young of kangaroos, or 'joeys', like those of other marsupials are therefore quite embryonic in appearance and must crawl into their mother's pouch after birth to remain attached to a teat during early development. In Australia they occupy a similar ecological niche to deer and antelope.

Their characteristic upward 'bounce' is achieved through elastic recoil of the Achilles tendon when it is stretched over the ankle as the foot hits the ground and the attached leg muscle contracts. This tendon works in the same way in all mammals but is especially efficient in the kangaroo when travelling at high speeds.

Although seen by earlier voyagers, it was only after it was seen in 1770 by Banks on Cook's expedition that the existence of this animal became widely believed.

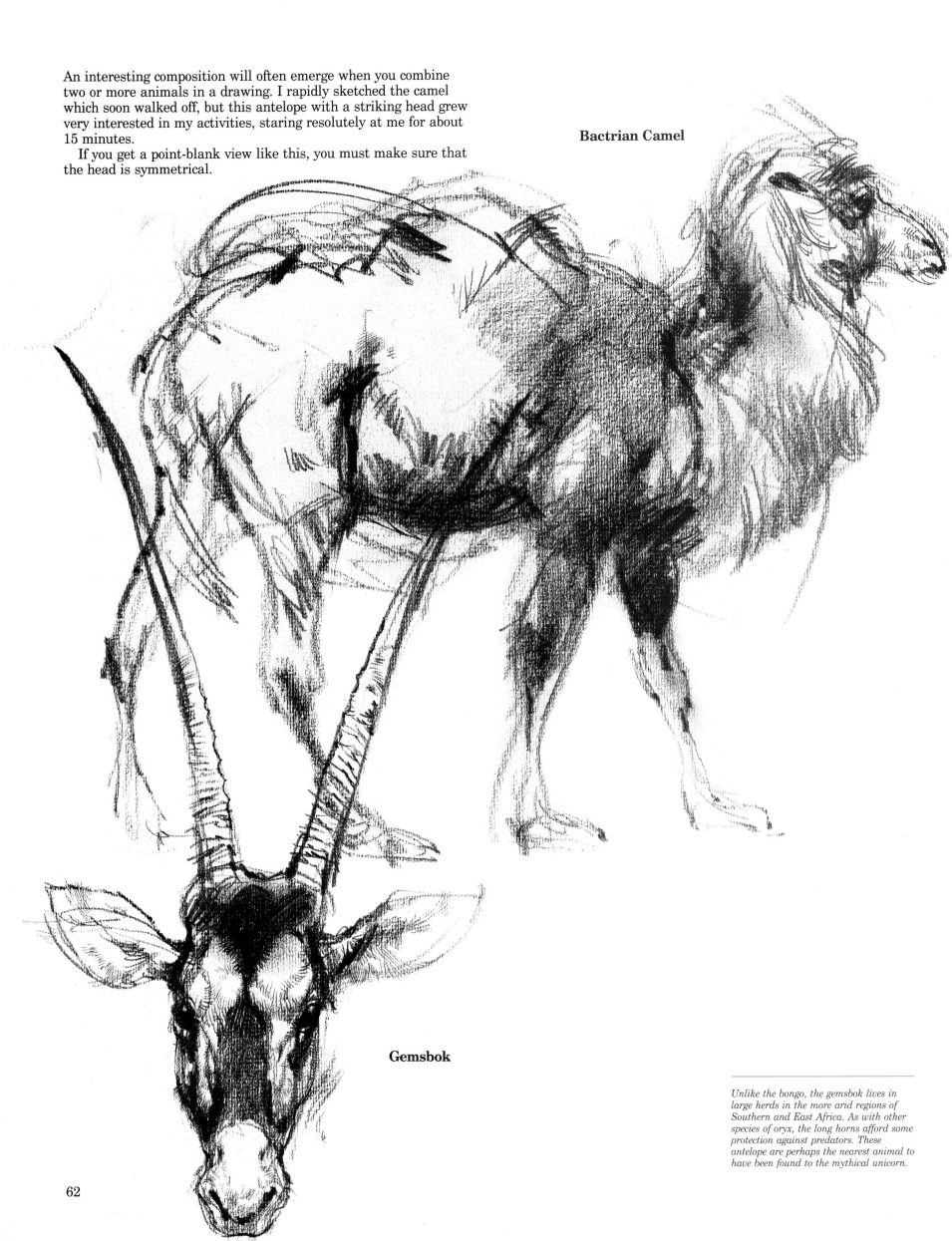

An interesting composition will often emerge when you combine two or more animals in a drawing. I rapidly sketched the camel which soon walked off, but this antelope with a striking head grew very interested in my activities, staring resolutely at me for about 15 minutes.

If you get a point-blank view like this, you must make sure that the head is symmetrical.

Bactrian Camel

Gemsbok

Unlike the bongo, the gemsbok lives in large herds in the more arid regions of Southern and East Africa. As with other species of oryx, the long horns afford some protection against predators. These antelope are perhaps the nearest animal to have been found to the mythical unicorn.

62

Roan Antelope

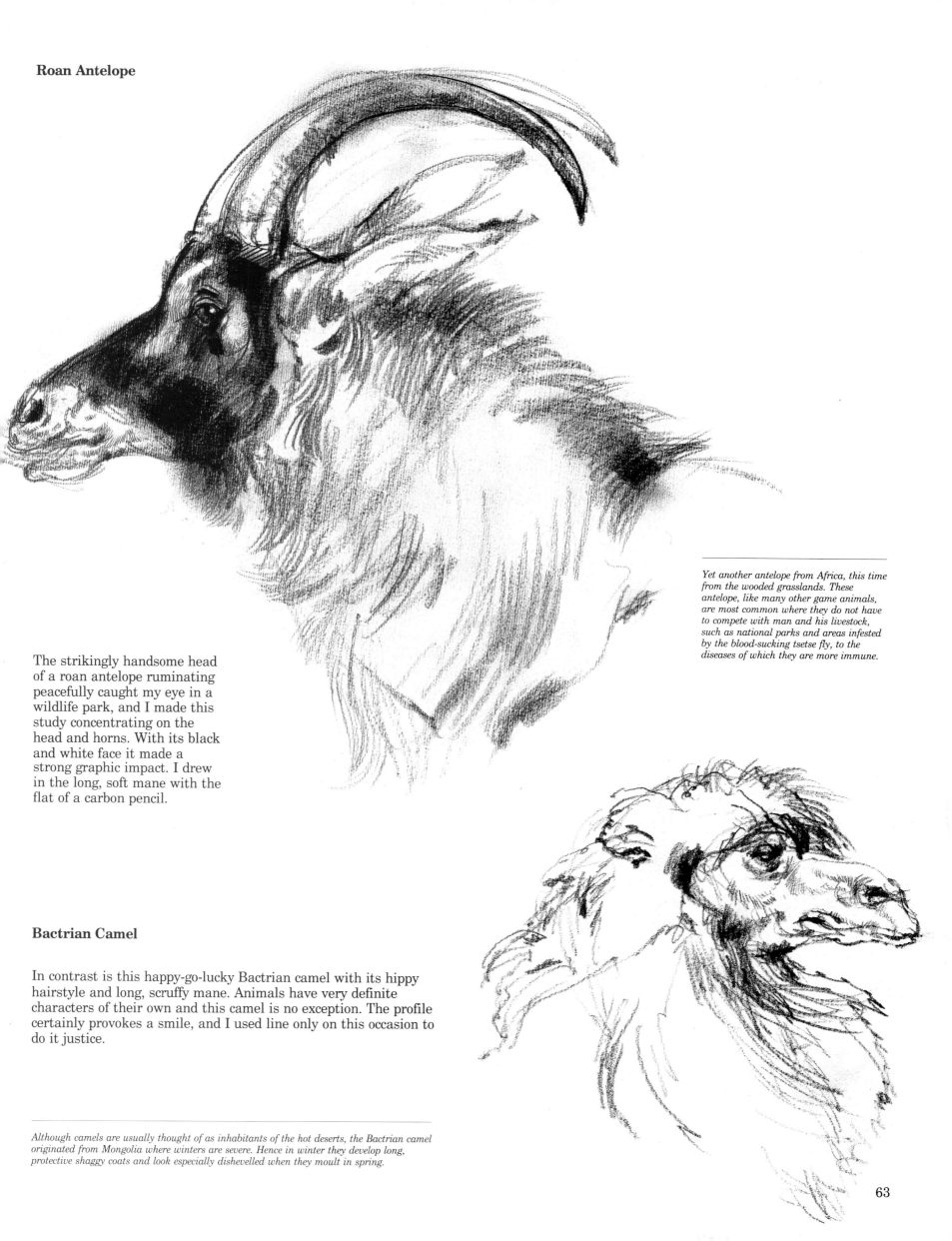

The strikingly handsome head of a roan antelope ruminating peacefully caught my eye in a wildlife park, and I made this study concentrating on the head and horns. With its black and white face it made a strong graphic impact. I drew in the long, soft mane with the flat of a carbon pencil.

Yet another antelope from Africa, this time from the wooded grasslands. These antelope, like many other game animals, are most common where they do not have to compete with man and his livestock, such as national parks and areas infested by the blood-sucking tsetse fly, to the diseases of which they are more immune.

Bactrian Camel

In contrast is this happy-go-lucky Bactrian camel with its hippy hairstyle and long, scruffy mane. Animals have very definite characters of their own and this camel is no exception. The profile certainly provokes a smile, and I used line only on this occasion to do it justice.

Although camels are usually thought of as inhabitants of the hot deserts, the Bactrian camel originated from Mongolia where winters are severe. Hence in winter they develop long, protective shaggy coats and look especially dishevelled when they moult in spring.

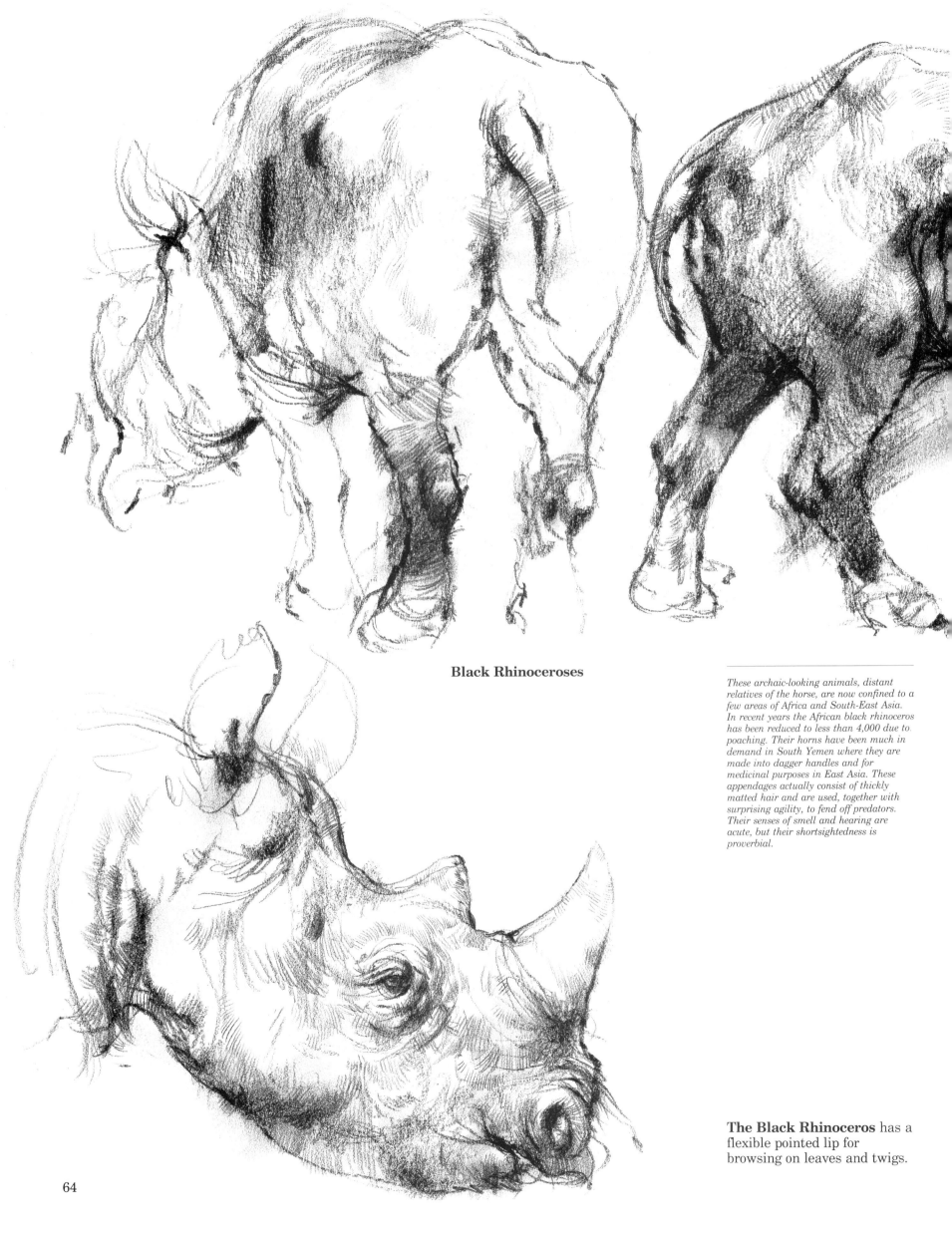

Black Rhinoceroses

These archaic-looking animals, distant
relatives of the horse, are now confined to a
few areas of Africa and South-East Asia.
In recent years the African black rhinoceros
has been reduced to less than 4,000 due to
poaching. Their horns have been much in
demand in South Yemen where they are
made into dagger handles and for
medicinal purposes in East Asia. These
appendages actually consist of thickly
matted hair and are used, together with
surprising agility, to fend off predators.
Their senses of smell and hearing are
acute, but their shortsightedness is
proverbial.

The Black Rhinoceros has a
flexible pointed lip for
browsing on leaves and twigs.

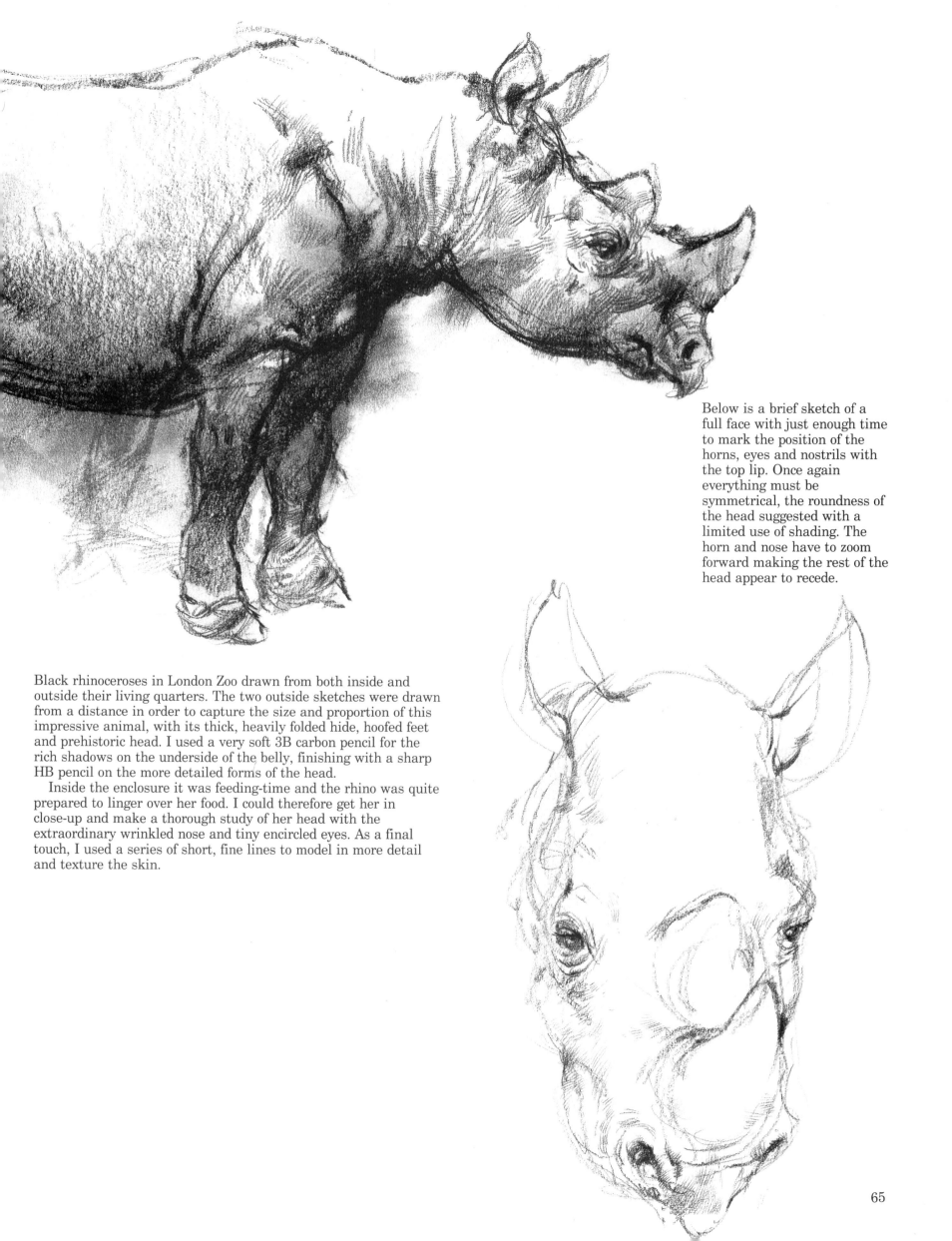

Below is a brief sketch of a full face with just enough time to mark the position of the horns, eyes and nostrils with the top lip. Once again everything must be symmetrical, the roundness of the head suggested with a limited use of shading. The horn and nose have to zoom forward making the rest of the head appear to recede.

Black rhinoceroses in London Zoo drawn from both inside and outside their living quarters. The two outside sketches were drawn from a distance in order to capture the size and proportion of this impressive animal, with its thick, heavily folded hide, hoofed feet and prehistoric head. I used a very soft 3B carbon pencil for the rich shadows on the underside of the belly, finishing with a sharp HB pencil on the more detailed forms of the head.

Inside the enclosure it was feeding-time and the rhino was quite prepared to linger over her food. I could therefore get her in close-up and make a thorough study of her head with the extraordinary wrinkled nose and tiny encircled eyes. As a final touch, I used a series of short, fine lines to model in more detail and texture the skin.

65

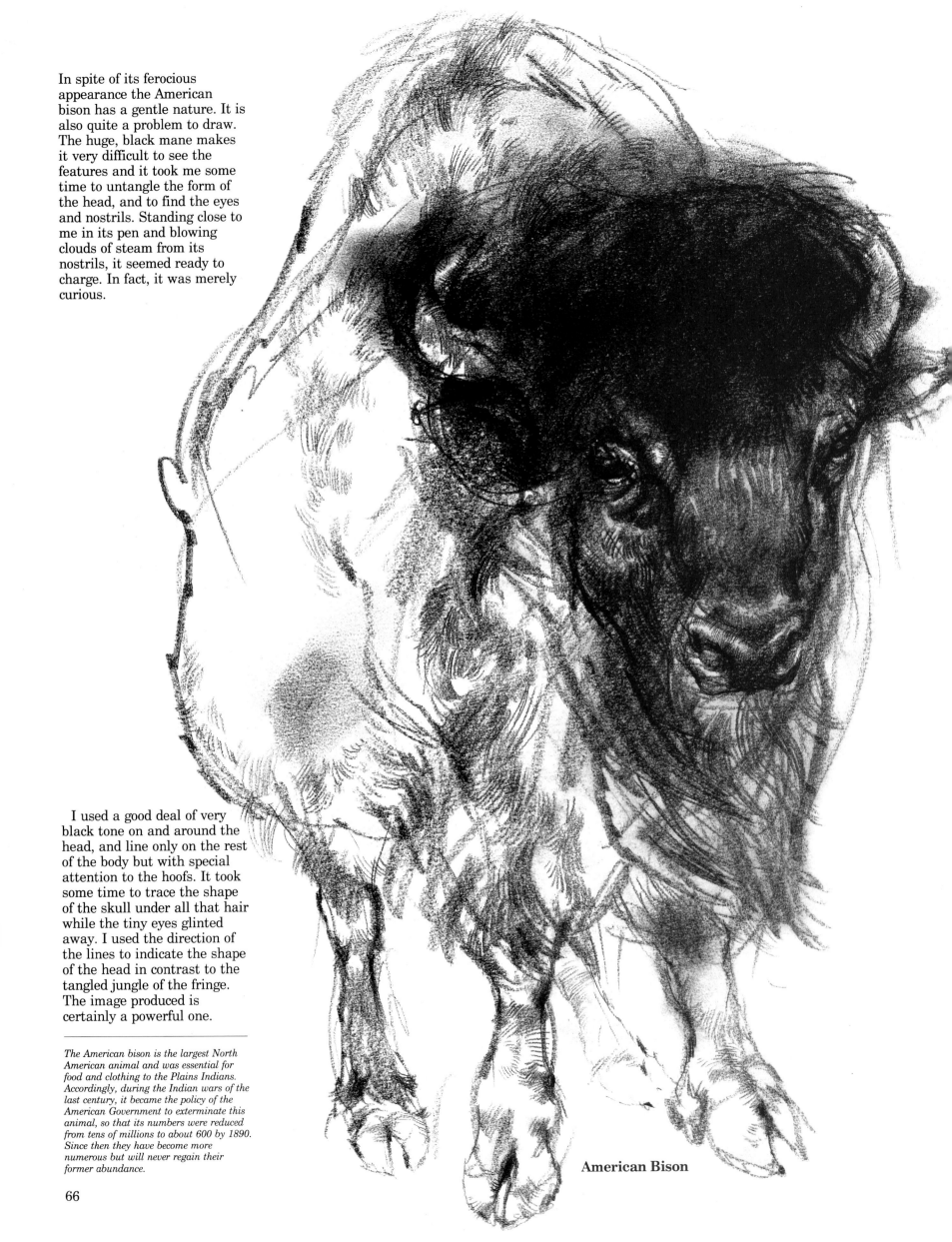

In spite of its ferocious appearance the American bison has a gentle nature. It is also quite a problem to draw. The huge, black mane makes it very difficult to see the features and it took me some time to untangle the form of the head, and to find the eyes and nostrils. Standing close to me in its pen and blowing clouds of steam from its nostrils, it seemed ready to charge. In fact, it was merely curious.

I used a good deal of very black tone on and around the head, and line only on the rest of the body but with special attention to the hoofs. It took some time to trace the shape of the skull under all that hair while the tiny eyes glinted away. I used the direction of the lines to indicate the shape of the head in contrast to the tangled jungle of the fringe. The image produced is certainly a powerful one.

The American bison is the largest North American animal and was essential for food and clothing to the Plains Indians. Accordingly, during the Indian wars of the last century, it became the policy of the American Government to exterminate this animal, so that its numbers were reduced from tens of millions to about 600 by 1890. Since then they have become more numerous but will never regain their former abundance.

American Bison

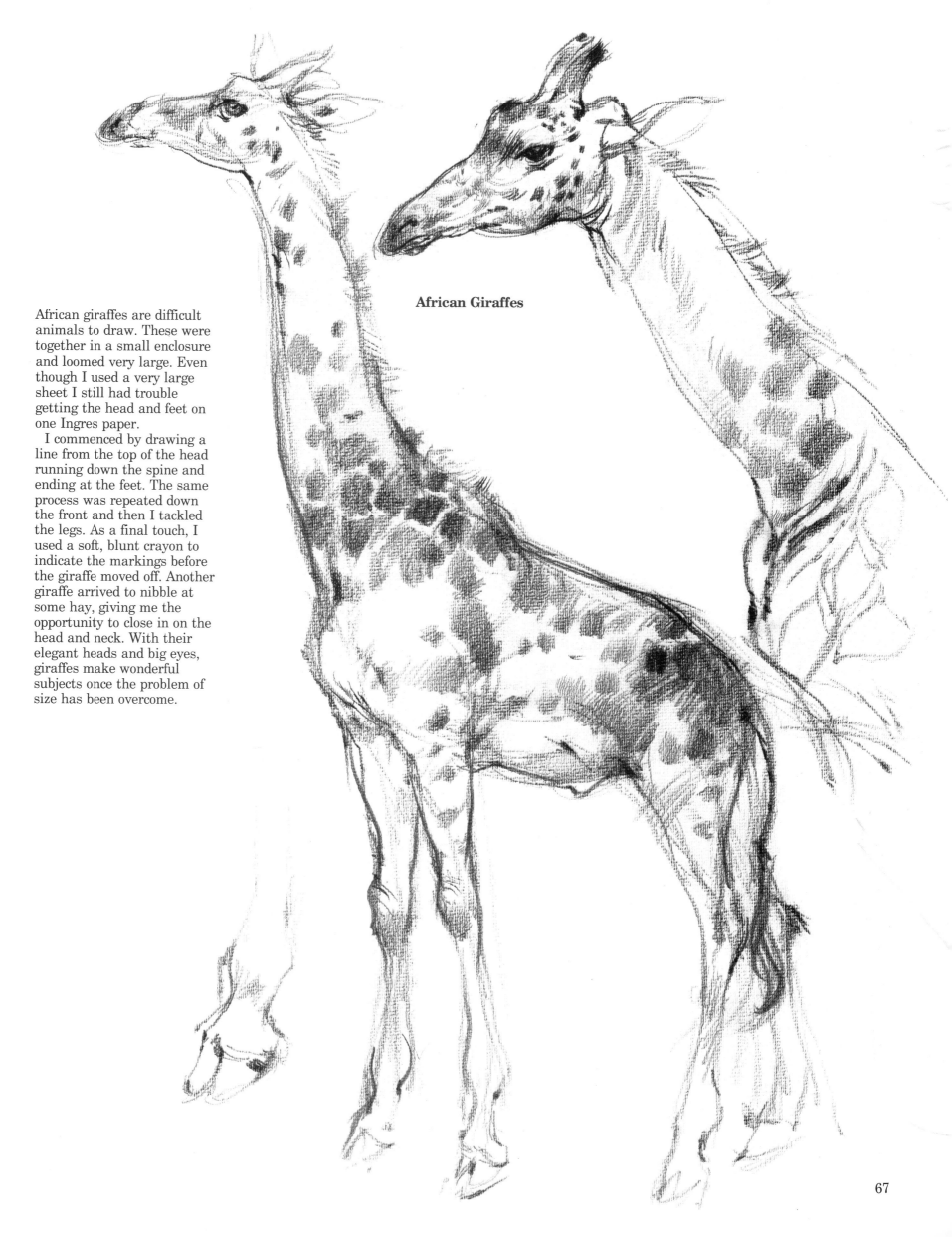

African Giraffes

African giraffes are difficult animals to draw. These were together in a small enclosure and loomed very large. Even though I used a very large sheet I still had trouble getting the head and feet on one Ingres paper.

I commenced by drawing a line from the top of the head running down the spine and ending at the feet. The same process was repeated down the front and then I tackled the legs. As a final touch, I used a soft, blunt crayon to indicate the markings before the giraffe moved off. Another giraffe arrived to nibble at some hay, giving me the opportunity to close in on the head and neck. With their elegant heads and big eyes, giraffes make wonderful subjects once the problem of size has been overcome.

It is nearly possible to construct a zebra out of stripes alone which almost seem to follow the forms.

When drawing zebras you have to be careful that the stripes do not run away with you. Try to ignore them and pretend that the animal has no such marking until you have tackled the main structural problems of the body, then draw in the head, neck and legs, checking for accuracy as you go. A zebra is more rounded than a horse, its legs are slightly shorter and its head with crested mane is most attractive. Now draw in the markings which are extremely decorative and make a strong graphic impact as well as clearly indicating the forms. I have made good use of the way in which the bold stripes sweep around the rump while other finer lines define delicate patterns around the head and legs. I used strong black tone and finer shading on top to indicate the diffused light coming from above.

Hartmann's Mountain Zebra

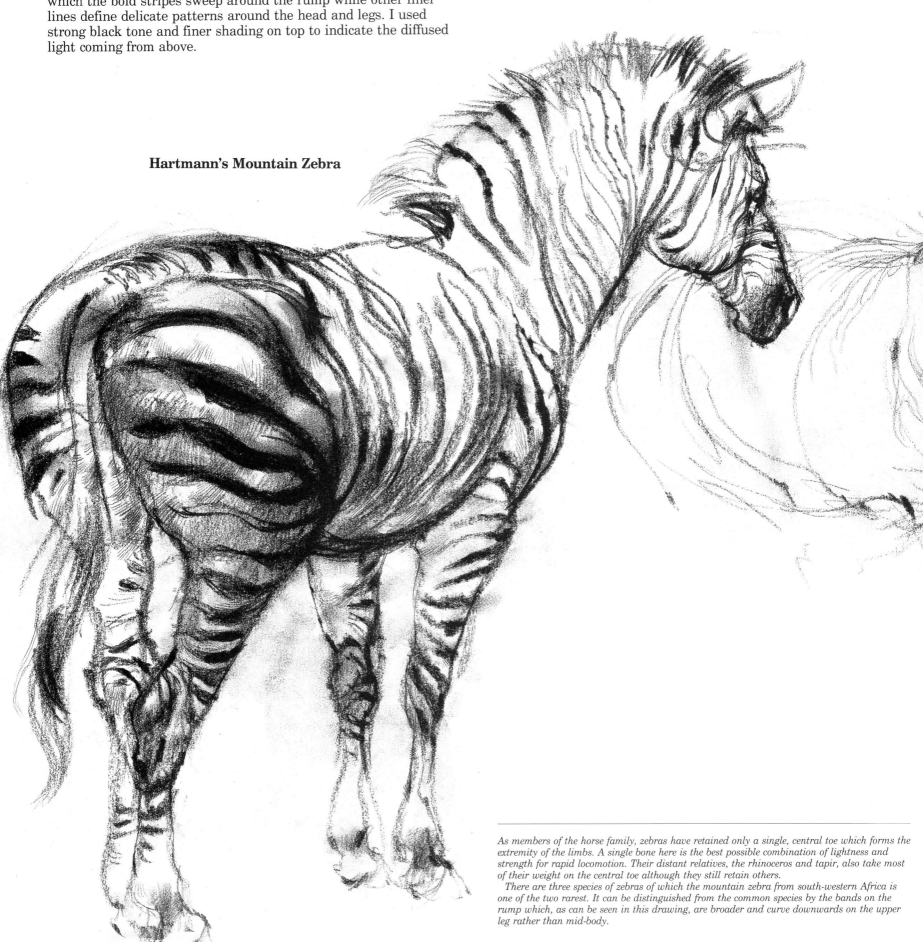

As members of the horse family, zebras have retained only a single, central toe which forms the extremity of the limbs. A single bone here is the best possible combination of lightness and strength for rapid locomotion. Their distant relatives, the rhinoceros and tapir, also take most of their weight on the central toe although they still retain others.

There are three species of zebras of which the mountain zebra from south-western Africa is one of the two rarest. It can be distinguished from the common species by the bands on the rump which, as can be seen in this drawing, are broader and curve downwards on the upper leg rather than mid-body.

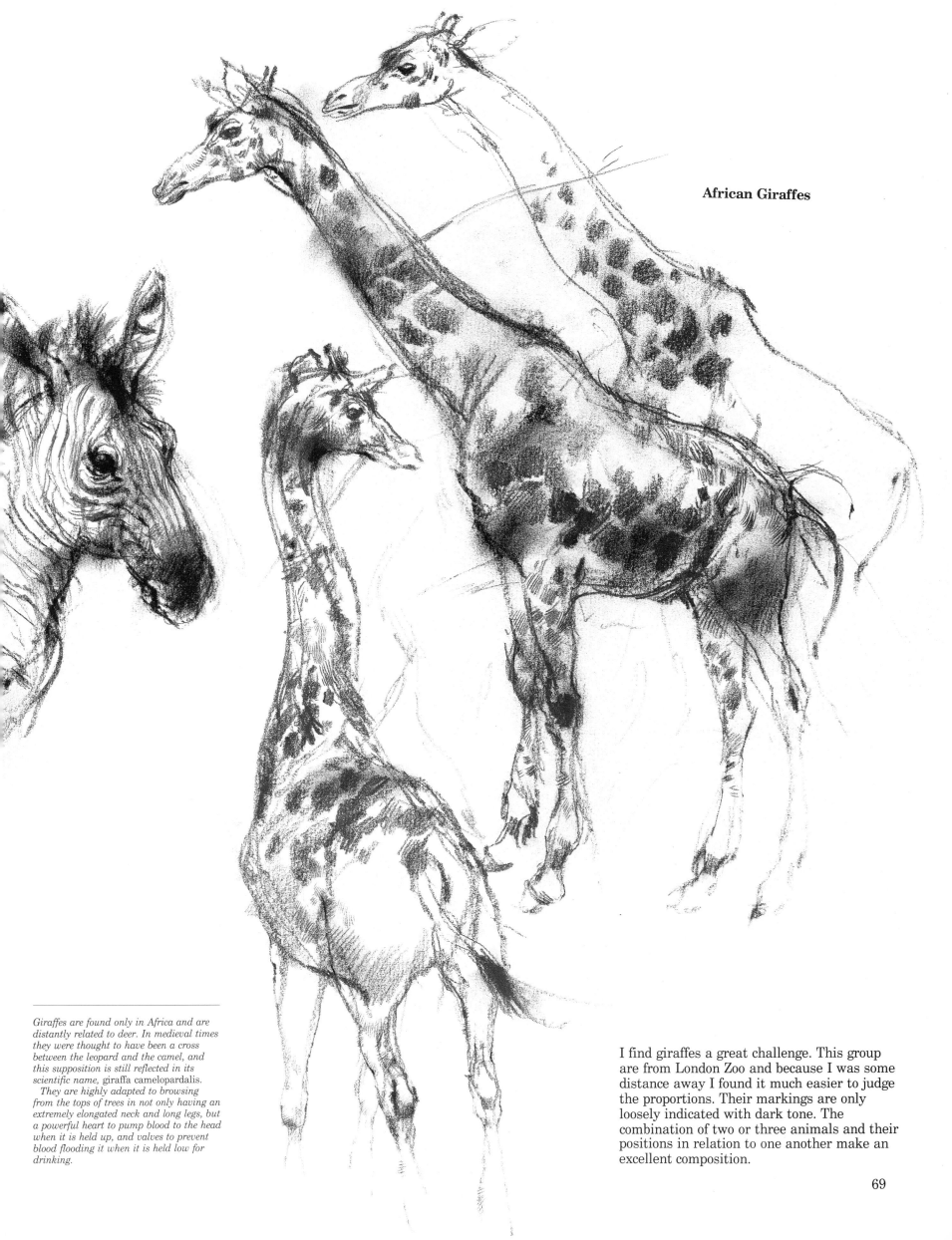

African Giraffes

Giraffes are found only in Africa and are distantly related to deer. In medieval times they were thought to have been a cross between the leopard and the camel, and this supposition is still reflected in its scientific name, giraffa camelopardalis.

They are highly adapted to browsing from the tops of trees in not only having an extremely elongated neck and long legs, but a powerful heart to pump blood to the head when it is held up, and valves to prevent blood flooding it when it is held low for drinking.

I find giraffes a great challenge. This group are from London Zoo and because I was some distance away I found it much easier to judge the proportions. Their markings are only loosely indicated with dark tone. The combination of two or three animals and their positions in relation to one another make an excellent composition.

69

Be sure to take a sketchpad with you wherever you go. I managed to draw these working camels in Tunisia, while they were resting in the sun. As soon as their driver saw me, however, he demanded some money. 'You take photographs, you pay!' 'Look, I have no camera', I said, waving my sketchbook and pencil. The driver pointed to the pencil that takes pictures. I went away and came back when he was on his prayer rug, facing towards Mecca, and I finished the drawings. I did pay him later though, to ride one of his camels out towards the Atlas mountains.

Scarcely any tone is used here, just lines. The blazing sun produced only small, sharp shadows on the undersides of the animals, but the shaggy fur provided fascinating texture. When the camels decided to lie down, they seemed to collapse in a heap, all hoofs disappearing from view. The finishing touch was provided by the profusion of rugs in a myriad vibrant colours.

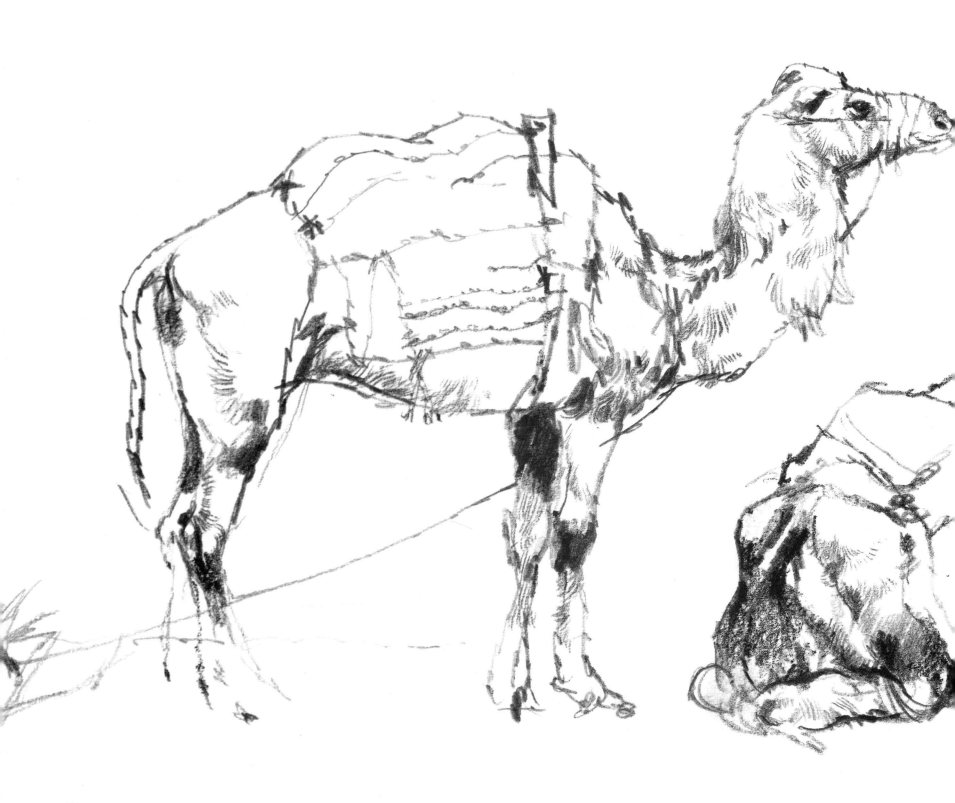

70

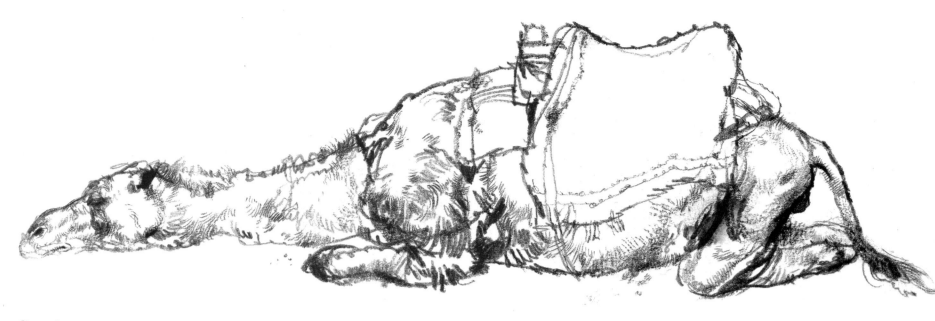

Camels

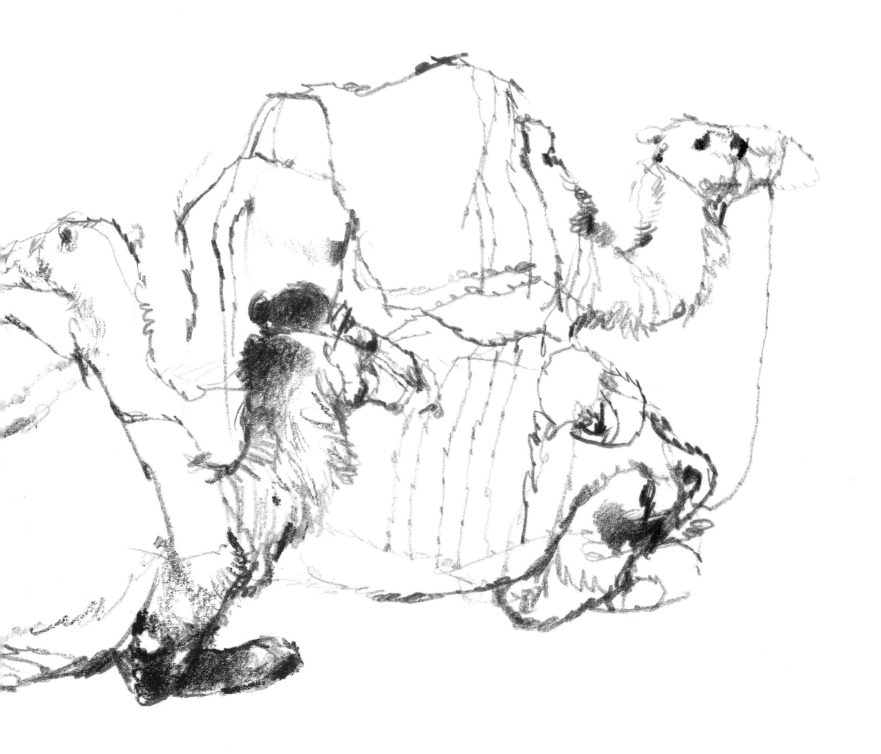

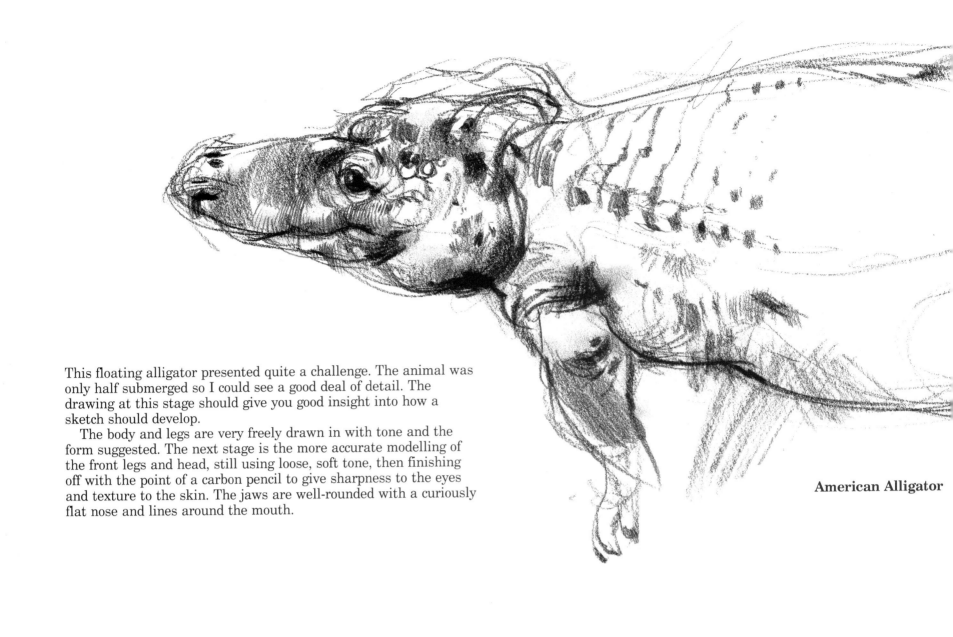

This floating alligator presented quite a challenge. The animal was only half submerged so I could see a good deal of detail. The drawing at this stage should give you good insight into how a sketch should develop.

The body and legs are very freely drawn in with tone and the form suggested. The next stage is the more accurate modelling of the front legs and head, still using loose, soft tone, then finishing off with the point of a carbon pencil to give sharpness to the eyes and texture to the skin. The jaws are well-rounded with a curiously flat nose and lines around the mouth.

American Alligator

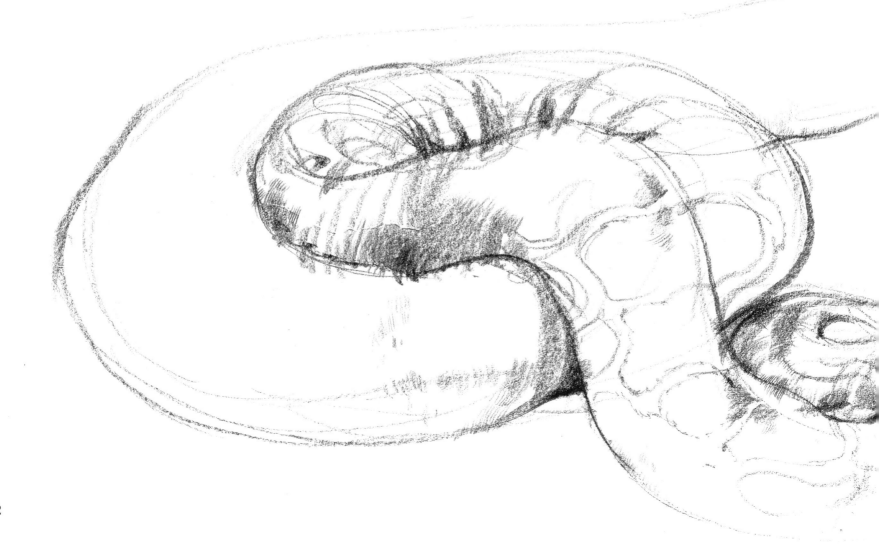

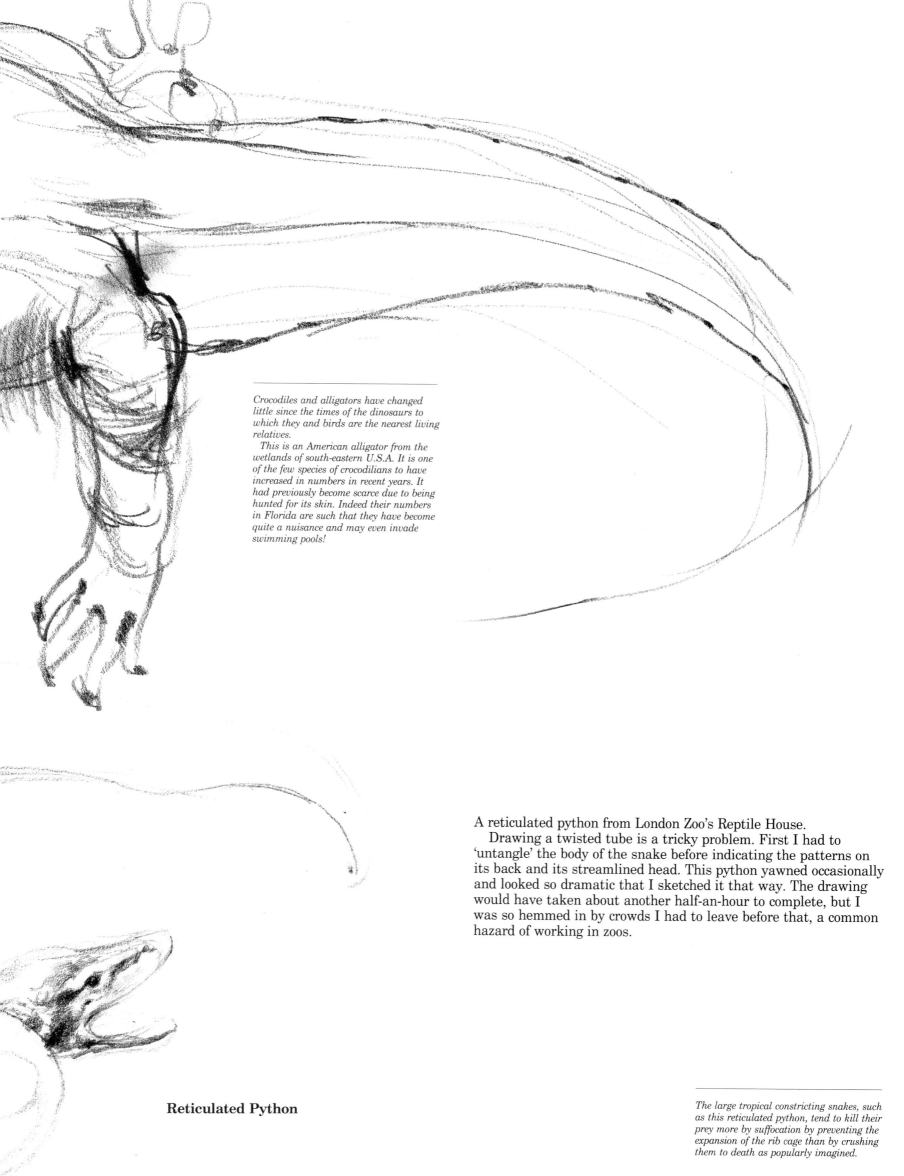

Crocodiles and alligators have changed
little since the times of the dinosaurs to
which they and birds are the nearest living
relatives.
 This is an American alligator from the
wetlands of south-eastern U.S.A. It is one
of the few species of crocodilians to have
increased in numbers in recent years. It
had previously become scarce due to being
hunted for its skin. Indeed their numbers
in Florida are such that they have become
quite a nuisance and may even invade
swimming pools!

A reticulated python from London Zoo's Reptile House.
 Drawing a twisted tube is a tricky problem. First I had to
'untangle' the body of the snake before indicating the patterns on
its back and its streamlined head. This python yawned occasionally
and looked so dramatic that I sketched it that way. The drawing
would have taken about another half-an-hour to complete, but I
was so hemmed in by crowds I had to leave before that, a common
hazard of working in zoos.

Reticulated Python

The large tropical constricting snakes, such
as this reticulated python, tend to kill their
prey more by suffocation by preventing the
expansion of the rib cage than by crushing
them to death as popularly imagined.

73

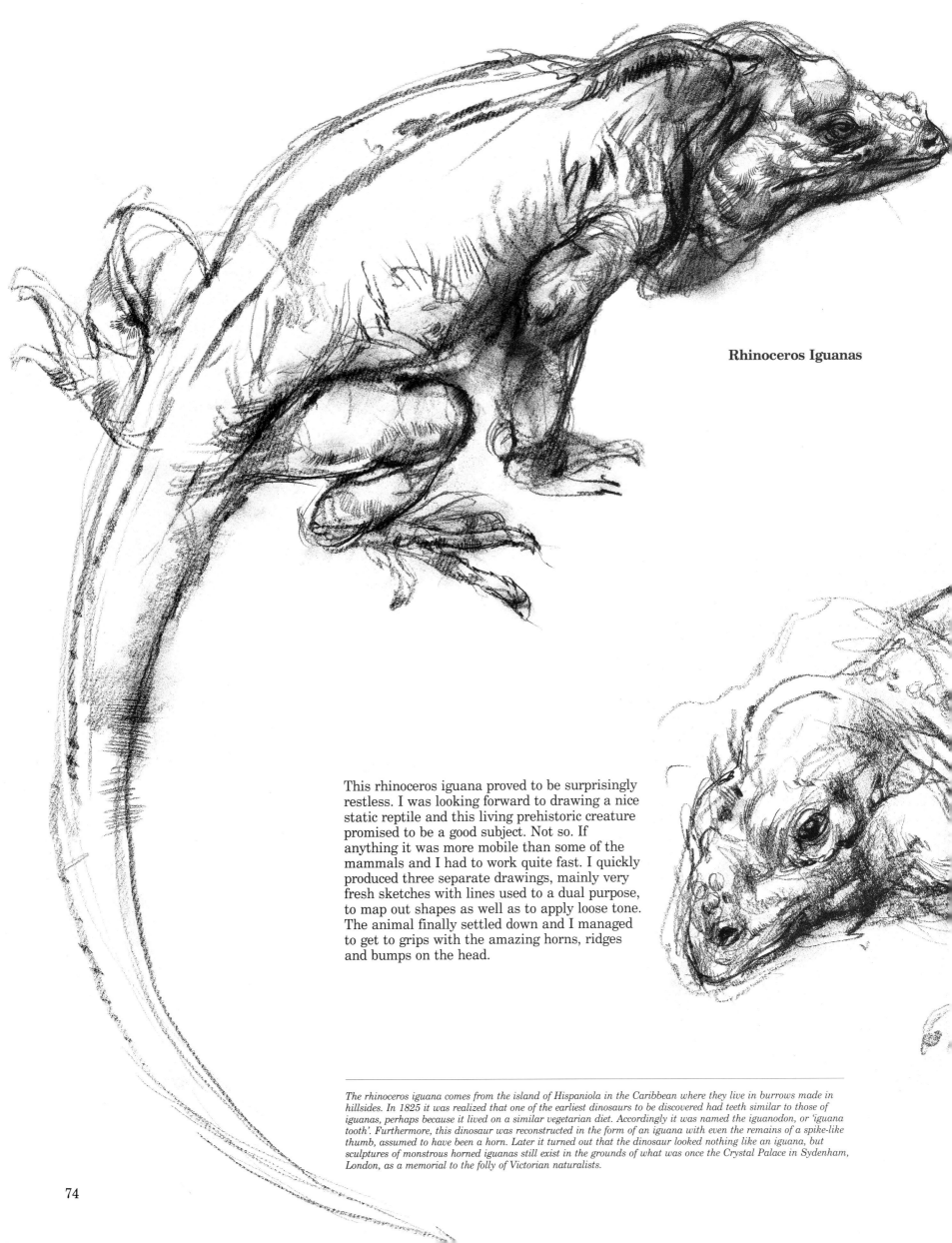

Rhinoceros Iguanas

This rhinoceros iguana proved to be surprisingly restless. I was looking forward to drawing a nice static reptile and this living prehistoric creature promised to be a good subject. Not so. If anything it was more mobile than some of the mammals and I had to work quite fast. I quickly produced three separate drawings, mainly very fresh sketches with lines used to a dual purpose, to map out shapes as well as to apply loose tone. The animal finally settled down and I managed to get to grips with the amazing horns, ridges and bumps on the head.

The rhinoceros iguana comes from the island of Hispaniola in the Caribbean where they live in burrows made in hillsides. In 1825 it was realized that one of the earliest dinosaurs to be discovered had teeth similar to those of iguanas, perhaps because it lived on a similar vegetarian diet. Accordingly it was named the iguanodon, or 'iguana tooth'. Furthermore, this dinosaur was reconstructed in the form of an iguana with even the remains of a spike-like thumb, assumed to have been a horn. Later it turned out that the dinosaur looked nothing like an iguana, but sculptures of monstrous horned iguanas still exist in the grounds of what was once the Crystal Palace in Sydenham, London, as a memorial to the folly of Victorian naturalists.

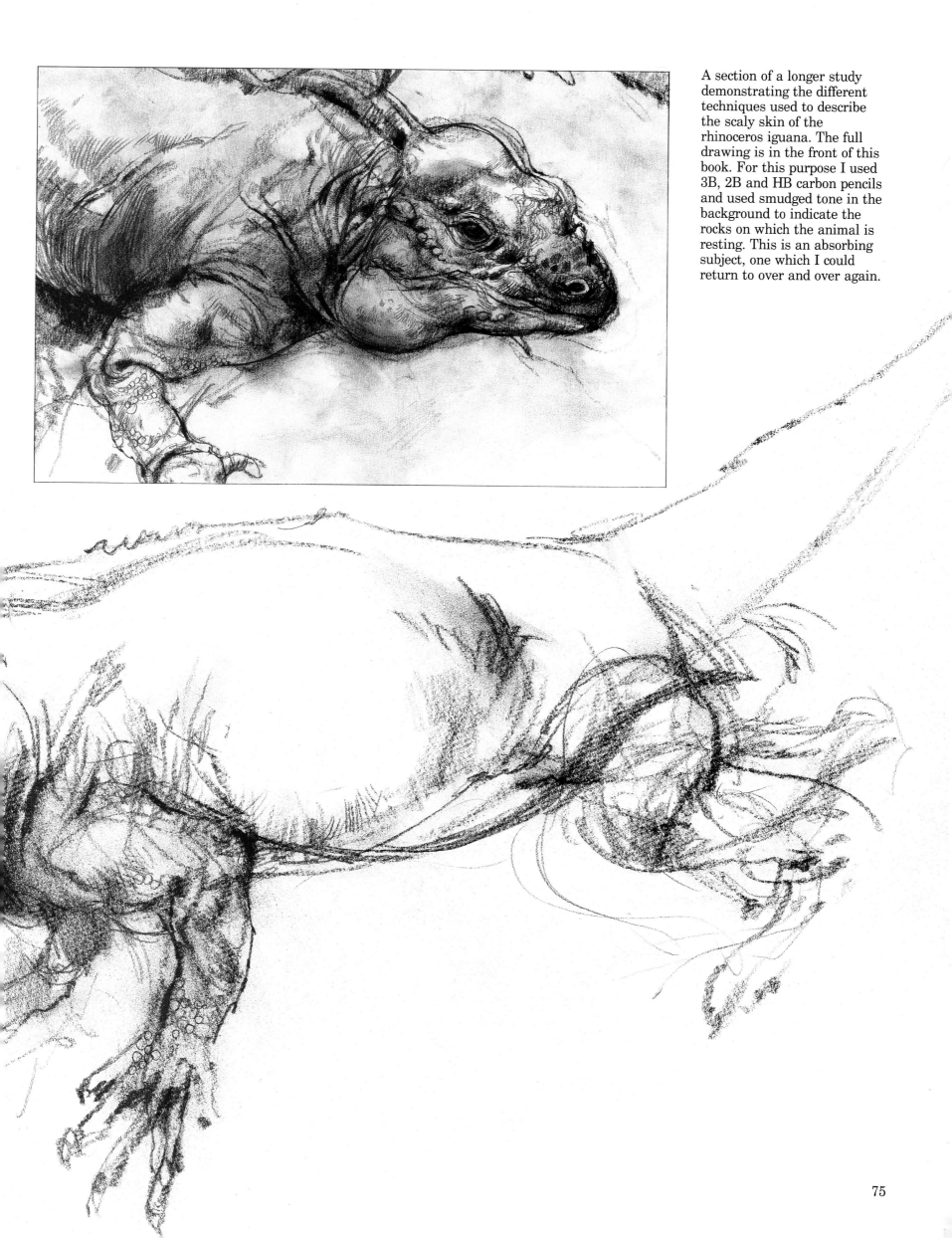

A section of a longer study demonstrating the different techniques used to describe the scaly skin of the rhinoceros iguana. The full drawing is in the front of this book. For this purpose I used 3B, 2B and HB carbon pencils and used smudged tone in the background to indicate the rocks on which the animal is resting. This is an absorbing subject, one which I could return to over and over again.

Fish

Now for something completely different, as the saying goes. In the
half-light of the aquarium I could not resist the elegant and exotic
shapes floating around me. Fish are beautiful but difficult to draw.
The first problem is to get all the different outline shapes right.
Try to suggest glossy, slim bodies or bulging, heavy flat ones with
fine flowing lines. Get the delicate fins and tails right before
drawing in the huge eyes.

The variety of their markings is enormous and the colours sensational. You could spend weeks looking at nothing else. They certainly provided a complete contrast to any creature I had drawn before – no ruffled feathers or shaggy coat to help me out here. It had to be an exercise in pure line drawing.

The collection of fish on this page gives the feel of a teeming aquarium, almost a pattern in the abstract.

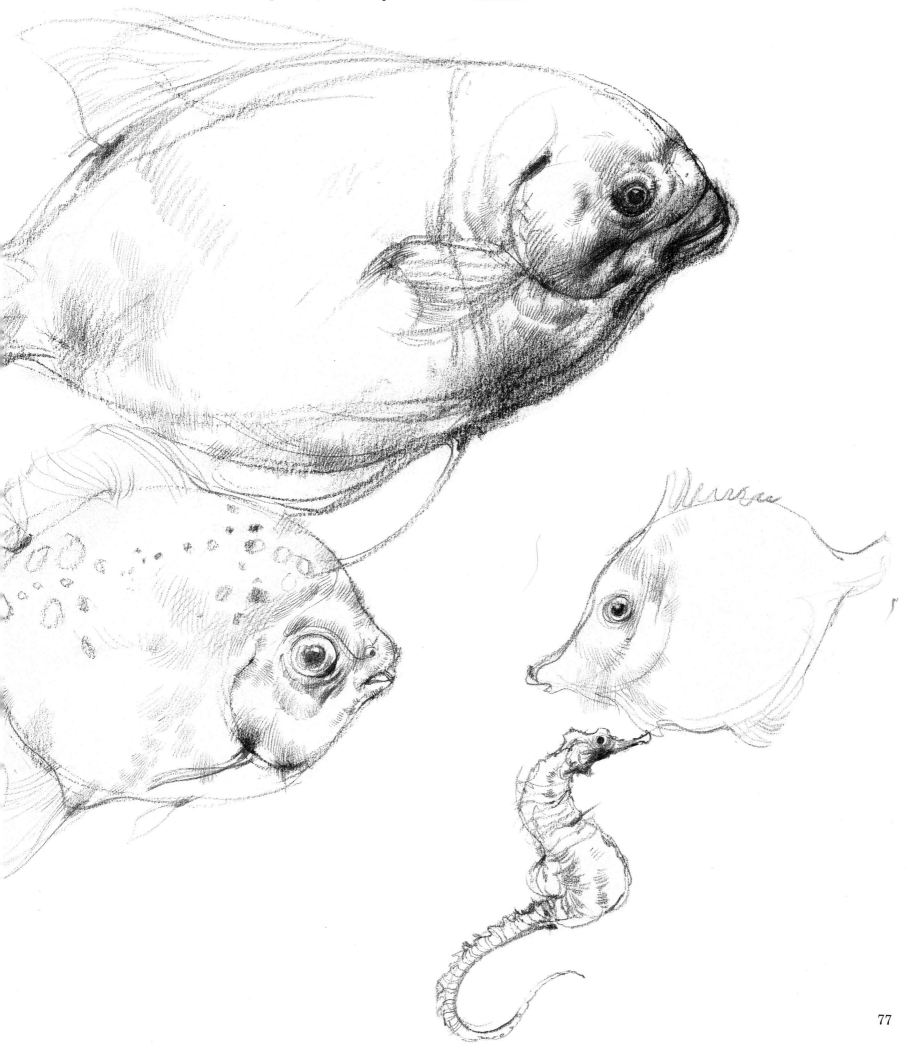

Domestic Animals

Domestic animals and pets are all around us and make rewarding subjects. They can, however, be just as difficult to draw as any animal in the wild.

I had to keep following this beautiful cat Toby around. He just would not stay still for me to draw him. Basically he is a bundle of fur with a nice head and expressive eyes, therefore I merely indicated the body with free outline, but concentrated on the head with its distinct stripes. I also tried to avoid hard lines and thereby give a feeling of softness to the drawings. A well textured paper also helped to create this quality.

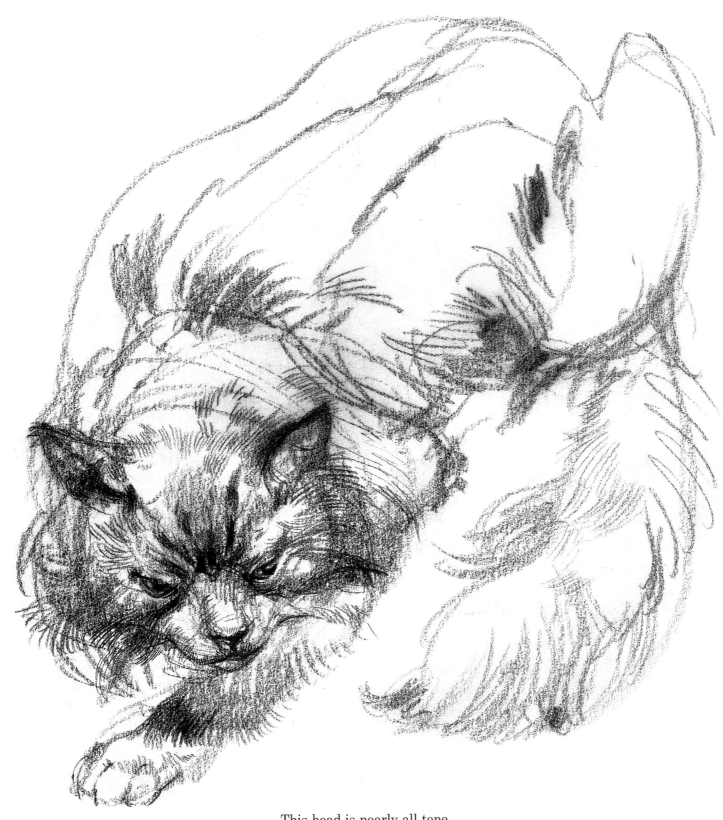

This head is nearly all tone with a limited amount of linear drawing around the eyes and nose. It also shows the effect paper texture can have on your work, in this case, softening it.

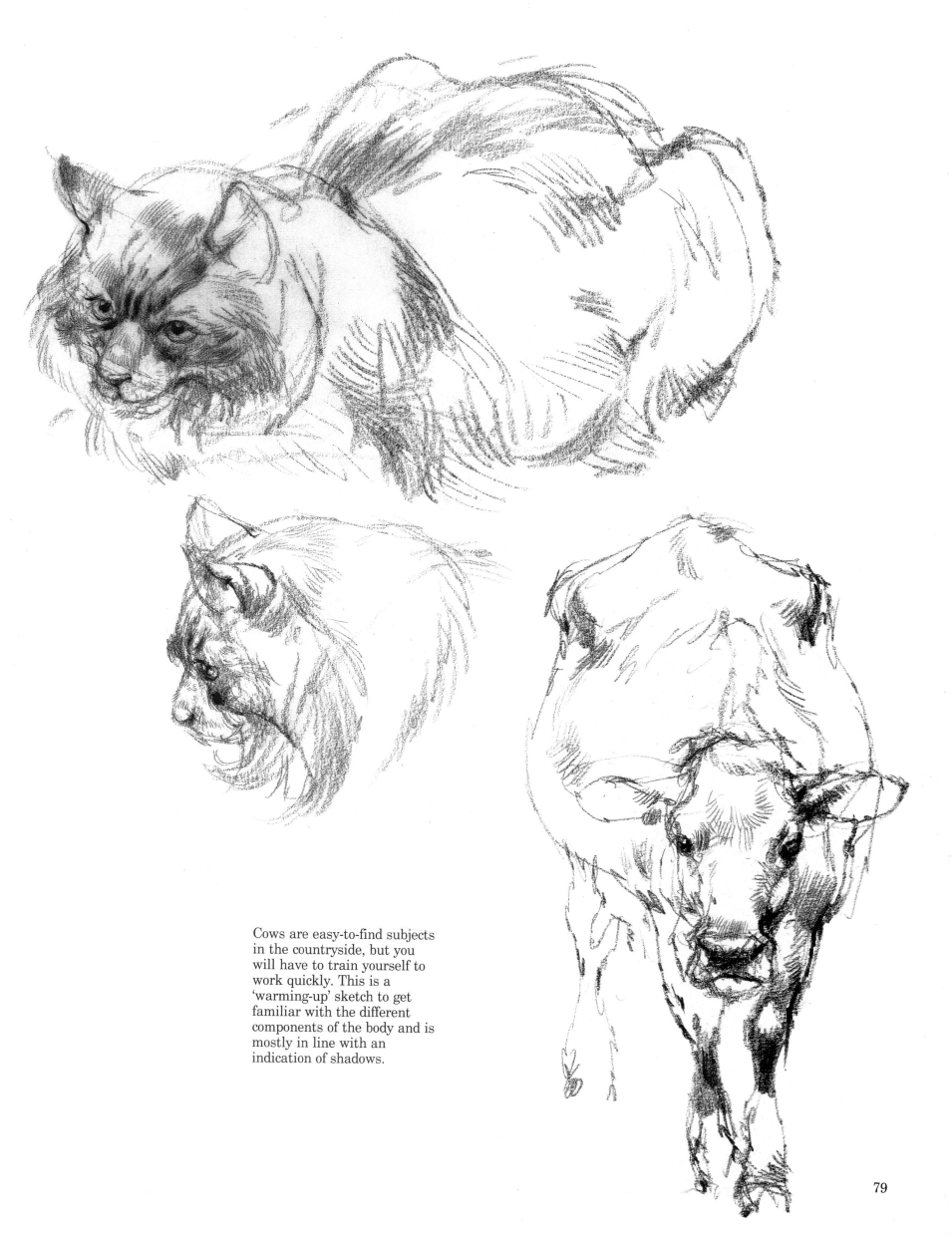

Cows are easy-to-find subjects in the countryside, but you will have to train yourself to work quickly. This is a 'warming-up' sketch to get familiar with the different components of the body and is mostly in line with an indication of shadows.

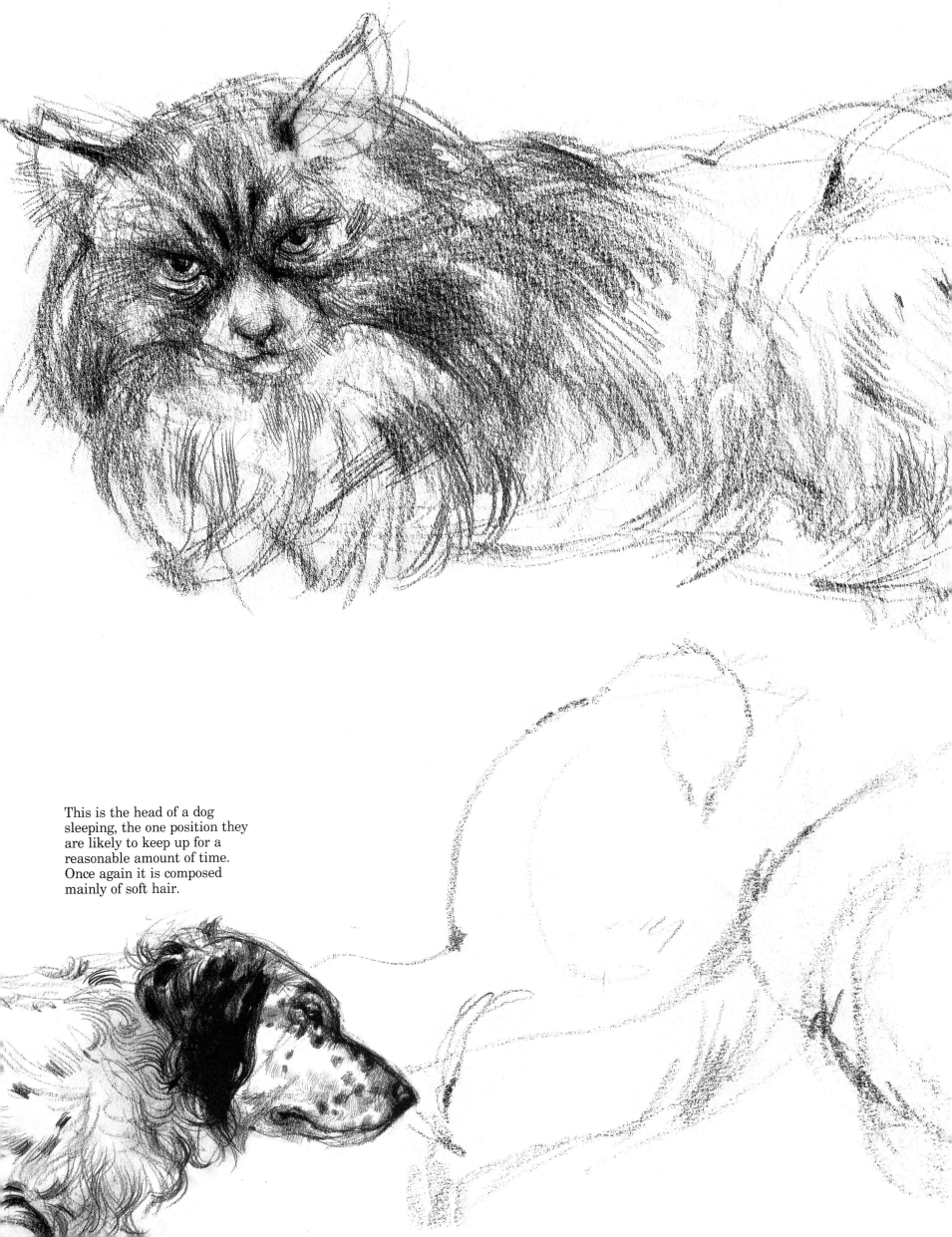

This is the head of a dog sleeping, the one position they are likely to keep up for a reasonable amount of time. Once again it is composed mainly of soft hair.

More soft cats moving about or lying about. Cats have a penetrating gaze not unlike that of the big cats. Even their profiles remind me of the head of a tiger. I had fun and games with this particular cat; at times I was drawing on my hands and knees under a table. Toby does not belong to me and consequently regarded me with suspicion, moving away whenever I became too involved. Hence, a number of 'active' sketches.

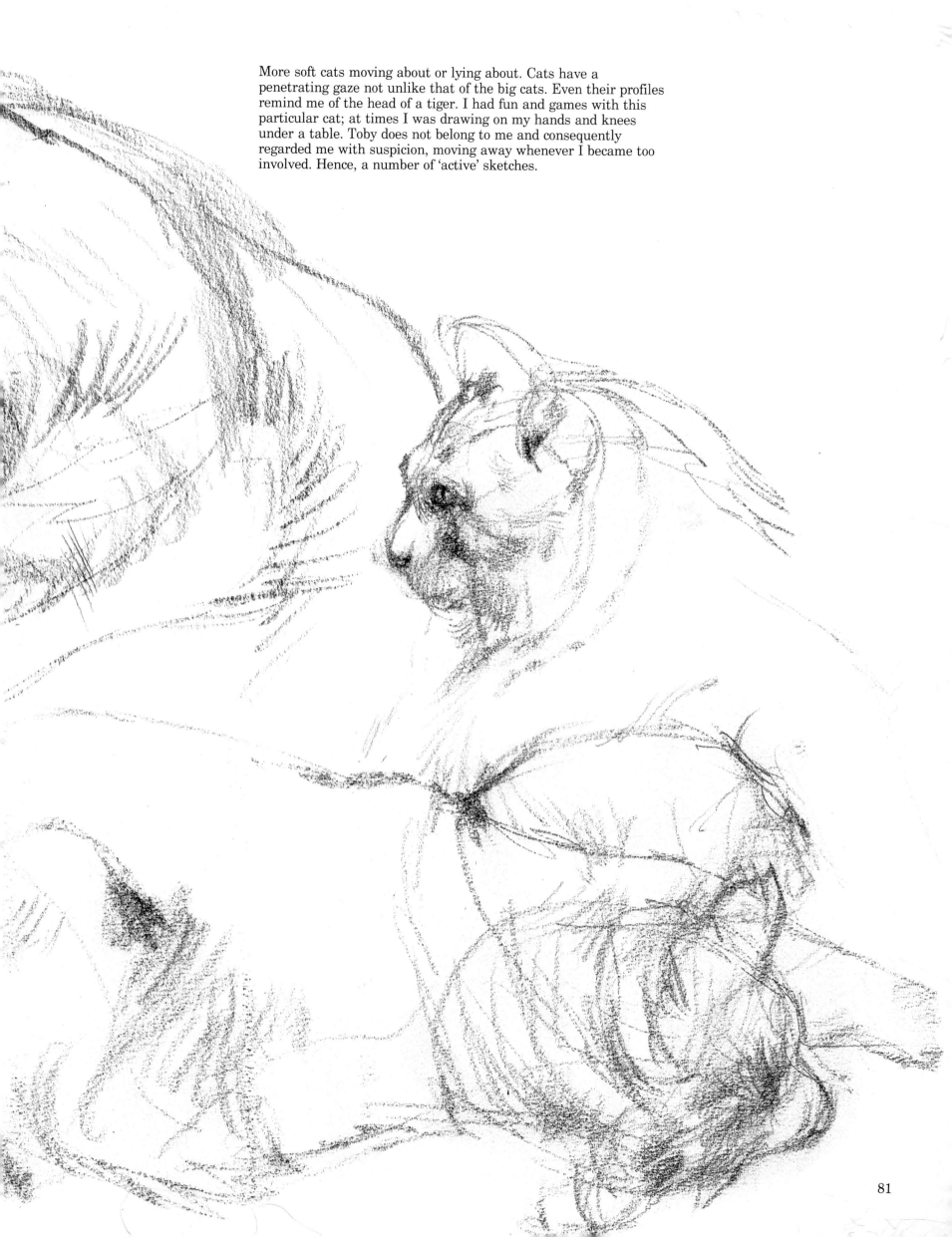

A group of cows having a siesta not far from my house. A nice combination of mothers and calves, either standing or sitting. Mixing up the sketches has the interesting effect of bringing your paper to life. The cows put up with me for some time, but then began to fear for their calves and to object, causing me to beat a hasty retreat.

The bulk of the animals is again all-important, heads and feet being the last additions where I used more descriptive shading. Cows are extremely inquisitive and will puzzle over anything unusual such as a man with a drawing board. You can turn this to your own advantage when looking for 'models'.

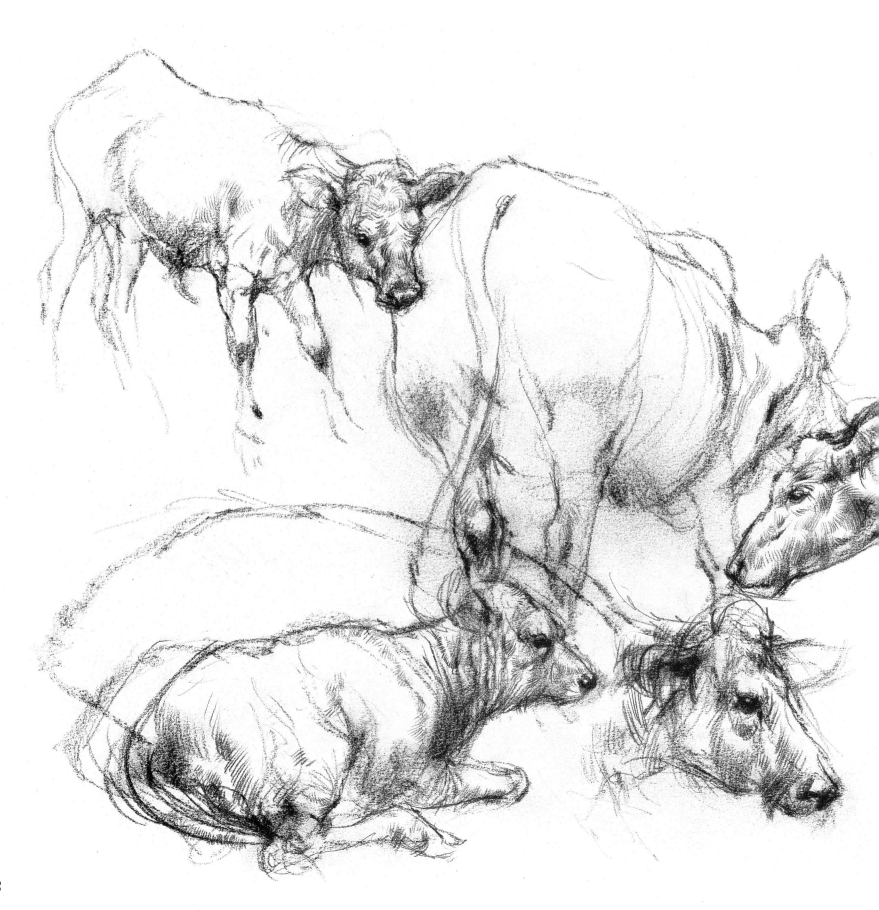

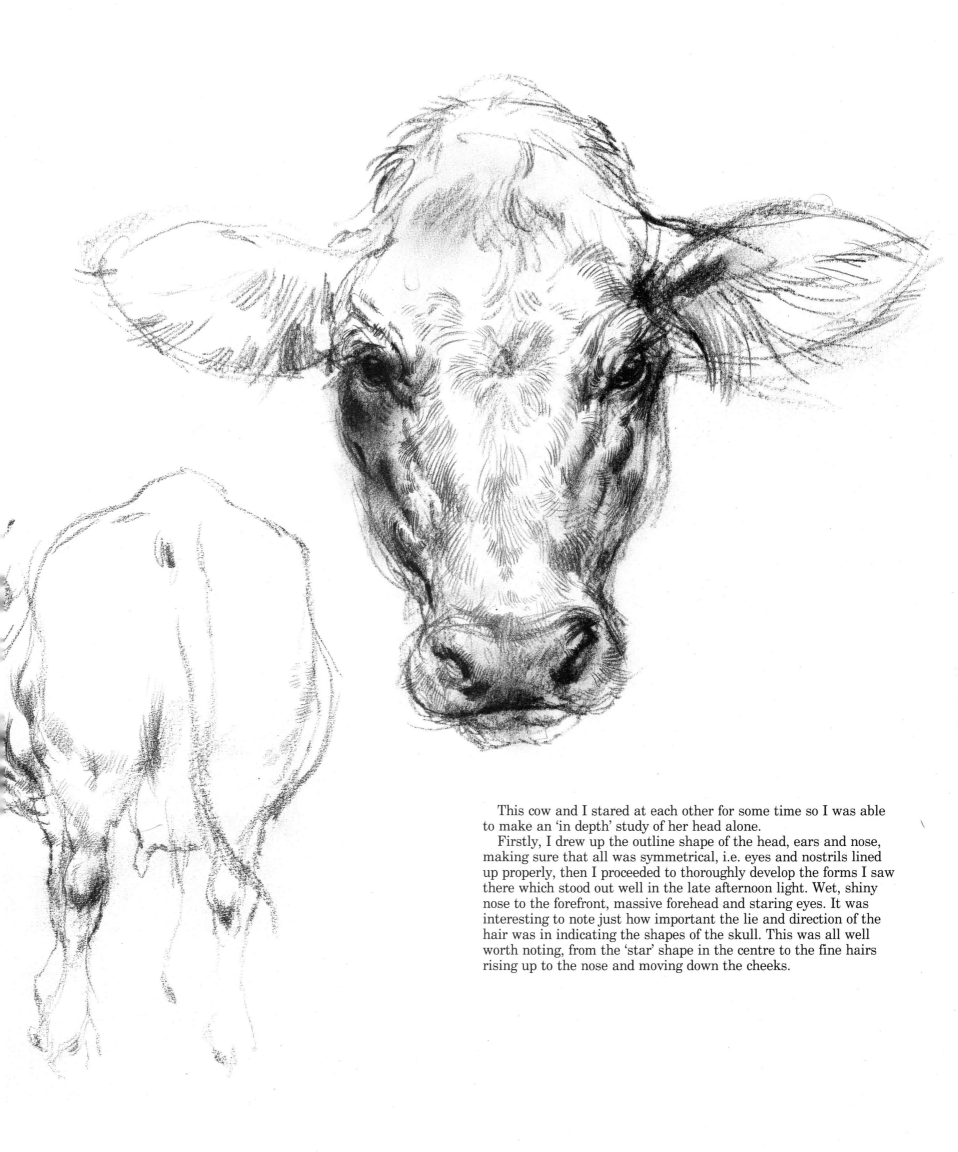

This cow and I stared at each other for some time so I was able to make an 'in depth' study of her head alone.

Firstly, I drew up the outline shape of the head, ears and nose, making sure that all was symmetrical, i.e. eyes and nostrils lined up properly, then I proceeded to thoroughly develop the forms I saw there which stood out well in the late afternoon light. Wet, shiny nose to the forefront, massive forehead and staring eyes. It was interesting to note just how important the lie and direction of the hair was in indicating the shapes of the skull. This was all well worth noting, from the 'star' shape in the centre to the fine hairs rising up to the nose and moving down the cheeks.

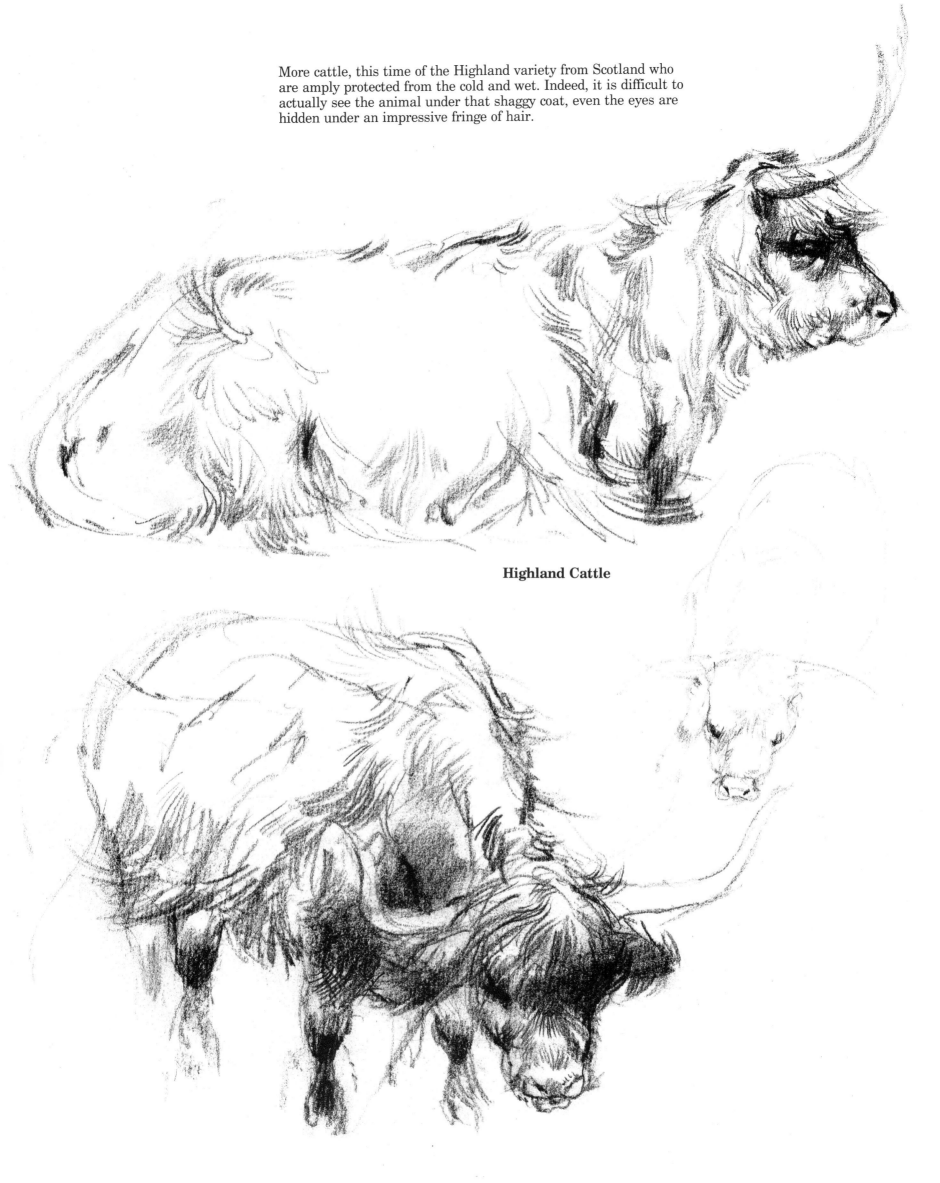

More cattle, this time of the Highland variety from Scotland who are amply protected from the cold and wet. Indeed, it is difficult to actually see the animal under that shaggy coat, even the eyes are hidden under an impressive fringe of hair.

Highland Cattle

Horses are also frequently seen in the country, this little pony being a friend's pet. Its lovely little face, full of character, and decorative black and white markings made it an ideal subject needing a lot of rich tone to do it justice. With its shaggy mane and long coat, it was a favourite subject of mine. It did not like to stand still and had to be held for this drawing.

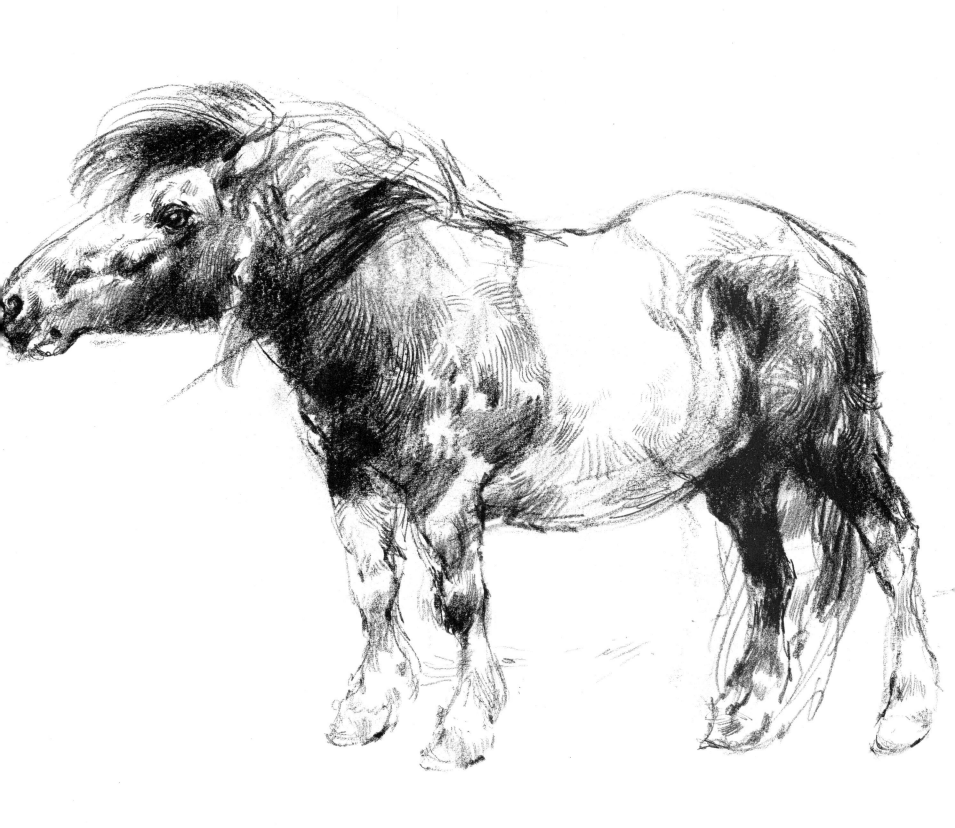

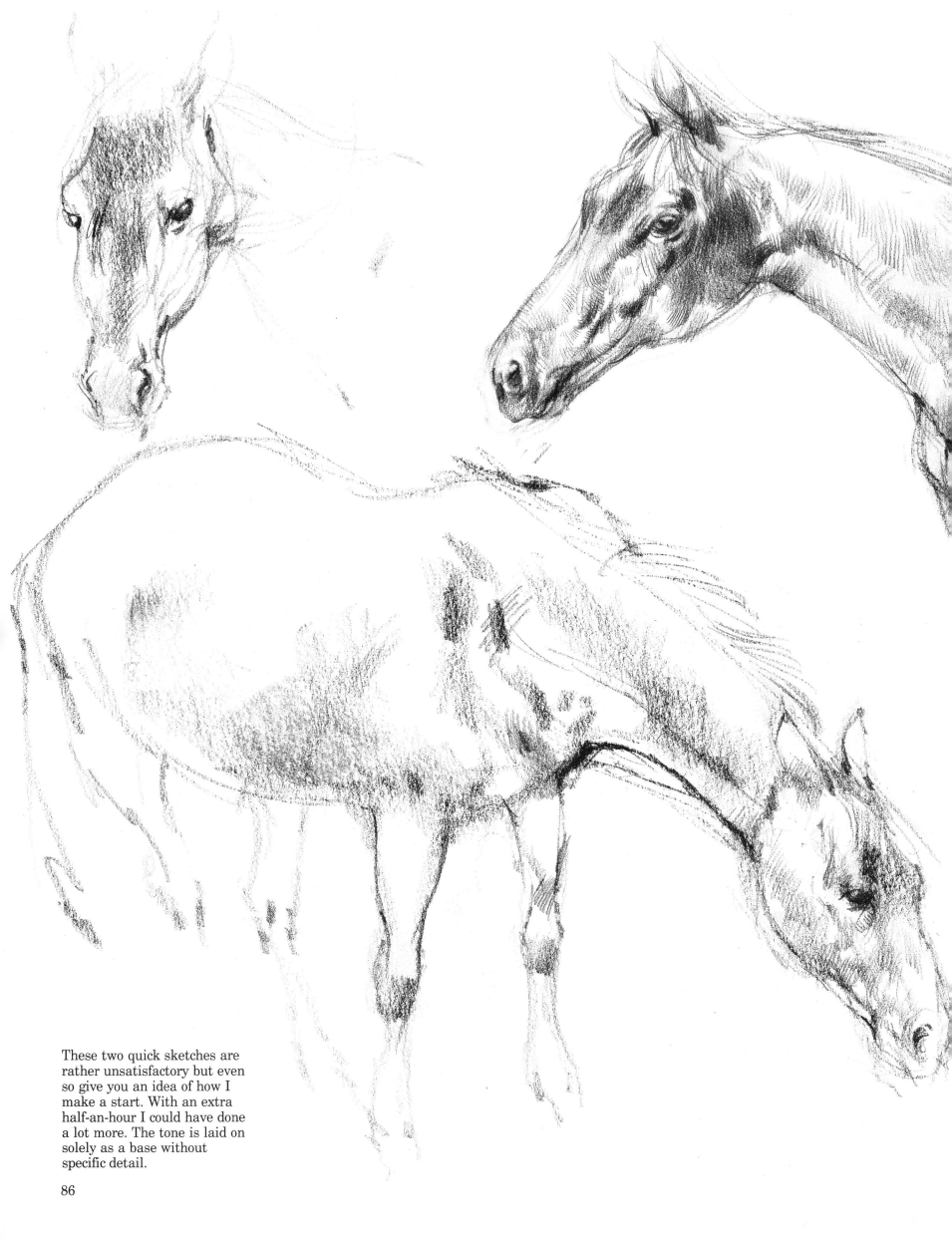

These two quick sketches are rather unsatisfactory but even so give you an idea of how I make a start. With an extra half-an-hour I could have done a lot more. The tone is laid on solely as a base without specific detail.

Finished study of a good quality horse with a fine head drawn on a friend's stud farm. I started off by making three drawings of two horses in a barn, switching from one to the other as each horse came back into the right position. With a little patience I actually managed to finish all three.

Like all animals, horses are creatures of habit and will return to the right place if you are prepared to wait. If you try to work on three drawings simultaneously the chances are that you will not be left standing around for long.

When you draw a really good horse you will be struck by the way in which the glossy coat highlights the rippling muscles, which calls for a lot of 'elbow grease' when it comes to shading.

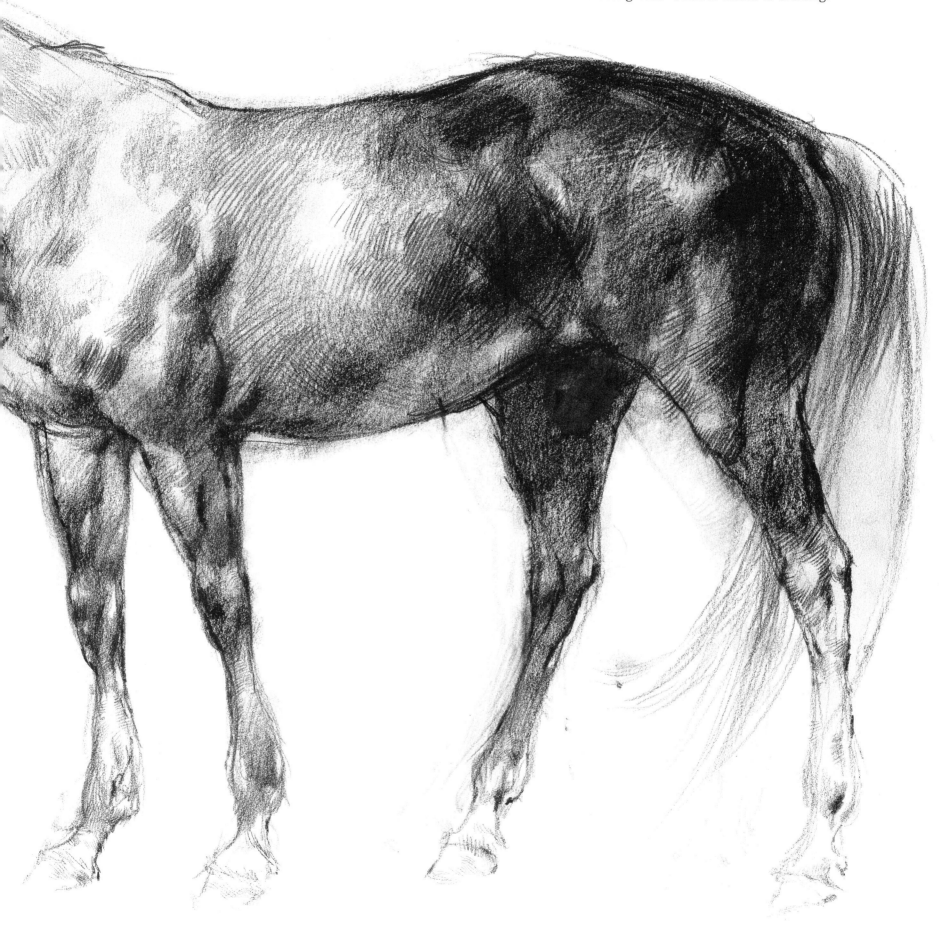

The same horse from a different angle. Here you can clearly see the base tone laid on with a flat Conté crayon and then worked into with the point of a 2B carbon pencil to give that extra shine and detail required on the face and legs. Before you do any of this however, you must get the basics absolutely correct. Check the proportions, make sure that the legs really stand and support the animal properly, measure the neck against the body. How many times will it fit into the length of the horse? Then carefully inspect the muscles to see what you can discover beneath the skin. Bring it out with careful use of line and tone.

This horse stands in what you might describe as a traditional 'horse portrait' pose and provides a perfect opportunity to enjoy the play of light and shade on its gleaming skin.

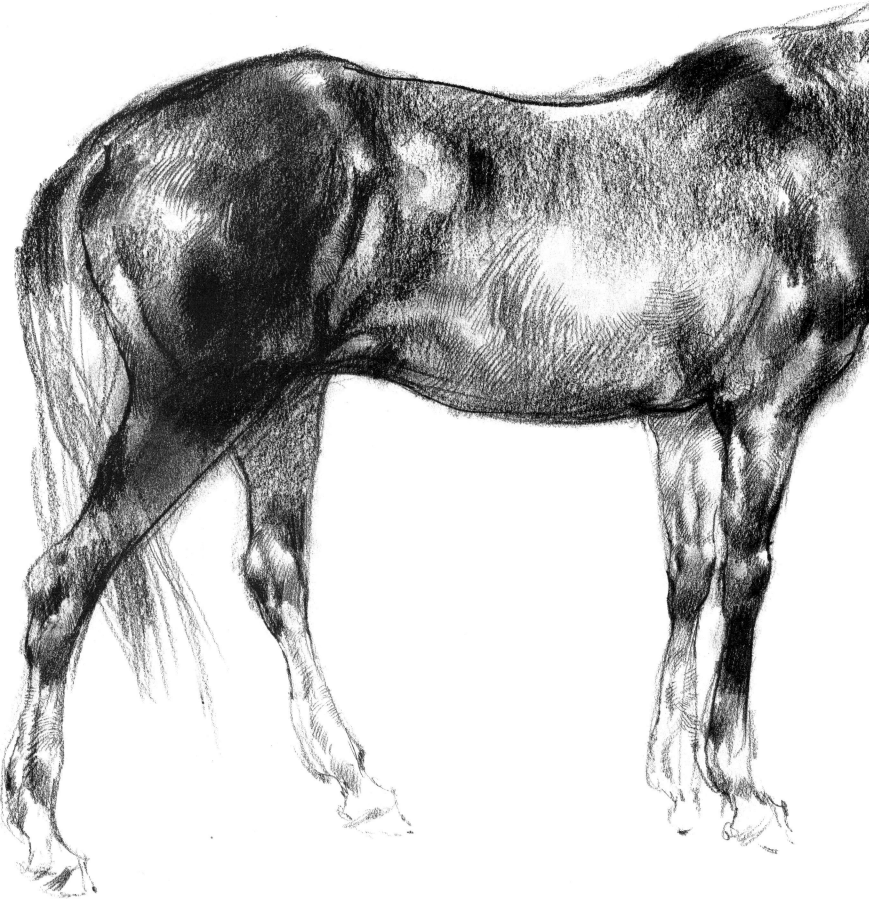

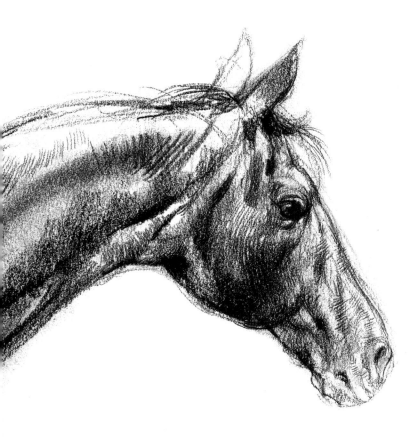

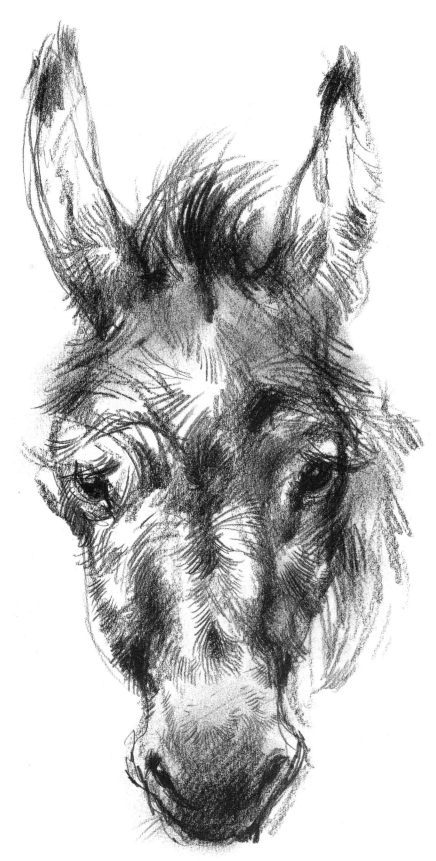

In contrast, a suspicious little donkey with lots of character – a friend's pet. With such a profusion of hair all over the place it was really a question of arranging the strands in the right order to get the structure of the head correct. I started off by marking the outline of the head, ears and nose and rough position of the eyes, then put down some background tone because I was impatient to get into the finer detail. The direction of the hairs was of great importance; they explained the form as well as giving the donkey his comical character, which said so much about the animal that it was hardly necessary to draw the rest of him.

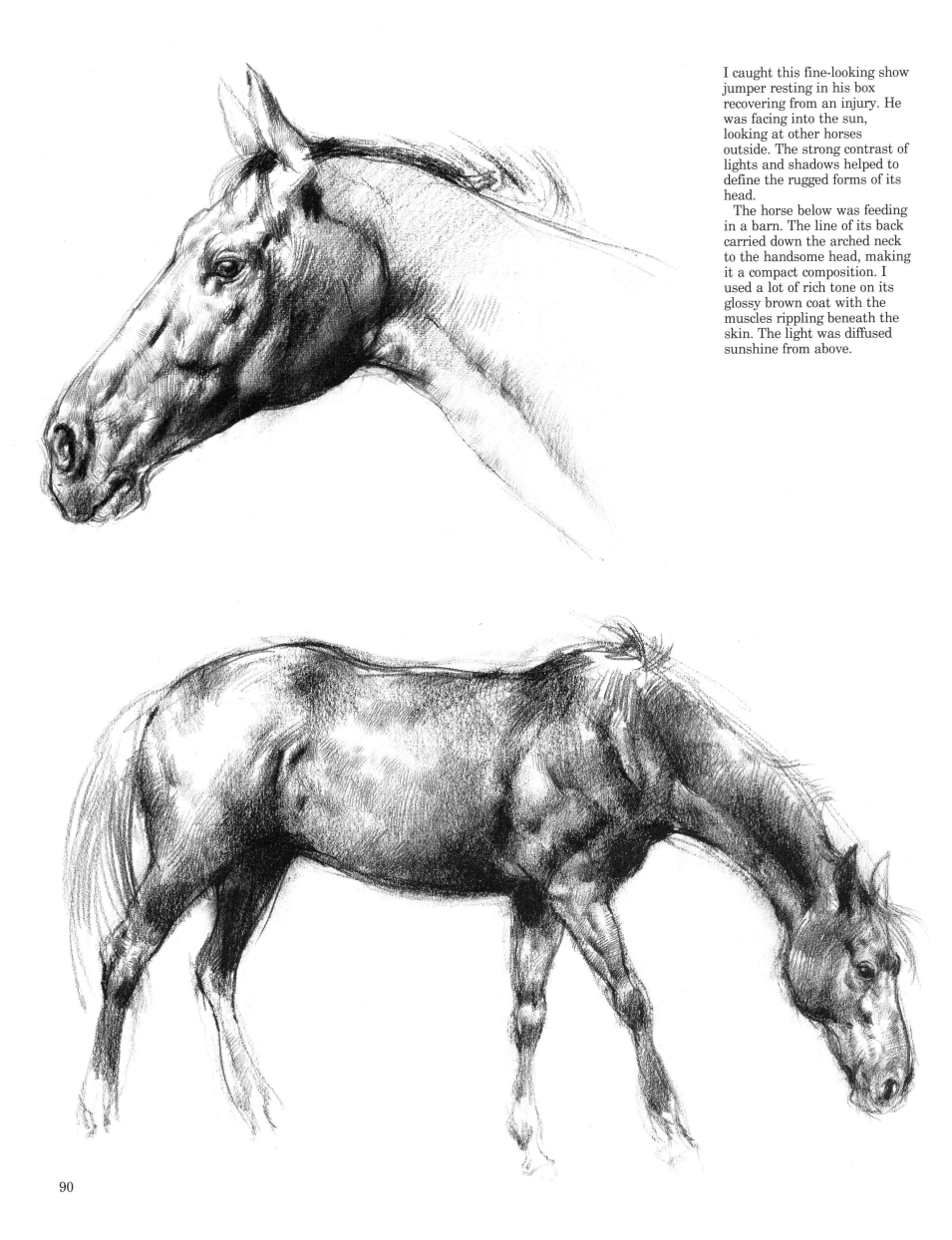

I caught this fine-looking show jumper resting in his box recovering from an injury. He was facing into the sun, looking at other horses outside. The strong contrast of lights and shadows helped to define the rugged forms of its head.

The horse below was feeding in a barn. The line of its back carried down the arched neck to the handsome head, making it a compact composition. I used a lot of rich tone on its glossy brown coat with the muscles rippling beneath the skin. The light was diffused sunshine from above.

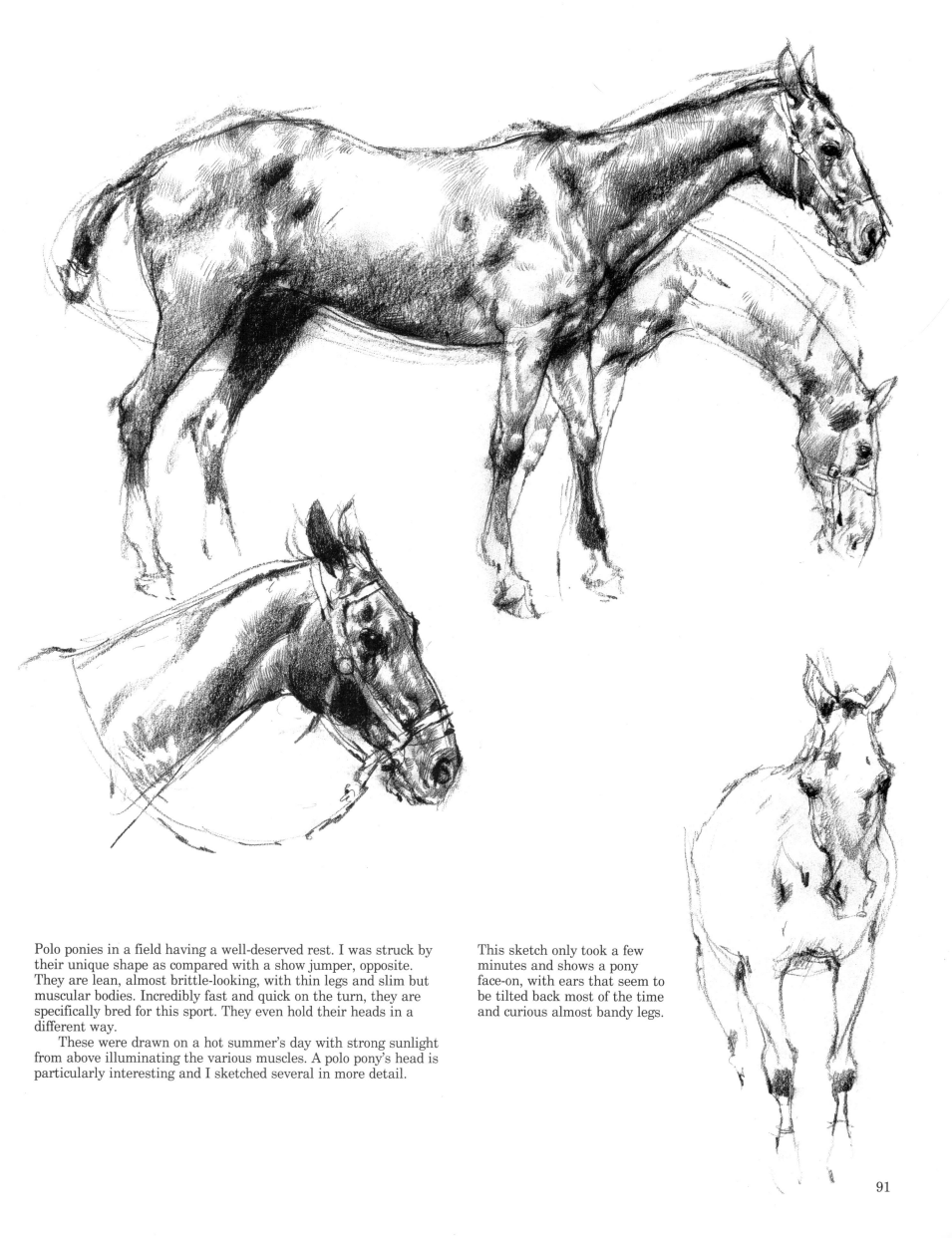

Polo ponies in a field having a well-deserved rest. I was struck by their unique shape as compared with a show jumper, opposite. They are lean, almost brittle-looking, with thin legs and slim but muscular bodies. Incredibly fast and quick on the turn, they are specifically bred for this sport. They even hold their heads in a different way.

These were drawn on a hot summer's day with strong sunlight from above illuminating the various muscles. A polo pony's head is particularly interesting and I sketched several in more detail.

This sketch only took a few minutes and shows a pony face-on, with ears that seem to be tilted back most of the time and curious almost bandy legs.

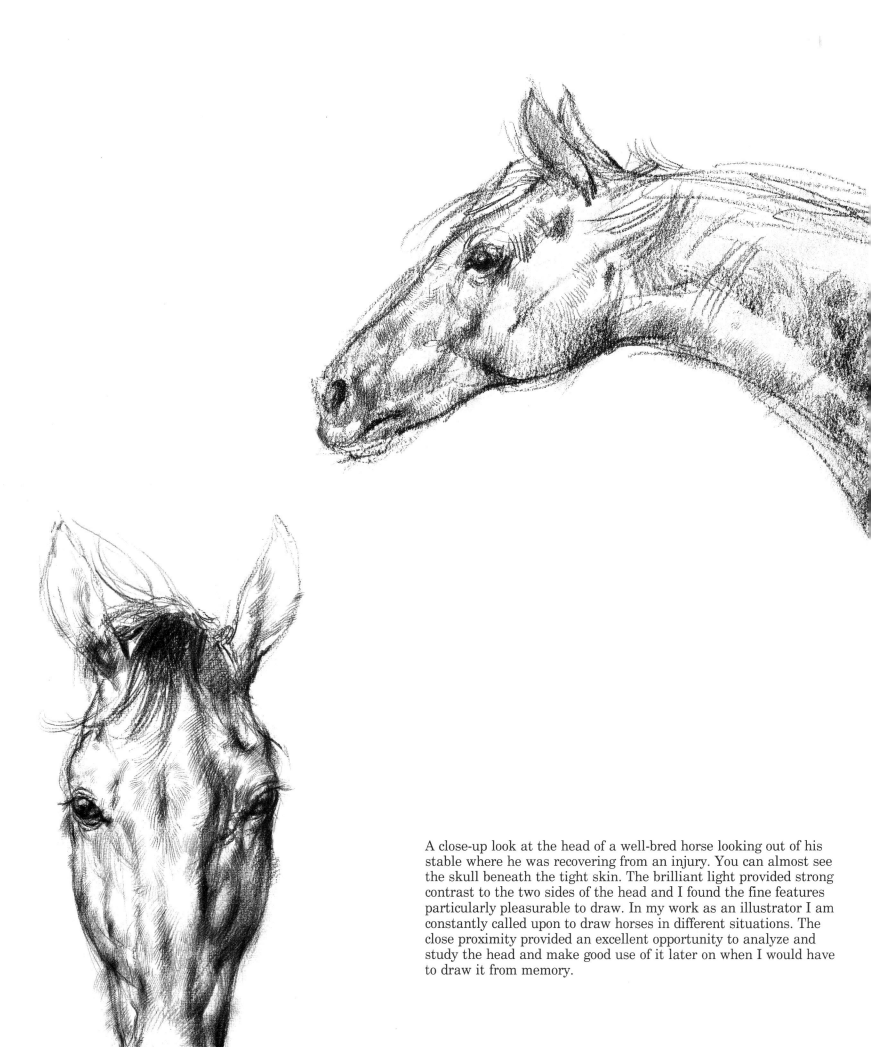

A close-up look at the head of a well-bred horse looking out of his stable where he was recovering from an injury. You can almost see the skull beneath the tight skin. The brilliant light provided strong contrast to the two sides of the head and I found the fine features particularly pleasurable to draw. In my work as an illustrator I am constantly called upon to draw horses in different situations. The close proximity provided an excellent opportunity to analyze and study the head and make good use of it later on when I would have to draw it from memory.

A handsome grey, which apart from its nice shape and fine lines had little in common with the previous horses. Instead of playing on the rippling light and shade of the dark horse's body, I had to accentuate the subtle mottling on its coat which gave it a decorative quality. The overall tone also indicated the difference in colour, this being a very light pastel shade of grey. It took a keen interest in the other horses outside the barn, and I drew it in this pose – head alert, listening and watching. The light was somewhat diffused by the overhanging roof of the barn, much less dramatic than bright sunlight.

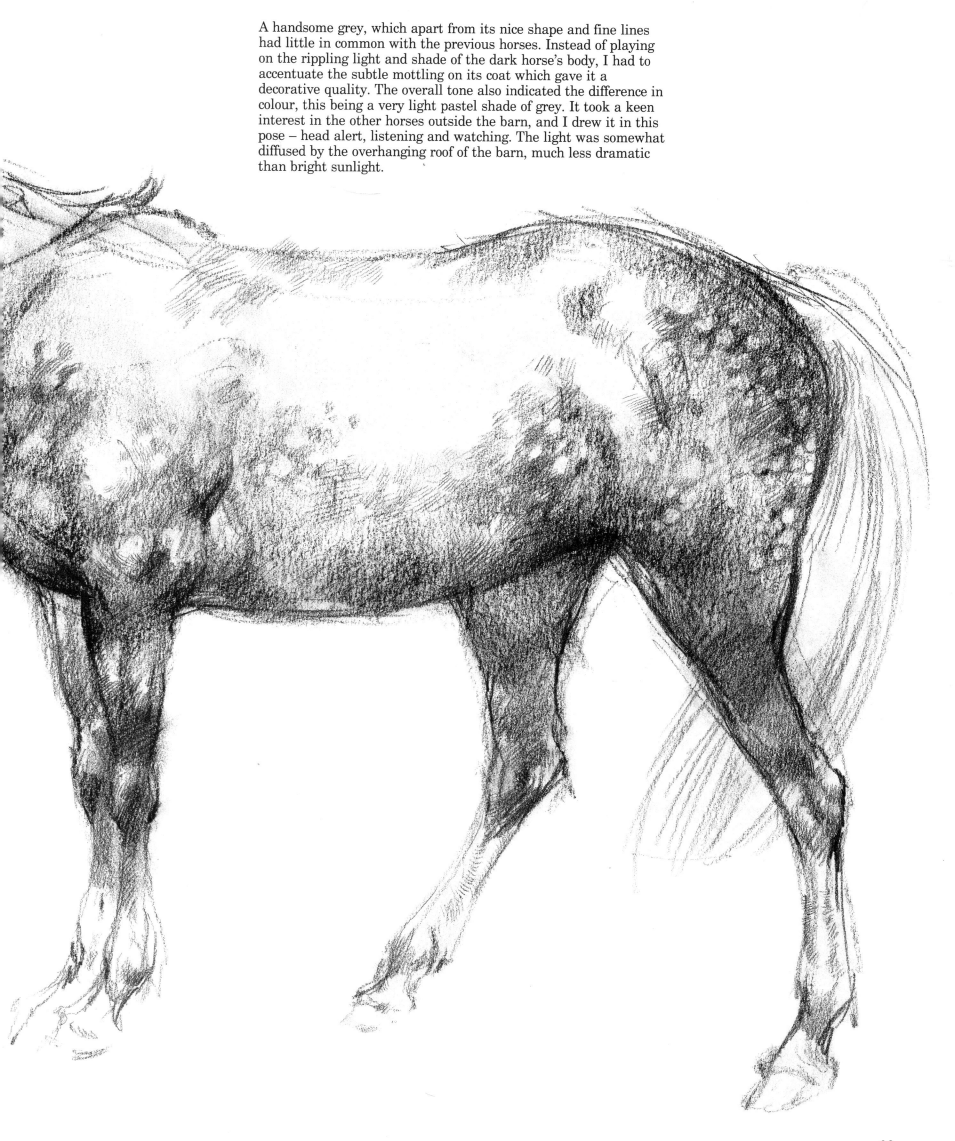

These are drawings of white Hungarian Lippizaner horses stabled near Norwich. They were being trotted and lunged as part of their daily exercise. At that time I was engaged in producing a painting of these horses harnessed to a Post Office Stage Coach for the National Postal Museum. In preparation I produced several sheets of sketches showing different views, this sheet being among the better ones. I often have to draw horses at the canter or gallop and learnt to ride in order to experience the feeling of a horse going at full speed.

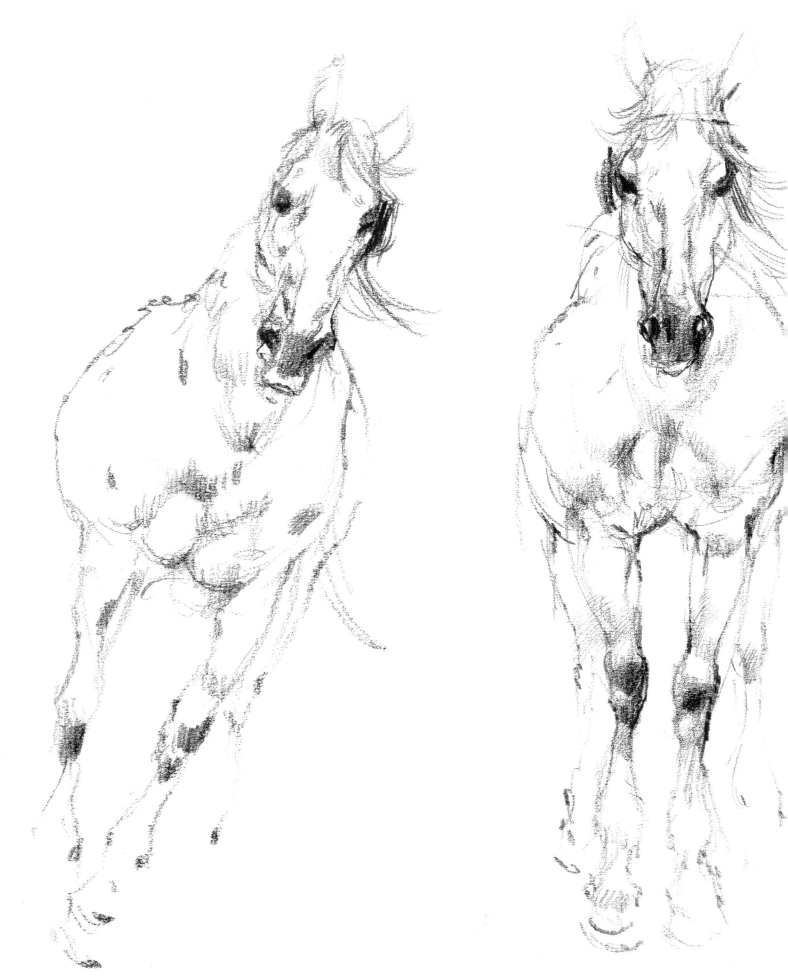

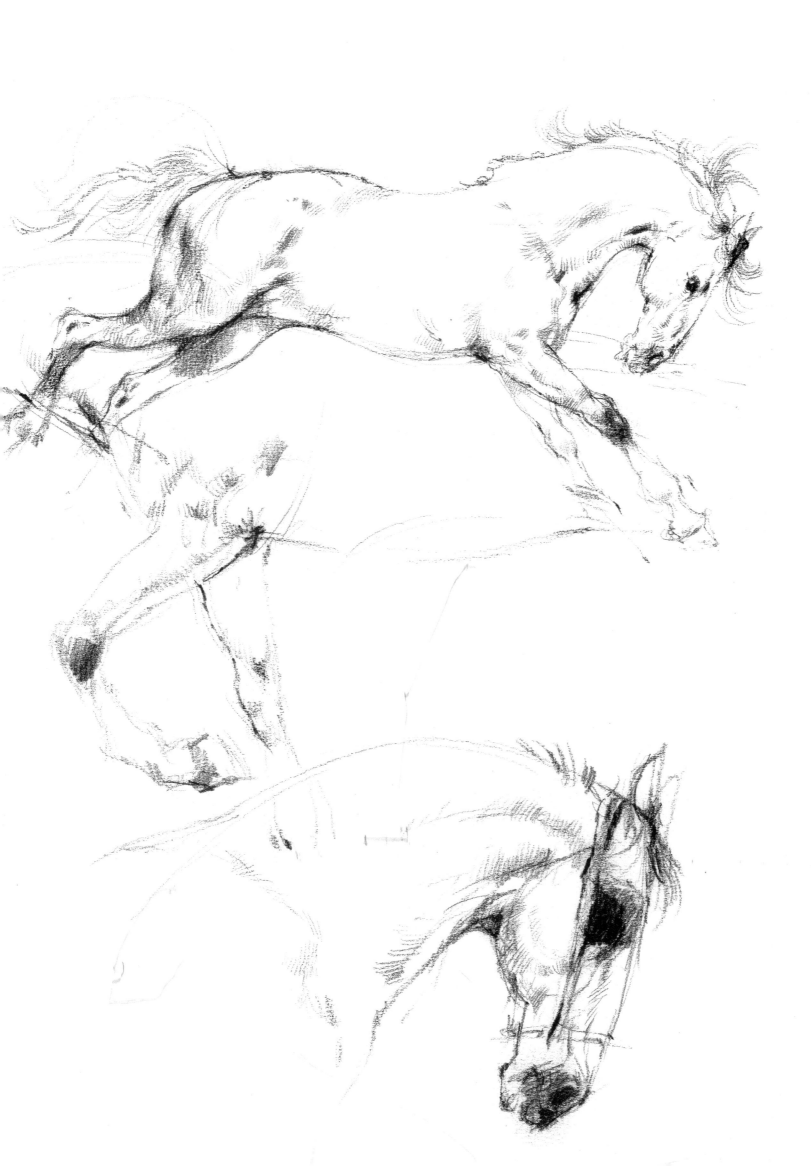

Another cow examining me with a mixture of curiosity and aggression. She seemed to be the ringleader and after staring me out for some time decided to get the rest of the herd to gang up on me, causing me to make a strategic withdrawal behind a fence. I think they were feeling jittery and protective towards their calves.

The strong sunlight, however, produced good shadows, helpful when you are searching out the forms. I used plenty of tone on the right side of the drawing to bring out the muscles on the head, the shape of the nose and mouth and the bulk of the body.

Dogs

My 'model' in this case was an English setter
called Bertie with an aristocratic air and masses
of long, curly hair. He is sitting here in a pose
very characteristic of him, bolt upright with front
legs apart.

 Most of the tone and interest is concentrated
on the expressive head, and I used the direction
of my lines to suggest the ridge of his long nose,
the cheeks and slightly hooded eyes. The black
ears make a good accent or focal point to the
drawing.

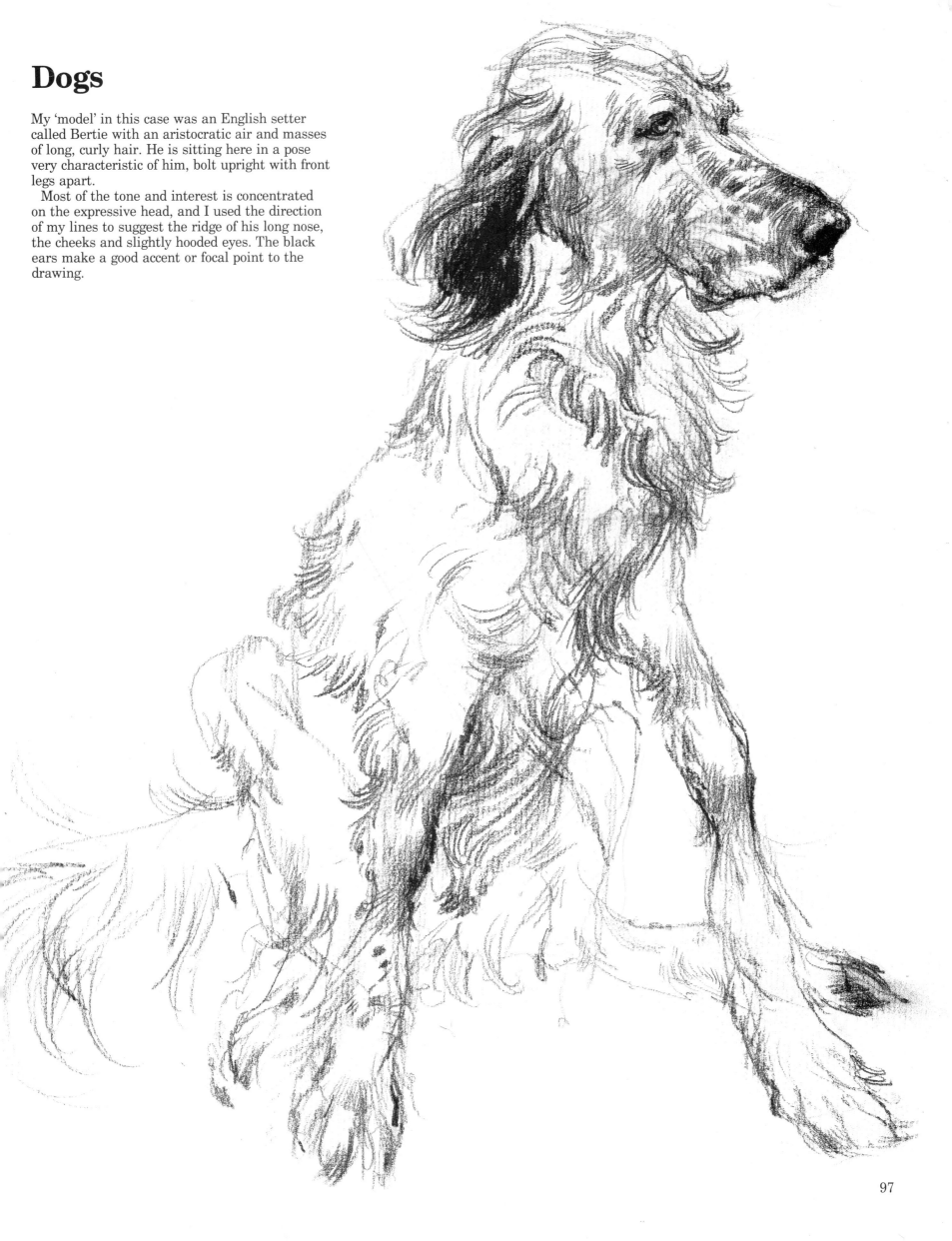

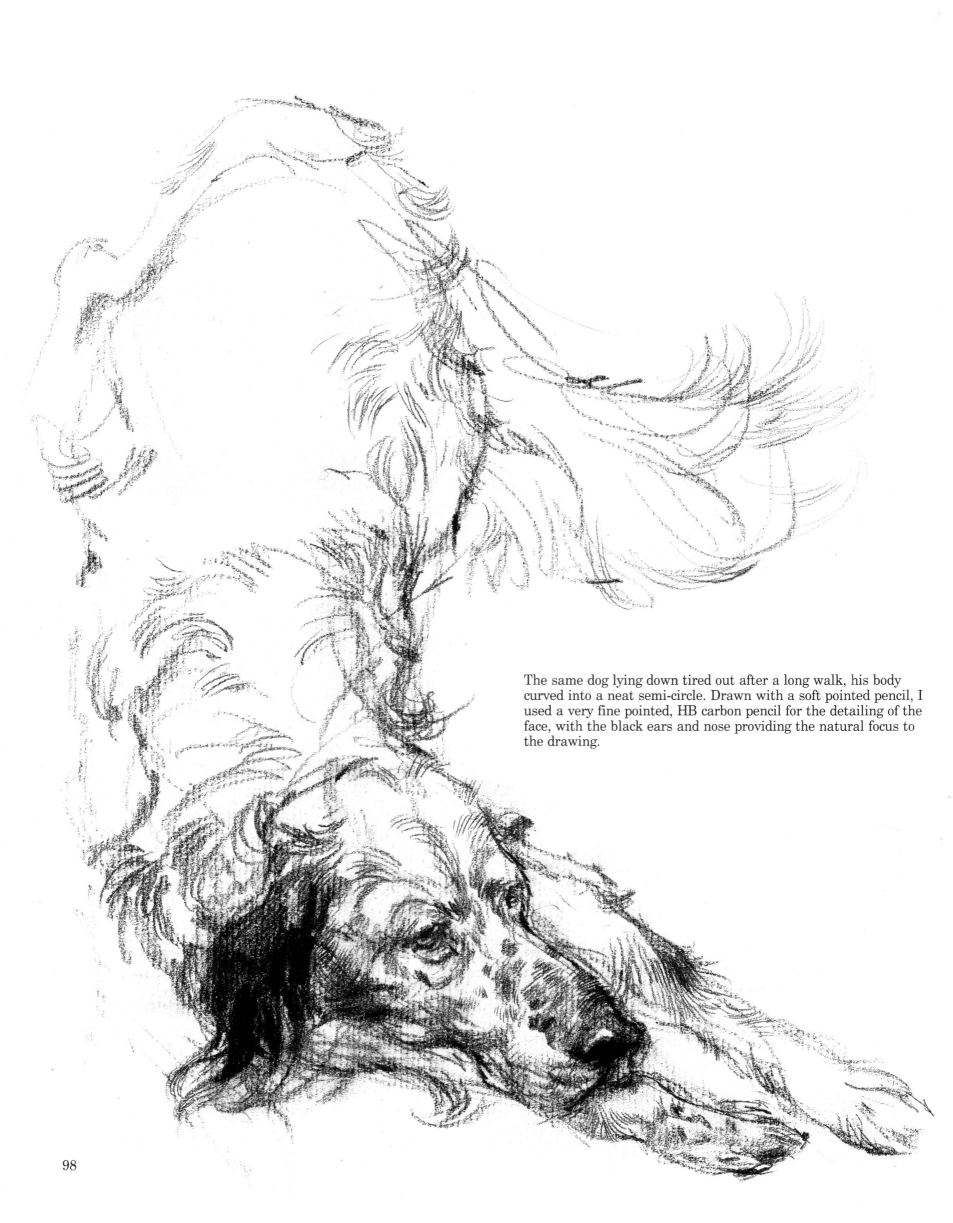

The same dog lying down tired out after a long walk, his body curved into a neat semi-circle. Drawn with a soft pointed pencil, I used a very fine pointed, HB carbon pencil for the detailing of the face, with the black ears and nose providing the natural focus to the drawing.

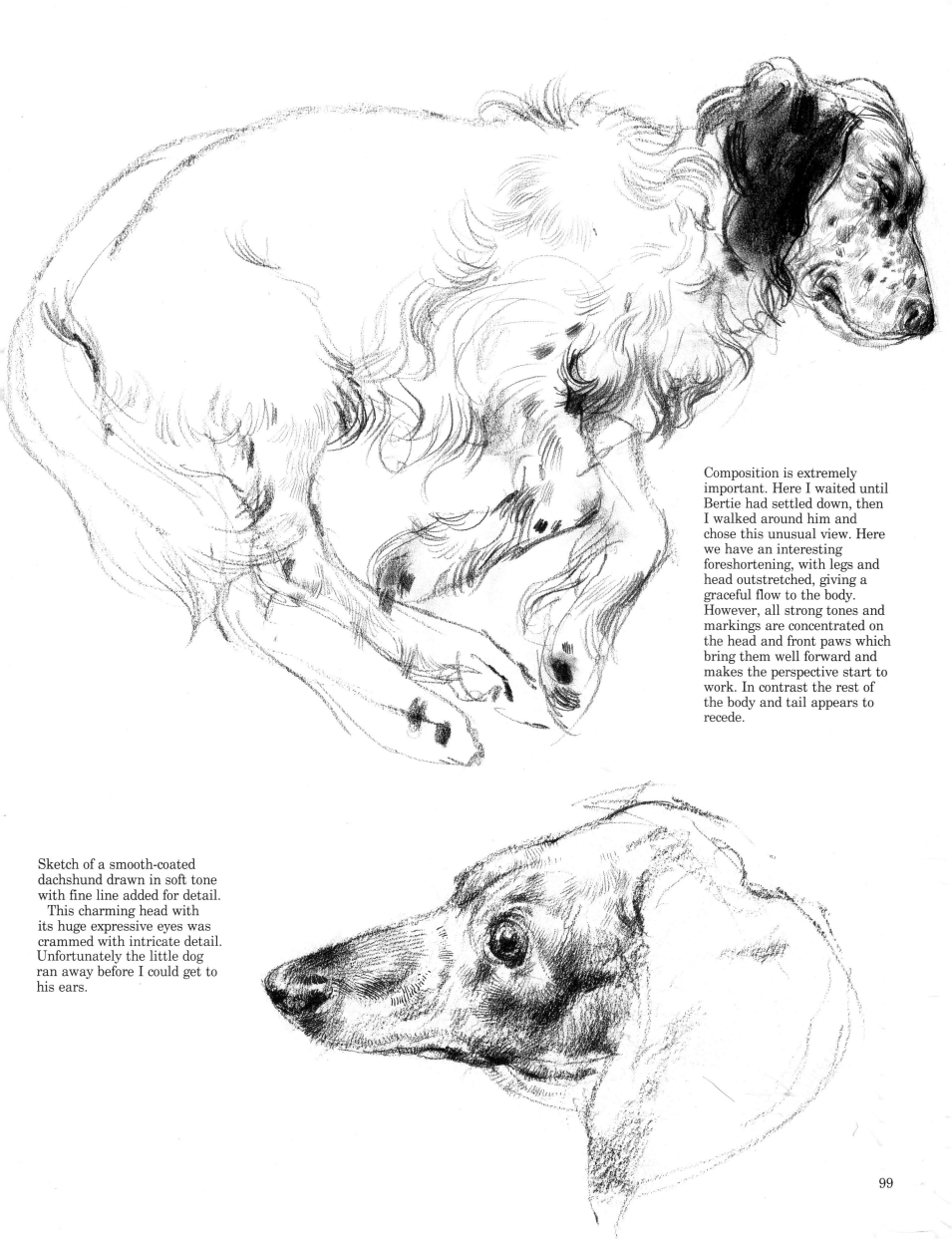

Composition is extremely important. Here I waited until Bertie had settled down, then I walked around him and chose this unusual view. Here we have an interesting foreshortening, with legs and head outstretched, giving a graceful flow to the body. However, all strong tones and markings are concentrated on the head and front paws which bring them well forward and makes the perspective start to work. In contrast the rest of the body and tail appears to recede.

Sketch of a smooth-coated dachshund drawn in soft tone with fine line added for detail.
 This charming head with its huge expressive eyes was crammed with intricate detail. Unfortunately the little dog ran away before I could get to his ears.

99

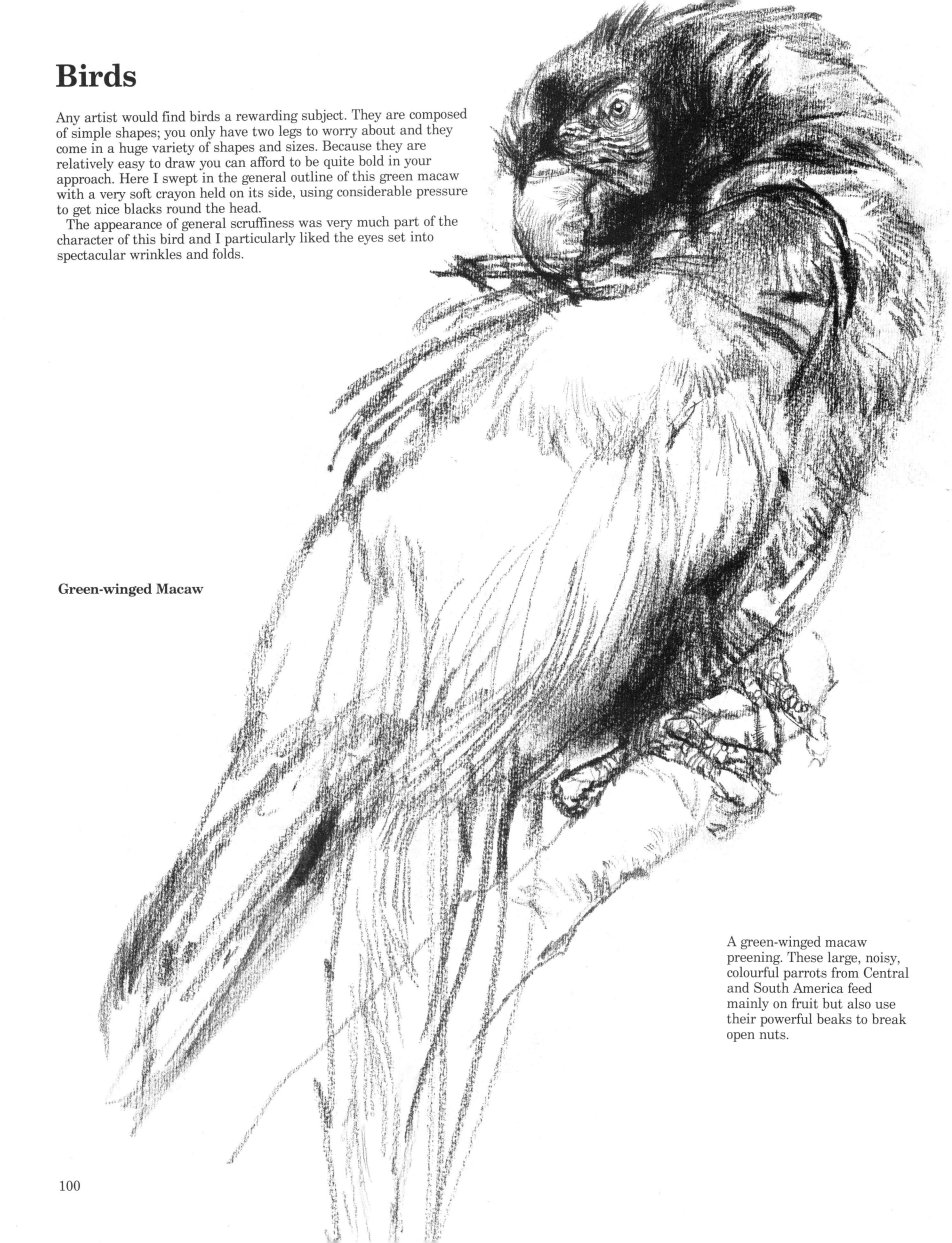

Birds

Any artist would find birds a rewarding subject. They are composed of simple shapes; you only have two legs to worry about and they come in a huge variety of shapes and sizes. Because they are relatively easy to draw you can afford to be quite bold in your approach. Here I swept in the general outline of this green macaw with a very soft crayon held on its side, using considerable pressure to get nice blacks round the head.

The appearance of general scruffiness was very much part of the character of this bird and I particularly liked the eyes set into spectacular wrinkles and folds.

Green-winged Macaw

A green-winged macaw preening. These large, noisy, colourful parrots from Central and South America feed mainly on fruit but also use their powerful beaks to break open nuts.

100

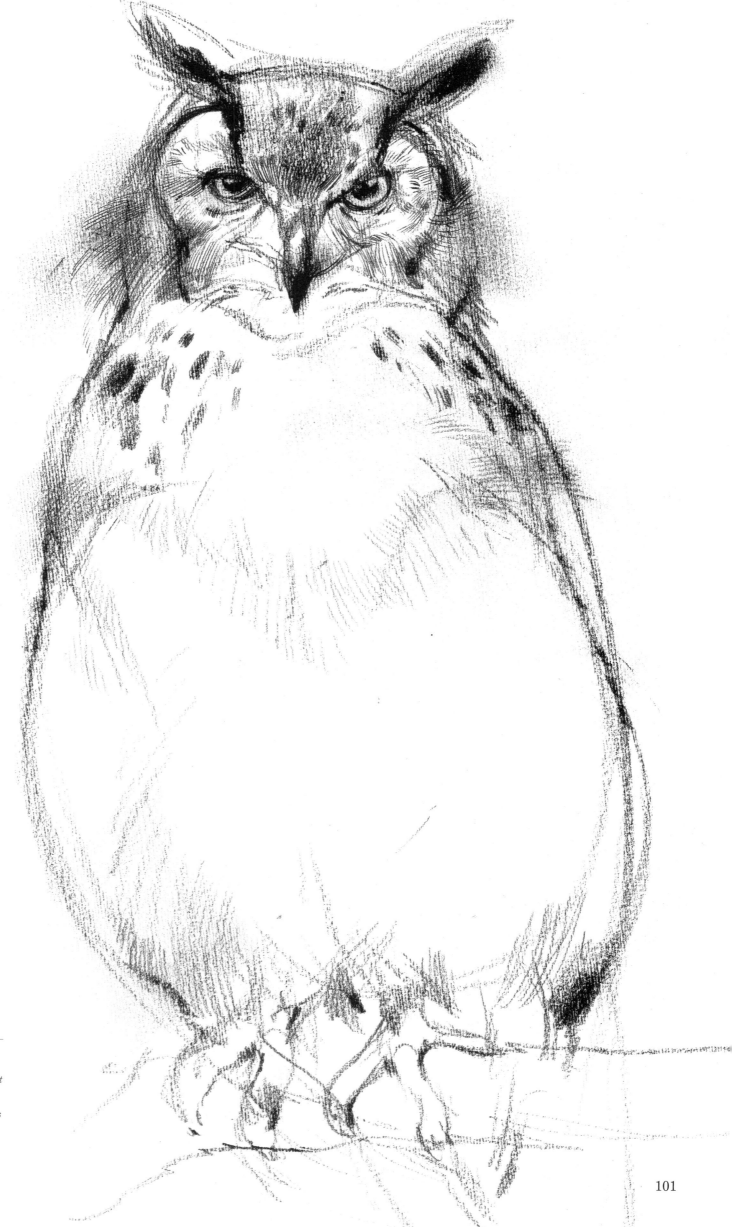

In contrast to the macaw, this great Indian horned owl was all smoothness and dignity. A lovely, compact shape which could be given a simple treatment. Instead of just lines, I used soft tone rubbed on first with only a few lines to suggest the fine feathers of the face. The huge, arresting eyes I drew in extremely carefully in deep black.

Great Indian Horned Owl

The great Indian horned owl relies upon perception and surprise to capture its prey of small mammals. For the first purpose, it has eyes like ours which face forward enabling it to judge distances and acute hearing, and it emits low frequency sounds to help it to navigate in the dark by echo location.

For the second it has feathers fringed to help muffle sound as it flaps its wings.

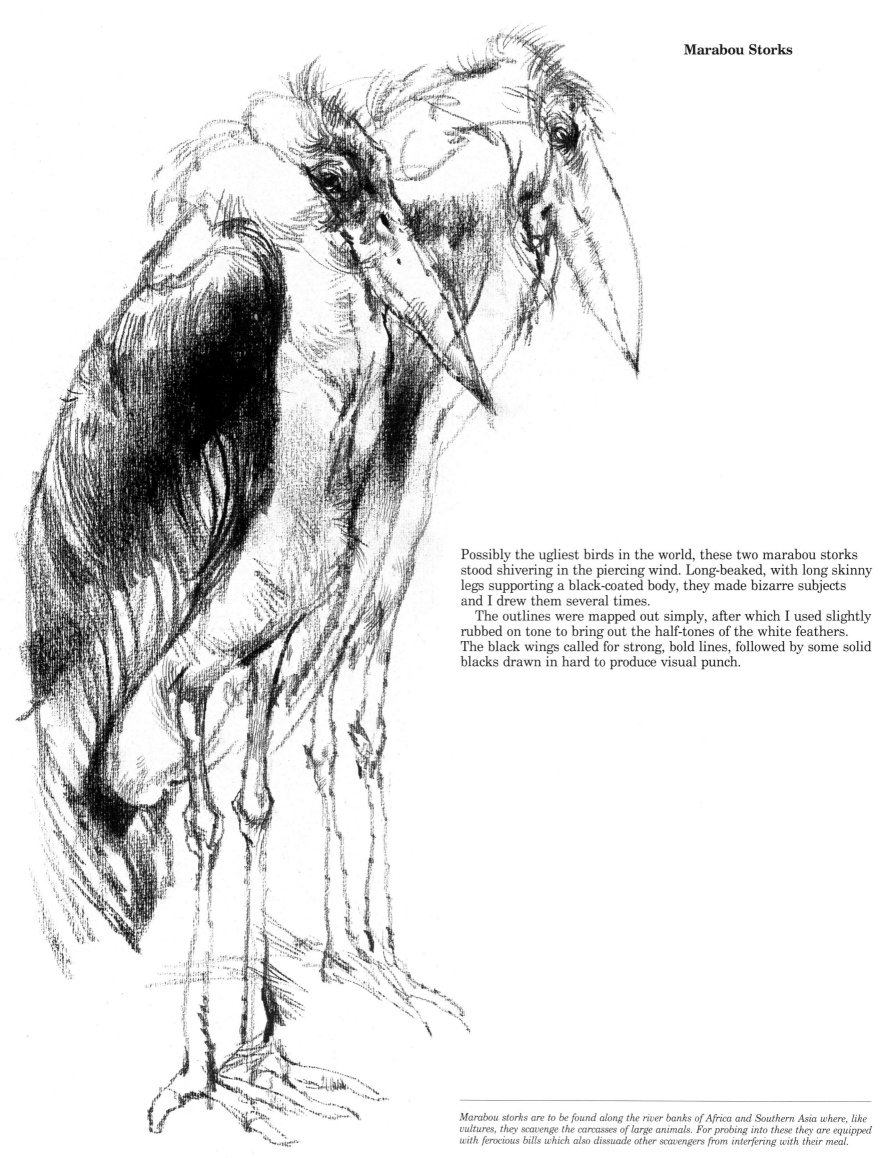

Possibly the ugliest birds in the world, these two marabou storks stood shivering in the piercing wind. Long-beaked, with long skinny legs supporting a black-coated body, they made bizarre subjects and I drew them several times.

The outlines were mapped out simply, after which I used slightly rubbed on tone to bring out the half-tones of the white feathers. The black wings called for strong, bold lines, followed by some solid blacks drawn in hard to produce visual punch.

Marabou storks are to be found along the river banks of Africa and Southern Asia where, like vultures, they scavenge the carcasses of large animals. For probing into these they are equipped with ferocious bills which also dissuade other scavengers from interfering with their meal.

Superimposed sketches of two types of hornbills which give a good idea of the working process I use. The small drawing in the background is the starting point, with all major shapes and forms mapped out and ready for the addition of tone and further detail.

The larger sketch, being a more finished study, shows the heavy use of tone and strong, short lines to suggest the quality of the feathers in contrast to the smooth, bright yellowish beak.

Hornbills

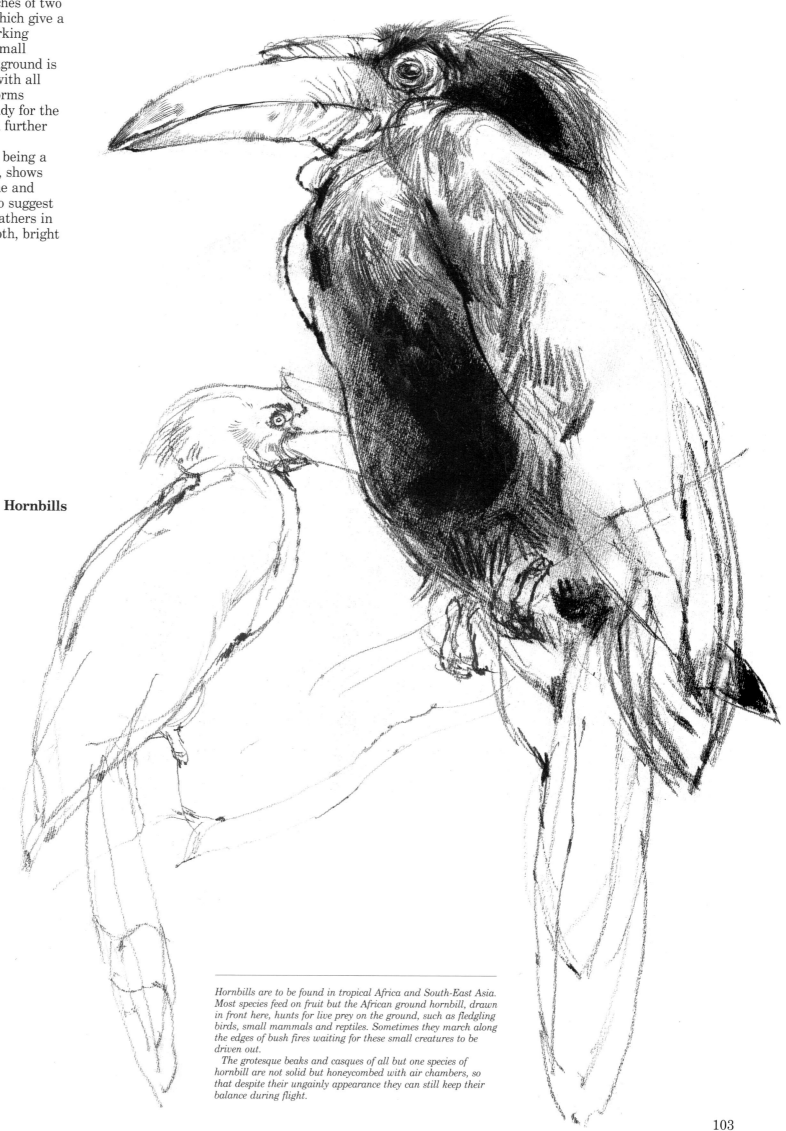

Hornbills are to be found in tropical Africa and South-East Asia. Most species feed on fruit but the African ground hornbill, drawn in front here, hunts for live prey on the ground, such as fledgling birds, small mammals and reptiles. Sometimes they march along the edges of bush fires waiting for these small creatures to be driven out.

The grotesque beaks and casques of all but one species of hornbill are not solid but honeycombed with air chambers, so that despite their ungainly appearance they can still keep their balance during flight.

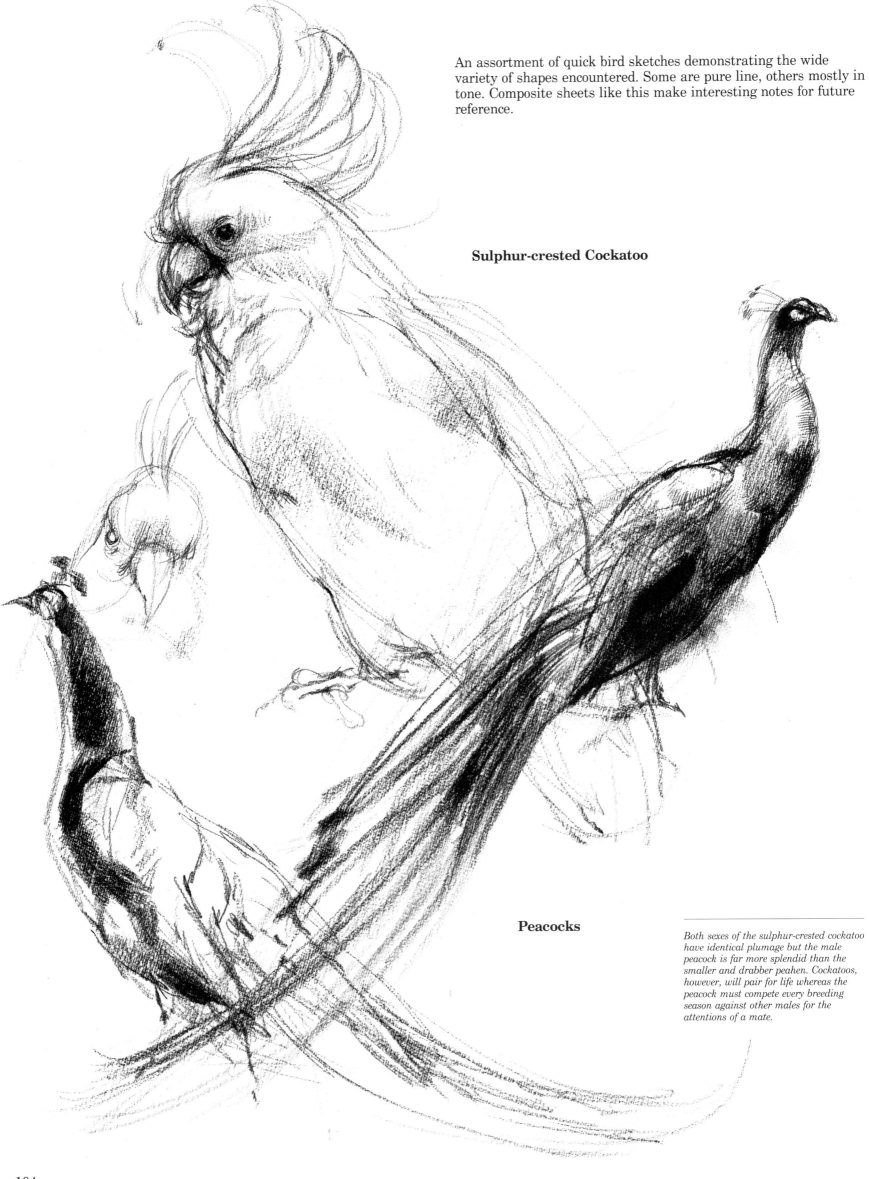

An assortment of quick bird sketches demonstrating the wide variety of shapes encountered. Some are pure line, others mostly in tone. Composite sheets like this make interesting notes for future reference.

Sulphur-crested Cockatoo

Peacocks

Both sexes of the sulphur-crested cockatoo have identical plumage but the male peacock is far more splendid than the smaller and drabber peahen. Cockatoos, however, will pair for life whereas the peacock must compete every breeding season against other males for the attentions of a mate.

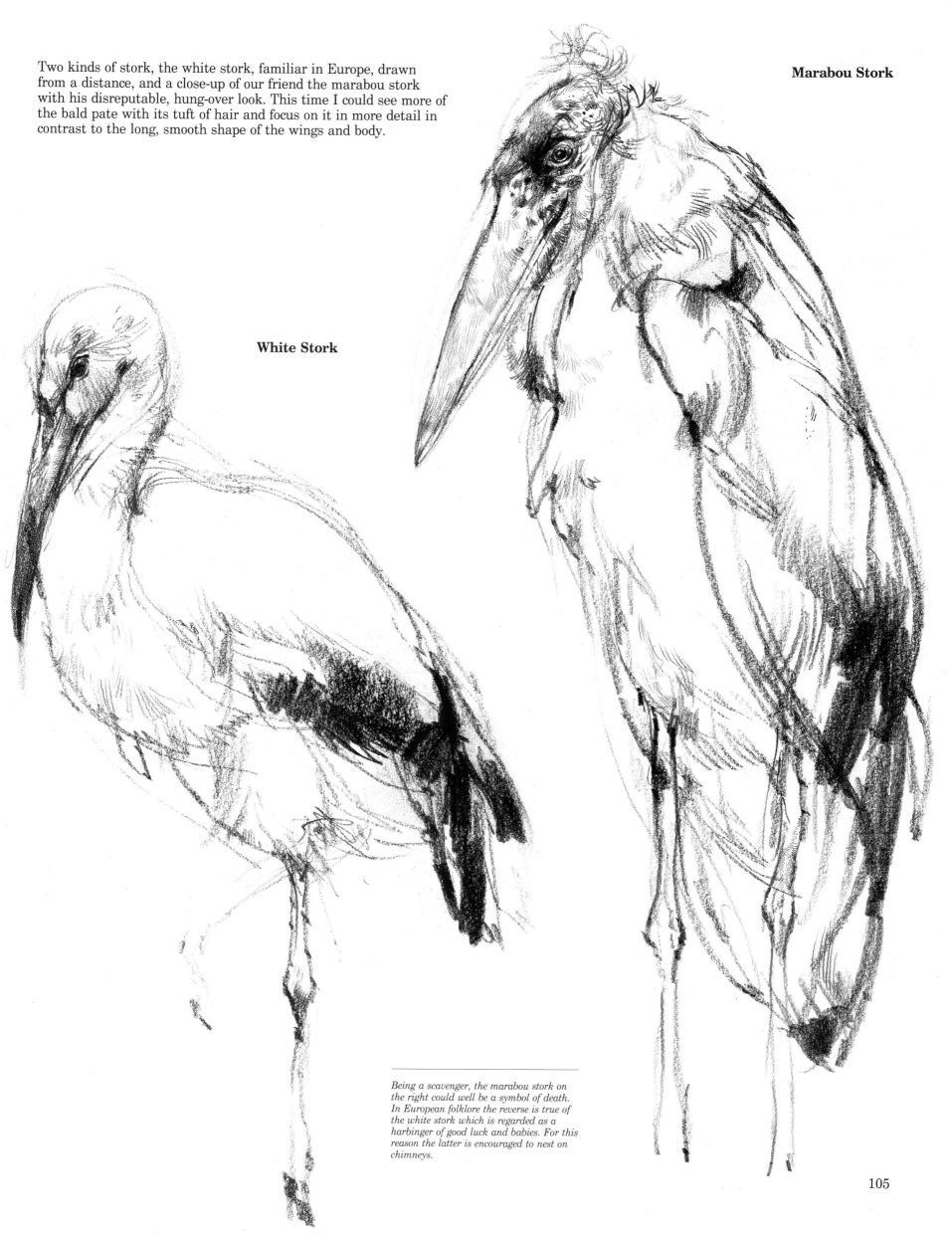

Two kinds of stork, the white stork, familiar in Europe, drawn from a distance, and a close-up of our friend the marabou stork with his disreputable, hung-over look. This time I could see more of the bald pate with its tuft of hair and focus on it in more detail in contrast to the long, smooth shape of the wings and body.

Marabou Stork

White Stork

Being a scavenger, the marabou stork on the right could well be a symbol of death. In European folklore the reverse is true of the white stork which is regarded as a harbinger of good luck and babies. For this reason the latter is encouraged to nest on chimneys.

105

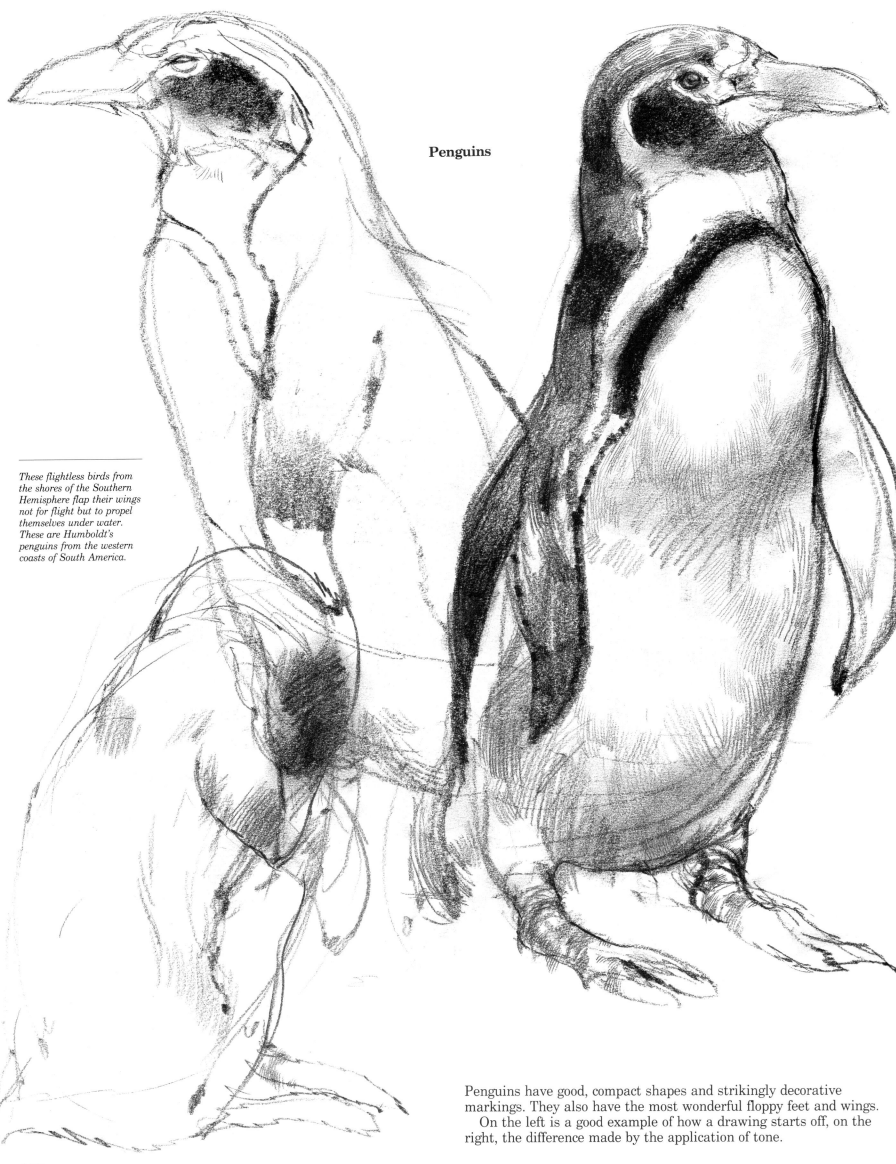

Penguins

These flightless birds from the shores of the Southern Hemisphere flap their wings not for flight but to propel themselves under water. These are Humboldt's penguins from the western coasts of South America.

Penguins have good, compact shapes and strikingly decorative markings. They also have the most wonderful floppy feet and wings. On the left is a good example of how a drawing starts off, on the right, the difference made by the application of tone.

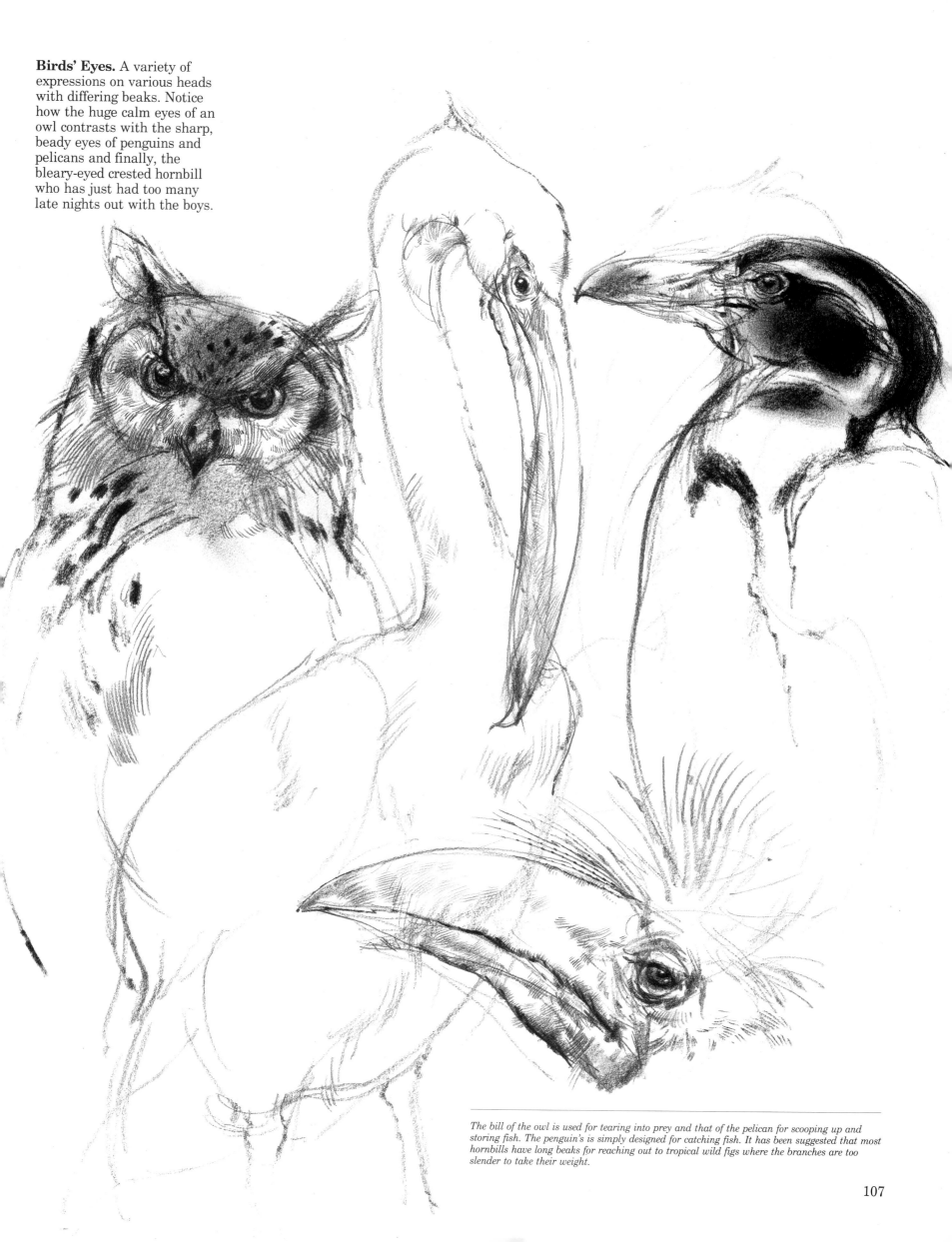

Birds' Eyes. A variety of expressions on various heads with differing beaks. Notice how the huge calm eyes of an owl contrasts with the sharp, beady eyes of penguins and pelicans and finally, the bleary-eyed crested hornbill who has just had too many late nights out with the boys.

The bill of the owl is used for tearing into prey and that of the pelican for scooping up and storing fish. The penguin's is simply designed for catching fish. It has been suggested that most hornbills have long beaks for reaching out to tropical wild figs where the branches are too slender to take their weight.

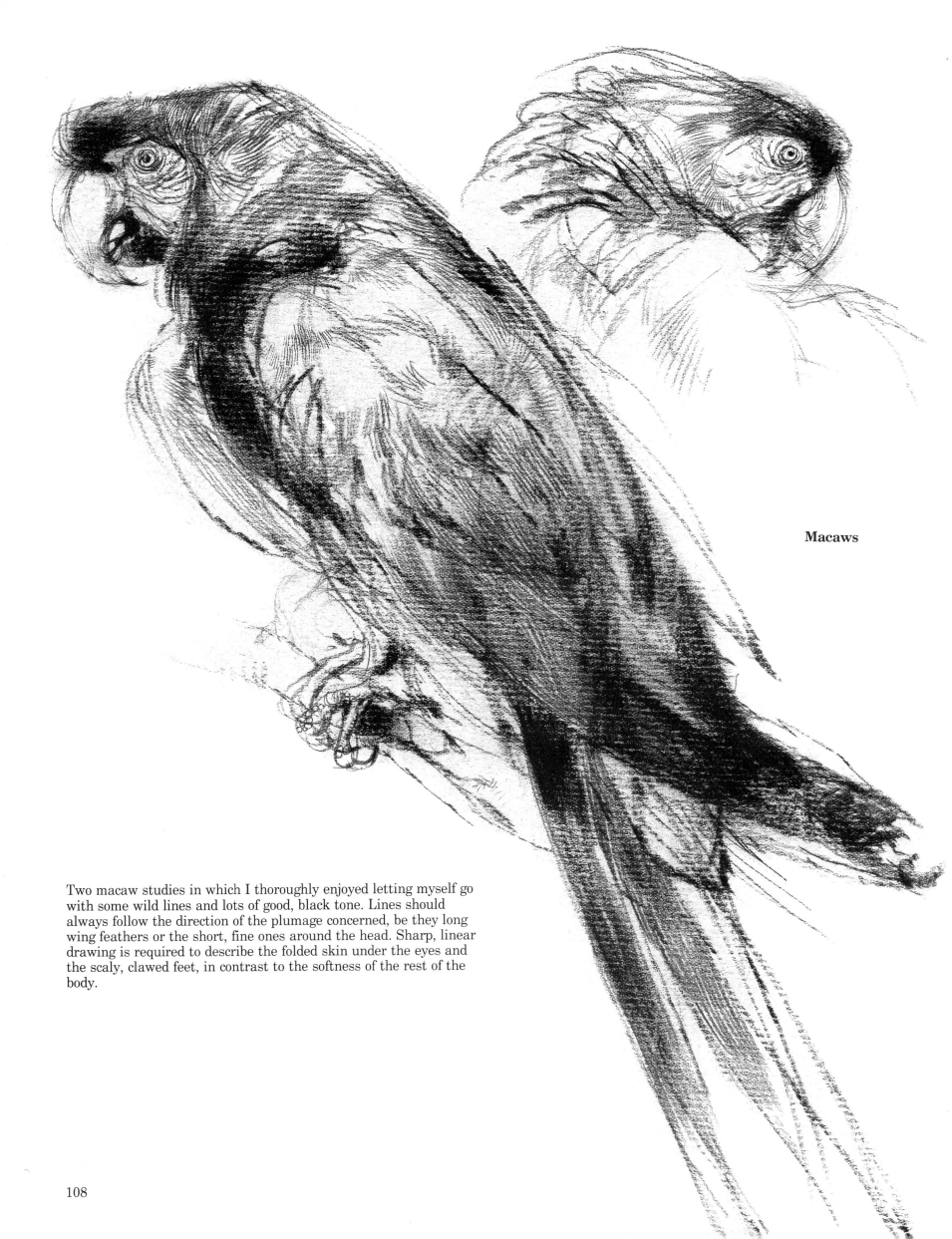

Macaws

Two macaw studies in which I thoroughly enjoyed letting myself go with some wild lines and lots of good, black tone. Lines should always follow the direction of the plumage concerned, be they long wing feathers or the short, fine ones around the head. Sharp, linear drawing is required to describe the folded skin under the eyes and the scaly, clawed feet, in contrast to the softness of the rest of the body.

108

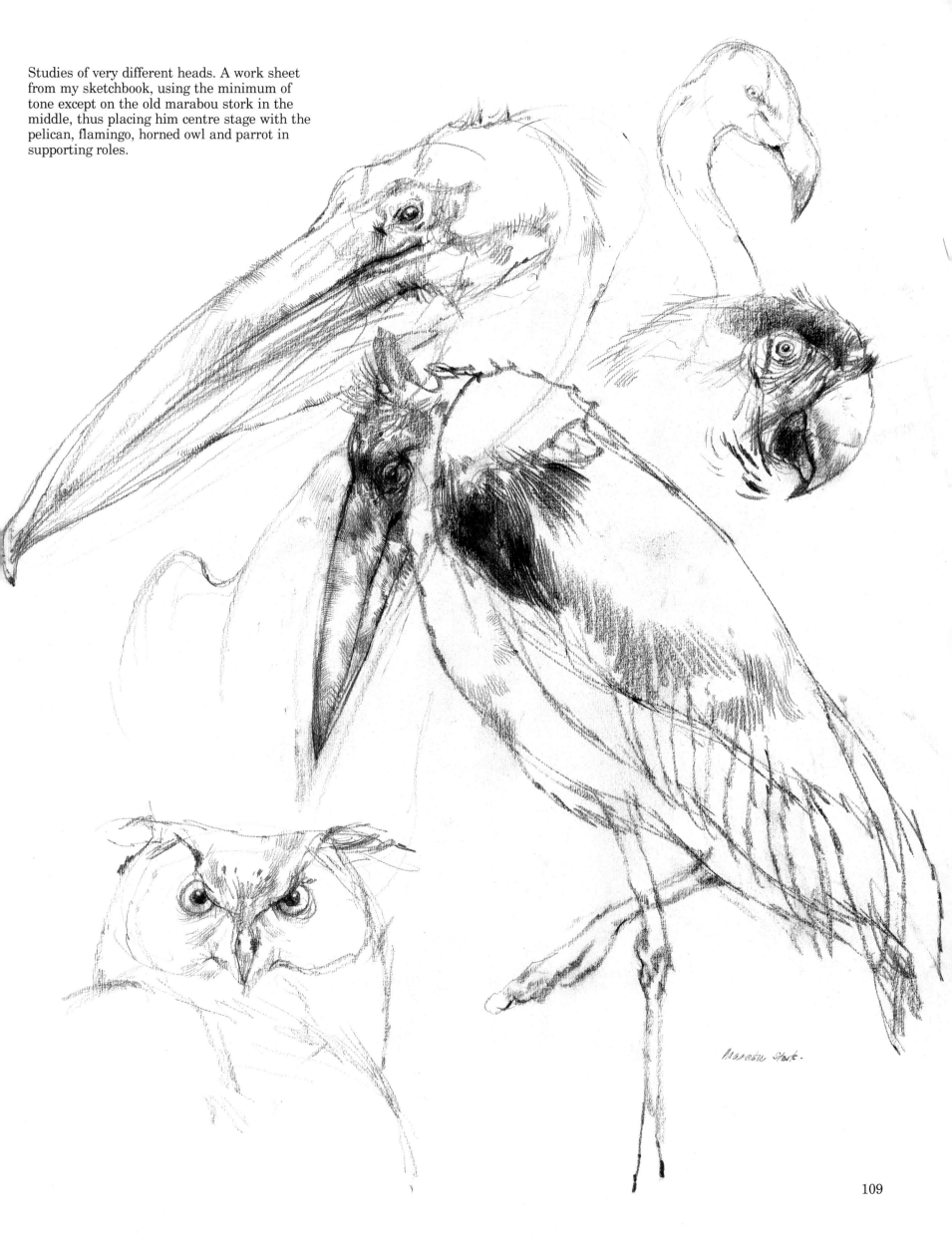

Studies of very different heads. A work sheet from my sketchbook, using the minimum of tone except on the old marabou stork in the middle, thus placing him centre stage with the pelican, flamingo, horned owl and parrot in supporting roles.

Marabou Stork.

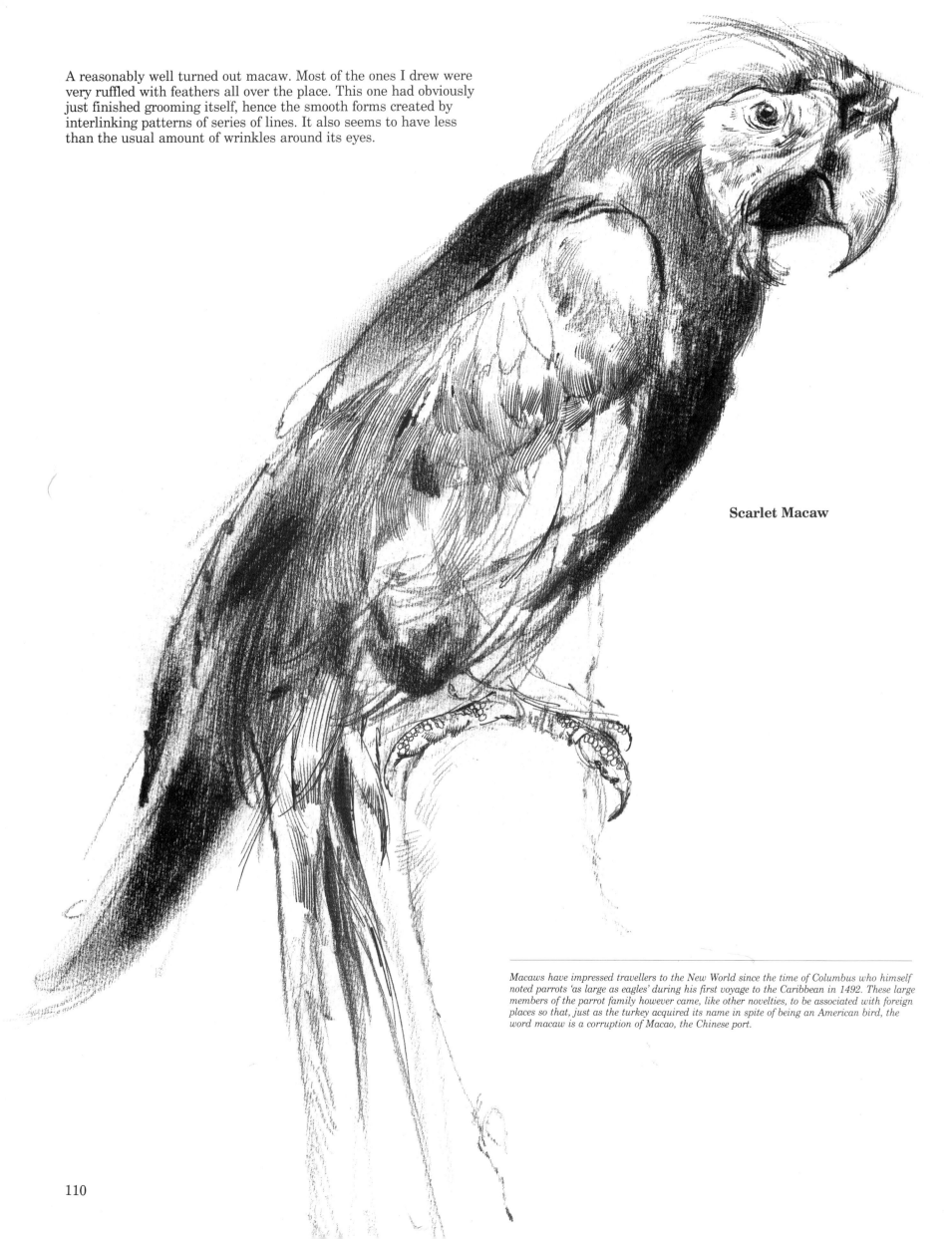

A reasonably well turned out macaw. Most of the ones I drew were very ruffled with feathers all over the place. This one had obviously just finished grooming itself, hence the smooth forms created by interlinking patterns of series of lines. It also seems to have less than the usual amount of wrinkles around its eyes.

Scarlet Macaw

Macaws have impressed travellers to the New World since the time of Columbus who himself noted parrots 'as large as eagles' during his first voyage to the Caribbean in 1492. These large members of the parrot family however came, like other novelties, to be associated with foreign places so that, just as the turkey acquired its name in spite of being an American bird, the word macaw is a corruption of Macao, the Chinese port.

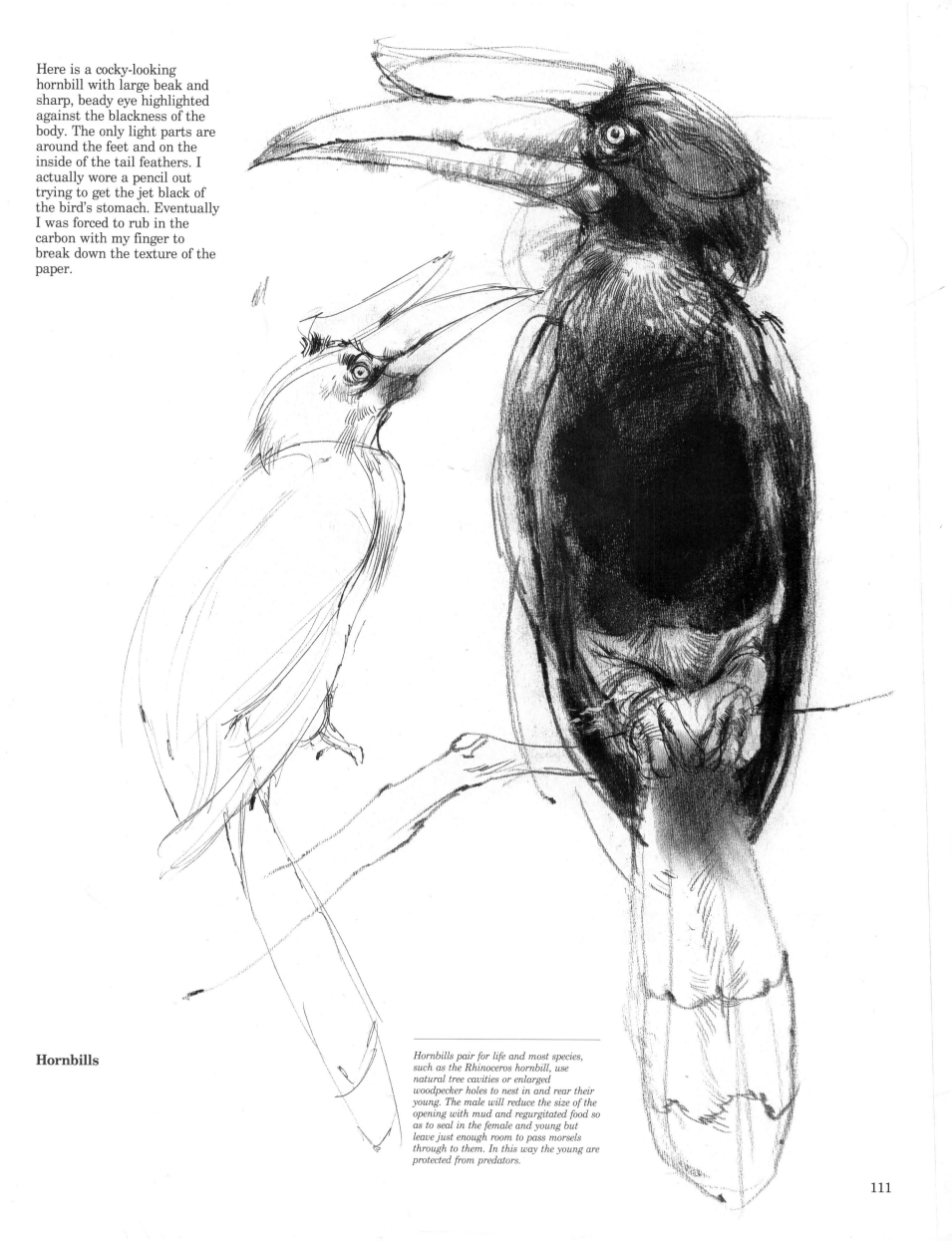

Here is a cocky-looking hornbill with large beak and sharp, beady eye highlighted against the blackness of the body. The only light parts are around the feet and on the inside of the tail feathers. I actually wore a pencil out trying to get the jet black of the bird's stomach. Eventually I was forced to rub in the carbon with my finger to break down the texture of the paper.

Hornbills

Hornbills pair for life and most species, such as the Rhinoceros hornbill, use natural tree cavities or enlarged woodpecker holes to nest in and rear their young. The male will reduce the size of the opening with mud and regurgitated food so as to seal in the female and young but leave just enough room to pass morsels through to them. In this way the young are protected from predators.

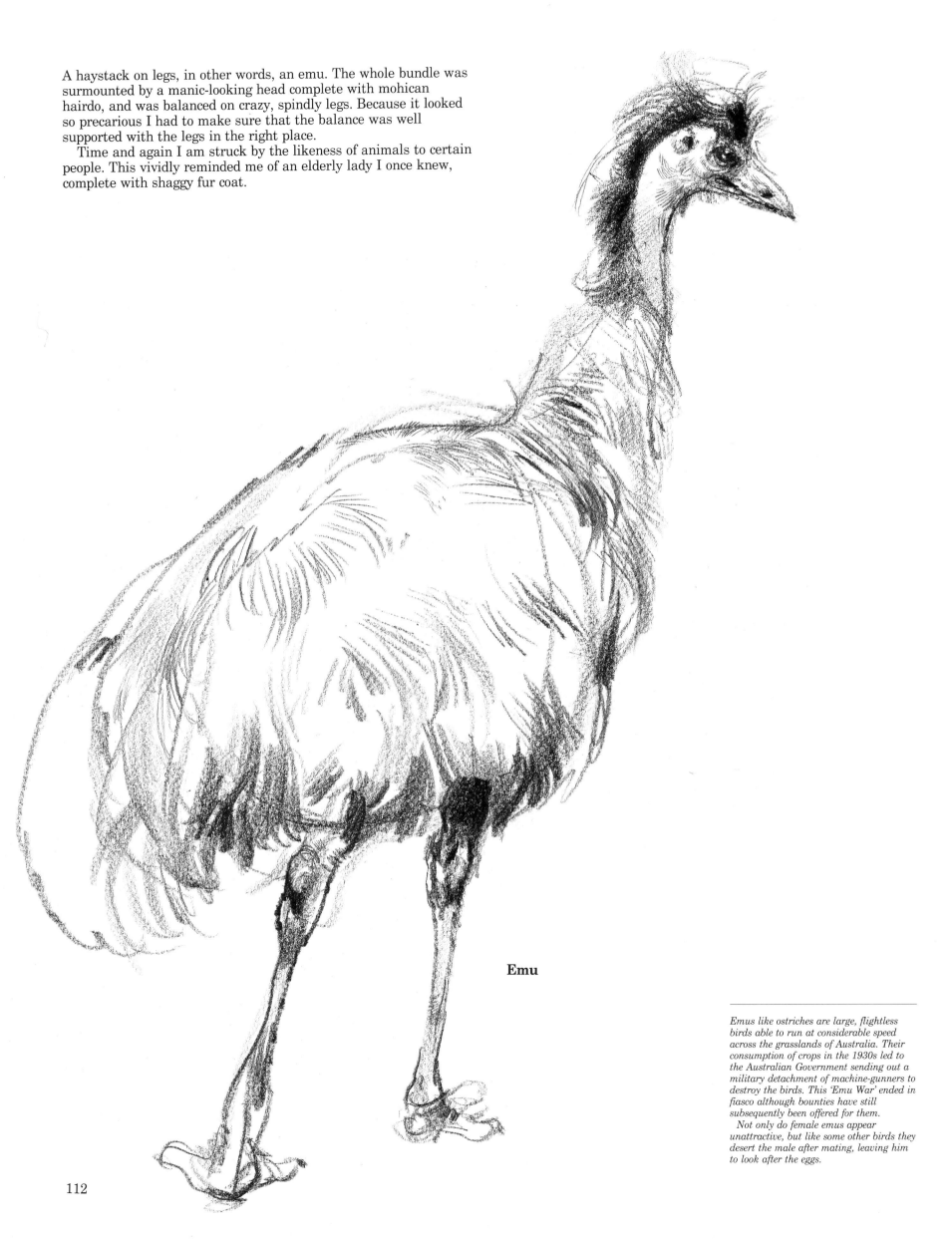

A haystack on legs, in other words, an emu. The whole bundle was surmounted by a manic-looking head complete with mohican hairdo, and was balanced on crazy, spindly legs. Because it looked so precarious I had to make sure that the balance was well supported with the legs in the right place.

Time and again I am struck by the likeness of animals to certain people. This vividly reminded me of an elderly lady I once knew, complete with shaggy fur coat.

Emu

Emus like ostriches are large, flightless birds able to run at considerable speed across the grasslands of Australia. Their consumption of crops in the 1930s led to the Australian Government sending out a military detachment of machine-gunners to destroy the birds. This 'Emu War' ended in fiasco although bounties have still subsequently been offered for them.

Not only do female emus appear unattractive, but like some other birds they desert the male after mating, leaving him to look after the eggs.

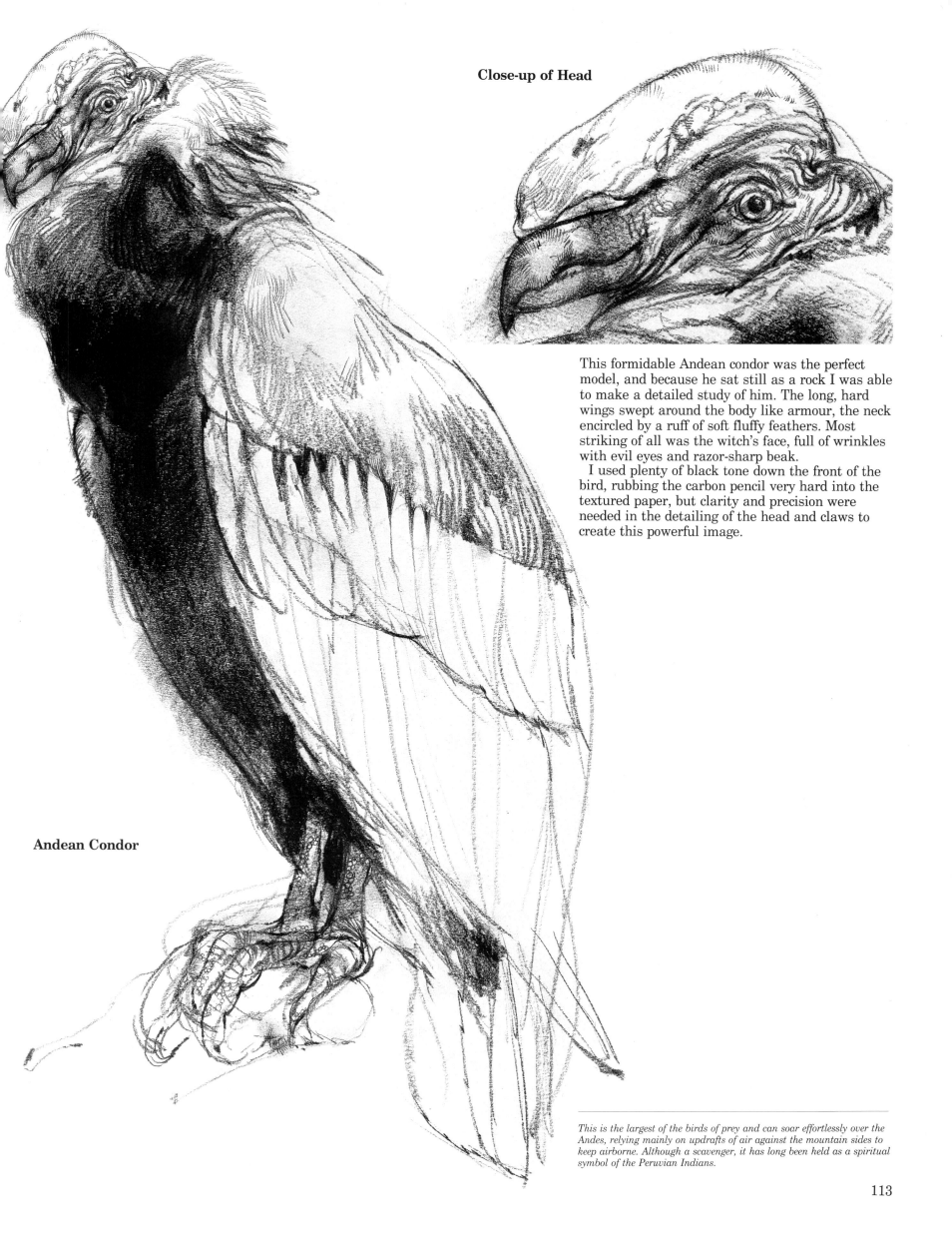

Close-up of Head

This formidable Andean condor was the perfect
model, and because he sat still as a rock I was able
to make a detailed study of him. The long, hard
wings swept around the body like armour, the neck
encircled by a ruff of soft fluffy feathers. Most
striking of all was the witch's face, full of wrinkles
with evil eyes and razor-sharp beak.

I used plenty of black tone down the front of the
bird, rubbing the carbon pencil very hard into the
textured paper, but clarity and precision were
needed in the detailing of the head and claws to
create this powerful image.

Andean Condor

*This is the largest of the birds of prey and can soar effortlessly over the
Andes, relying mainly on updrafts of air against the mountain sides to
keep airborne. Although a scavenger, it has long been held as a spiritual
symbol of the Peruvian Indians.*

This inquisitive emu hovered around me for a long time and actually peered into my drawing board. Being so close I made this penetrating study of its head. It was only after we had been amicably working away together for some 20 minutes that I noticed a placard above my head. It said: 'These animals can be dangerous'. The emu looked deeply into my eyes to refute this allegation.

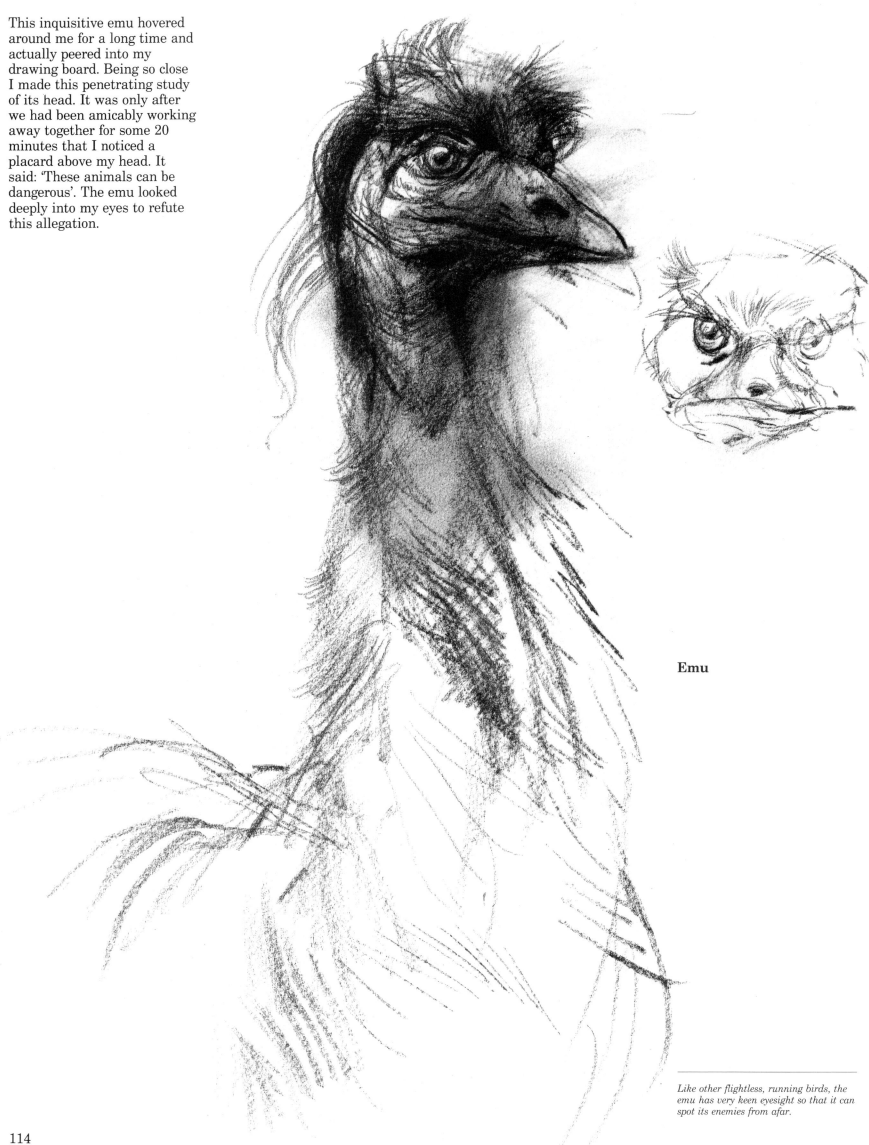

Emu

Like other flightless, running birds, the emu has very keen eyesight so that it can spot its enemies from afar.

I sketched these graceful, pretty cranes very quickly in simple line adding tone here and there to bring the drawing alive.

This is also a good example of how a sketch starts out and how it should progress into a more finished state. Being interested only in the general shape and movement of these birds, I did no more to them at this stage.

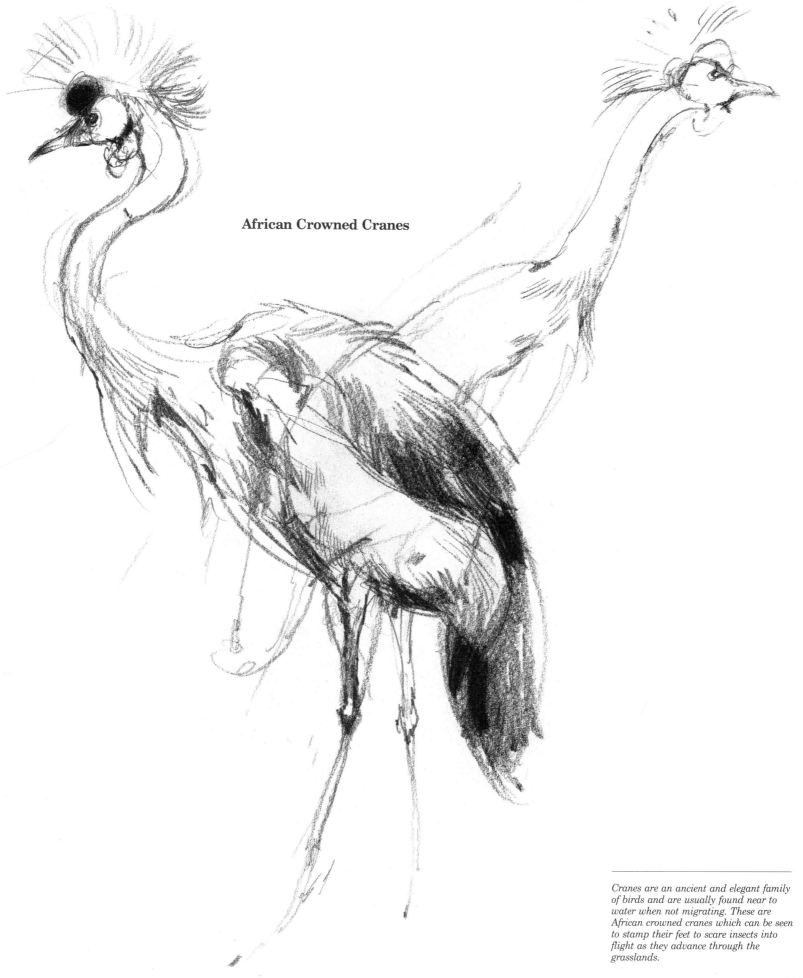

African Crowned Cranes

Cranes are an ancient and elegant family of birds and are usually found near to water when not migrating. These are African crowned cranes which can be seen to stamp their feet to scare insects into flight as they advance through the grasslands.

115

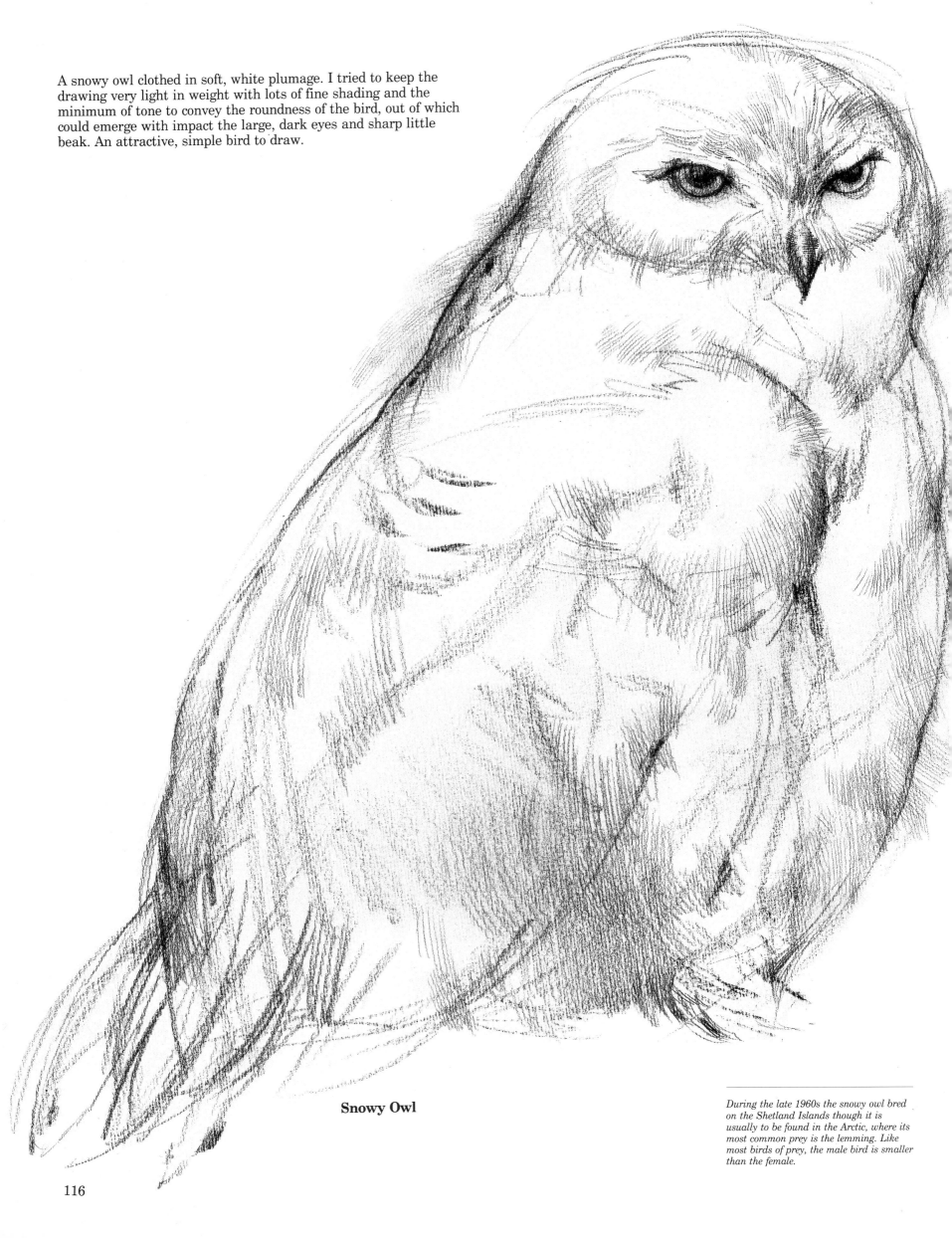

A snowy owl clothed in soft, white plumage. I tried to keep the drawing very light in weight with lots of fine shading and the minimum of tone to convey the roundness of the bird, out of which could emerge with impact the large, dark eyes and sharp little beak. An attractive, simple bird to draw.

Snowy Owl

During the late 1960s the snowy owl bred on the Shetland Islands though it is usually to be found in the Arctic, where its most common prey is the lemming. Like most birds of prey, the male bird is smaller than the female.

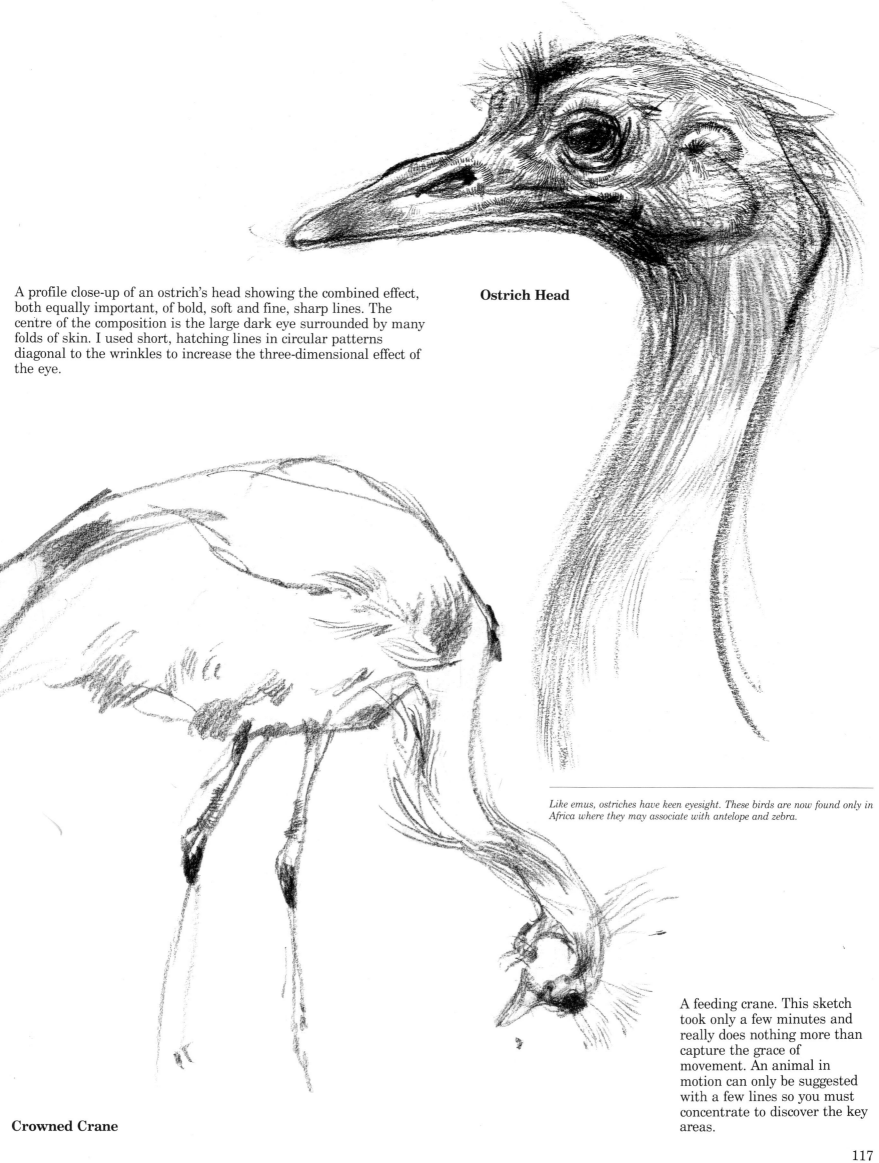

Ostrich Head

A profile close-up of an ostrich's head showing the combined effect, both equally important, of bold, soft and fine, sharp lines. The centre of the composition is the large dark eye surrounded by many folds of skin. I used short, hatching lines in circular patterns diagonal to the wrinkles to increase the three-dimensional effect of the eye.

Like emus, ostriches have keen eyesight. These birds are now found only in Africa where they may associate with antelope and zebra.

A feeding crane. This sketch took only a few minutes and really does nothing more than capture the grace of movement. An animal in motion can only be suggested with a few lines so you must concentrate to discover the key areas.

Crowned Crane

117

I was fortunate to get this action shot of a vulture tearing at a dead rabbit instead of one in more characteristic pose, circling round in the sky or sitting on a branch in a dignified manner. The weather was pretty appalling and splashes of rain were starting to darken my pages, so I had to work quickly. The bird was tugging away at its prey, balancing slightly backwards on its legs to give it more purchase on its victim. I used up two or three pencil points to colour in the black of the huge wings and tail before finishing the head and feet with a re-sharpened carbon pencil.

The rhinoceros hornbill also disliked the approaching wet weather, so I sketched it quickly with what was left of my carbon pencil, endeavouring to catch the look of anxiety on its face.

Vulture

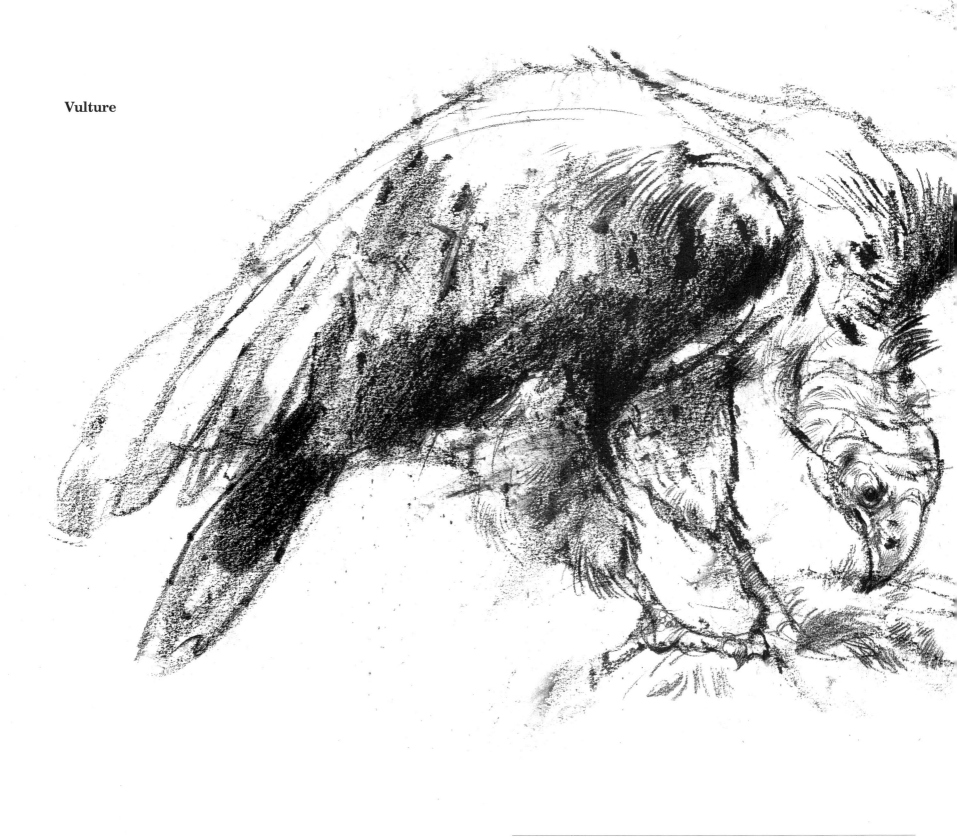

In the tropics and sub-tropics vultures soar effortlessly on uprising thermals of air to gain height, and then cross country by gliding downwards until they hit another thermal. In the sky they keep tabs on each other; if one descends the others follow in anticipation of a carcass to scavenge. The head and neck are bald since feathers would become clogged with blood.

118

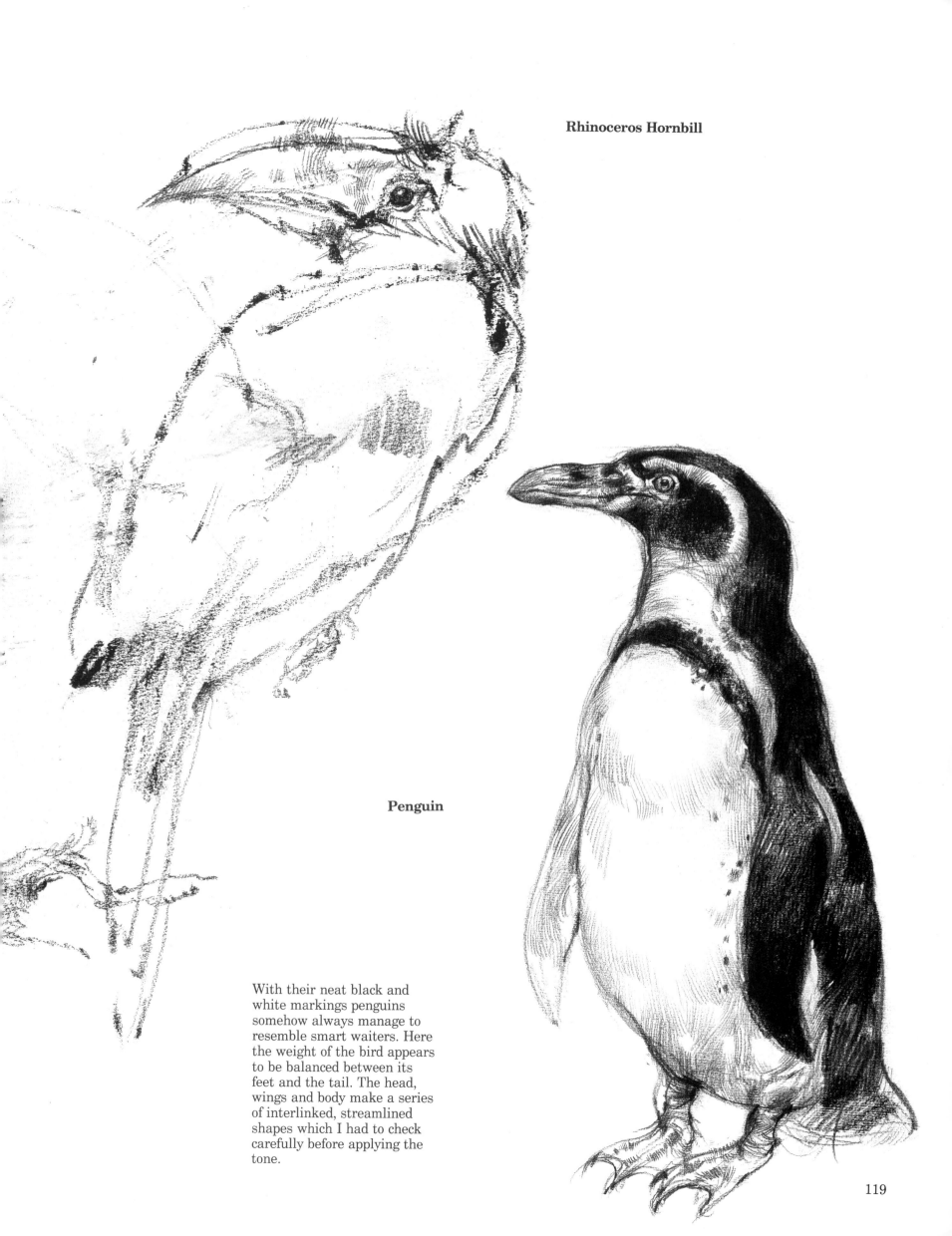

Rhinoceros Hornbill

Penguin

With their neat black and white markings penguins somehow always manage to resemble smart waiters. Here the weight of the bird appears to be balanced between its feet and the tail. The head, wings and body make a series of interlinked, streamlined shapes which I had to check carefully before applying the tone.

119

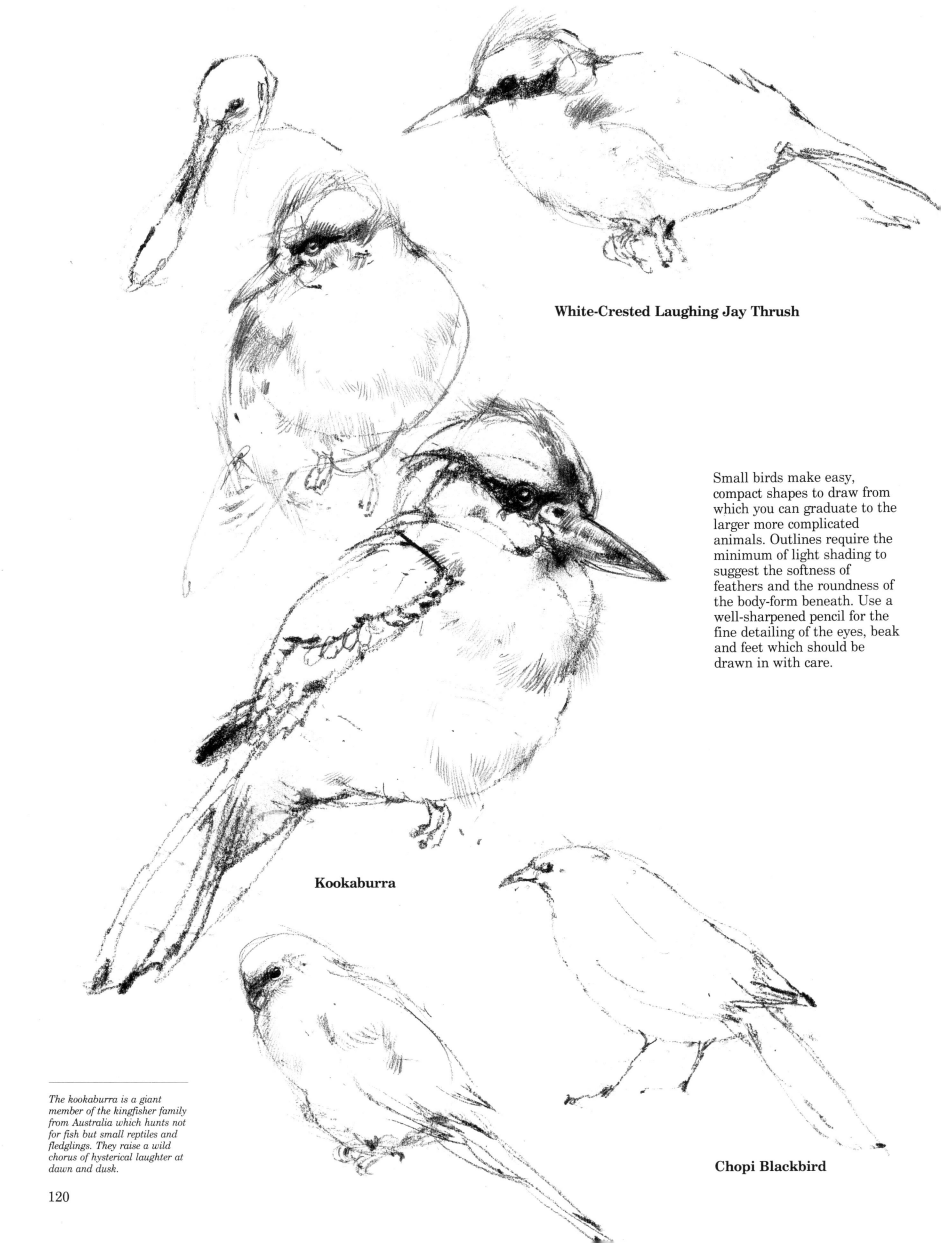

White-Crested Laughing Jay Thrush

Small birds make easy, compact shapes to draw from which you can graduate to the larger more complicated animals. Outlines require the minimum of light shading to suggest the softness of feathers and the roundness of the body-form beneath. Use a well-sharpened pencil for the fine detailing of the eyes, beak and feet which should be drawn in with care.

Kookaburra

The kookaburra is a giant member of the kingfisher family from Australia which hunts not for fish but small reptiles and fledglings. They raise a wild chorus of hysterical laughter at dawn and dusk.

Chopi Blackbird